IMAGES
*of America*

# WARMINSTER
# TOWNSHIP

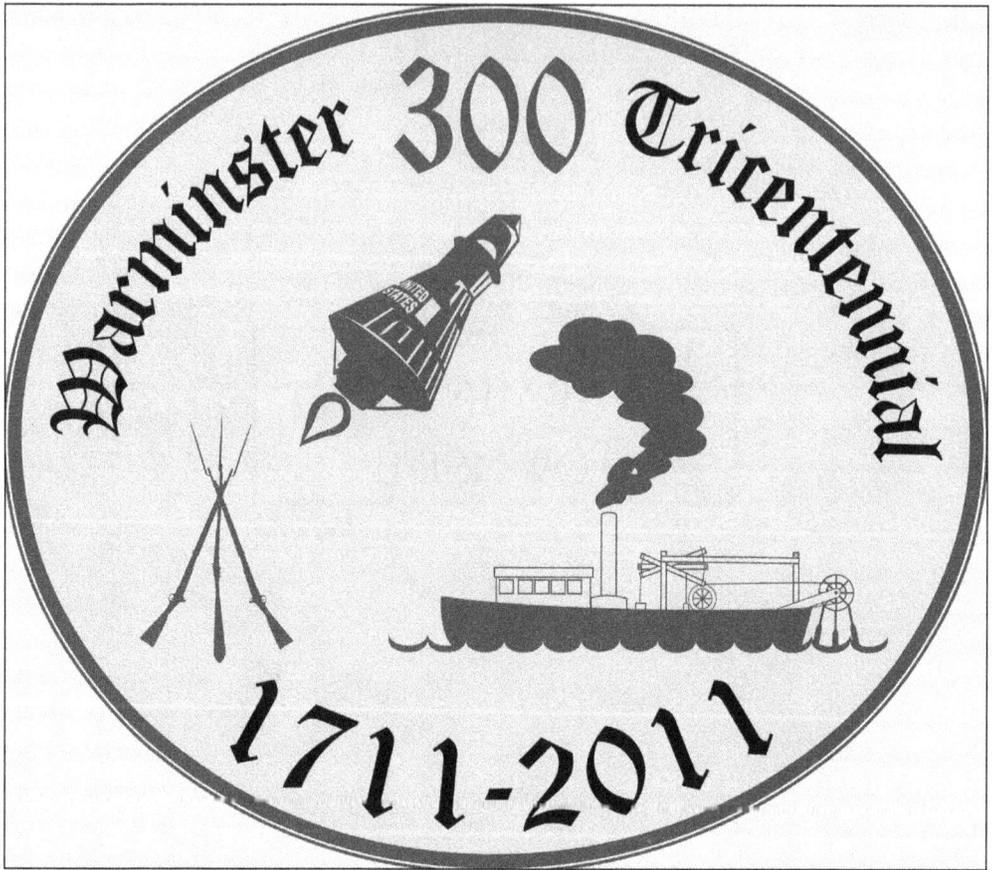

James Anthony Melio's design for Warminster Township's tricentennial logo was selected from among 143 contest entries submitted in 2009 by local fourth- to twelfth-grade students. The Log College Middle School eighth grader received a plaque and $300 from the Tricentennial Committee. His design, later refined by a professional artist, is seen above. Officials presiding over the tricentennial celebrations are Warminster Township's Board of Supervisors: Gail E. Johnson, chairman; Frank Feinberg, vice-chairman; Ellen Jarvis, secretary; Leo I. Quinn III, treasurer; and Thomas E. Panzer, Esq. Also assisting in the tricentennial activities is the Tricentennial Committee: Judge Daniel J. Finello Jr., chairman; Gary Hanley, vice-chairman; Richard Luce, treasurer; Debra Myatt, secretary; and members Edith Bitterlich, Neil A. Gibbons, Bernice Graetor-Reardon, Eva Luce, Douglas Mondel, and Joanne Thern. The untimely loss of member Jack Lennon (1934–2009) was keenly felt by all. (Courtesy Township of Warminster.)

ON THE COVER: These colonial-garbed children seen in 1928 were proudly participating in opening celebrations for Warminster Elementary, the first new public school in over 60 years. It was located on Street Road and Madison Avenue and contained six rooms. The "log cabin" was constructed by students for the event. (Courtesy Craven Hall Historical Society, Inc.)

IMAGES
*of America*

# WARMINSTER
# TOWNSHIP

Kathleen Zingaro Clark
for the Township of Warminster

ARCADIA
PUBLISHING

Published by Arcadia Publishing
Charleston, South Carolina

Library of Congress Control Number: 2010921764

For all general information contact Arcadia Publishing at:
Telephone 843-853-2070
Fax 843-853-0044
E-mail sales@arcadiapublishing.com
For customer service and orders:
Toll-Free 1-888-313-2665

Visit us on the Internet at www.arcadiapublishing.com

*To all the gracious people of Warminster*
*who helped create this book*

# CONTENTS

# ACKNOWLEDGMENTS

Thanks to the participation of many area residents and commitments from Warminster Township's Board of Supervisors; the Tricentennial Committee and its chairman Judge Daniel J. Finello Jr.; and Robert V. Tate Jr., township manager, the community now has a photographic history book to preserve its past for present and future generations.

Deepest gratitude goes to Erik Fleischer, president of the Craven Hall Historical Society, Inc. (CHHS, Inc.), and Mary Ullman, my editor, for their role in bringing this book to life and to the many others who assisted in both small and large ways: Sylvia Amato, Nancy Andal, Fred Bell, Janice Benson, Edith Bitterlich, Beverly Blackway, Otto Blavier, Eleanor Boyle, Janet Braker, Larry and Christina Brinkmann, Pauline Bush, Edwin Calhoun, Tony Carosi, Nancy Carver, Mary Ann Casele, Michael Chapman, Patricia Chazin, Father Citino, Marcy Connolly, Robert Clegg, Robert Cremeans, Douglas Crompton, Virginia Dare, Christopher Densmore, Timothy Dunn, Dr. Laure Duval, Ruthann Eynon, Jack Eyth, Mary Esbenshade, Katie Farrell, Anna Mae Fretz, Joan Fanelli, William Finney, Joyce Fox, George and Millie Forte, Charlotte Freed, Caroline Gallis, Charles Gerhart, Allan Gilmour, Jeffrey Glatz, Bernice Graeter-Reardon, Penrose Hallowell, Gary Hanley, Ruth Hannon, Kelly Harris, Russ Heaton, Harry and Dorothy Hellerman, Judith Herbst, David Hower, Charles L. Hower II, Donna Humprey, Phyllis Hurst, Gayle Jobst, Jay Johnson, Karen Kinzel, Jim Krueger, Cathy Krzywicki, Victor Lasher, Irene Lennon, Karl Lewis, Leigh Lieberman, Harding Lindhult, Paul Locke, Valerie-Ann Lutz, Michael Maguire, James Maier, Robert Mapleson, Jeffrey Marshall, June Maurer, Thomas Merkel, Fred Moll, Michael Mueller, Debra Myatt, Richard Noe, Patricia O'Donnell, Rick Parker, Dianna Peterson, Paul Petrun Jr., Ed Pfeiffer, Edward Price, Scott Randolph, Maryanne Rea, Jack and Ann Regenhard, Jesse Reilly, John Reilley, Josh Renaldo, Jean Rice, Elizabeth Sandell, Robert Schleyer, Linda Schreiner, Robert Severn, Diann Sgrillo, Tami Sharp, Len Sherlinski, Joy Shillingsburg, Wayne Siefert, John Simon, Kent Sloan, Richard Smyth, George Spalding, Judy Stafford, Michael Steffe, Joann Stotsenburgh, Diane Tangye, Jessica Tanner, Joseph Tryon, Clarence and Elaine Walker, Samuel Walker, Sewell Wallace, Helen Ward, Warren Williams, Cameron Wilson, Wendy Wirsch, and Andrew Zellers-Frederick.

The work of earlier researchers, including 20th century township historians Beverly Blackway and the late Paul Bailey, was extremely valuable in producing this book. Combined with the help of those recognized, I have endeavored to provide the essence of Warminster's past as accurately as possible and apologize for any errors, omissions, or oversights.

Love and thanks to my husband, parents, and friends for providing their support as I relentlessly pursue my passion.

—Kathleen Zingaro Clark

# INTRODUCTION

How many American communities played a key role in winning World War II and the Cold War or made major contributions to one of the greatest technological achievements of our time—human space exploration? How many hosted such laudable citizens as John Fitch, inventor of the first commercial steamboat, or William Tennent, founder of America's first Presbyterian theological seminary? Today Warminster proudly reflects on such noteworthy history and celebrates its 300th anniversary with *Warminster Township*.

The late local historian Paul Bailey wrote of roaming "deer, elk, bear, panther, fox and lynx" and the Native Americans who lived and hunted them here, leaving fields of arrowheads in their wake. In fact, it was these people, the Lenni Lenape, who accepted goods from proprietor William Penn in exchange for the land of Pennsylvania that King Charles II had granted him in 1681, land that included the township whose past we now review.

Confident he possessed clear ownership and selling rights, Penn began offering investors 5,000-acre parcels of hinterland along with a lot in his planned new city of Philadelphia. To settle the outlying region, he envisioned each 5,000-acre tract as a township uniformly laid out, squared off, and composed of ten 500-acre farms. Warminster, originally part of Southampton, became "a township in its own right" in 1711. As a 4.5-mile-long, 2.25-mile-wide rectangle "fairly well settled by European colonists," the township was among the few that actually resembled Penn's vision.

Following the early arrival of the Dutch and English, settlement in the region increased after the opening of York Road and Dyer's Mill Road (present-day Easton Road) in the early 1700s. The Scotch-Irish were particularly drawn to the area by William Tennent's Neshaminy Church in Hartsville, and subsequent population growth led to the creation of Warwick Township in 1733, splitting Hartsville between the two townships.

Among the first landholders in Warminster were John Hart, Bartholomew Longstreth, Henry Comly, Sarah Woolman, John Rush, and Abel Noble. Such pioneers often came in groups and worked heartily together to build their farmsteads and communities in the wilderness. They, and their descendants, participated in the flowering of America, unfolding in all its pain and glory.

During its first century, citizens of Warminster observed all manner of important events at the forefront of American history, from watching British soldiers perpetuate atrocities upon young Colonial militia recruits during the Battle of Crooked Billet to witnessing the struggles of transplanted, jack-of-all-trades John Fitch as he pursued his quest to revolutionize transportation.

From the early 1850s to 1870, the industrial sounds of manufacturing emitted by Bean's Agricultural Implement Factory on Street Road briefly enticed laborers to leave farmwork. Otherwise most of its 861 residents seemed quite content with the farming life, as virtually all 6,413 acres of its hilly, boulder-free land—promoted as "amongst the best in the County"—were completely under cultivation. Residents were described in print as "intelligent, industrious, and enterprising," but little else could predict that Warminster would become one of the most productive nonagricultural townships in Bucks County by the mid-20th century.

Change appeared in 1905 when Ivyland left Warminster to incorporate as its own borough. It had been over a quarter century since its founder, Edwin Lacey, had established the village hoping to capitalize on Philadelphia's 1876 Centennial Exposition by drawing travelers to his planned resort community. Then, during the early 20th century, another grand endeavor unraveled before it even got started: a motor speedway designed to rival the Indianapolis Speedway. Had it come to fruition, Warminster would be a different place indeed.

Although the farming community remained steadfast in its role of supplying the surrounding region and corporations such as the Campbell Soup Company with the fruits (and vegetables) of its labor into the mid-20th century, World War II was about to force a radical transformation. The spark was lit when military supplier Brewster Aeronautical Corporation opened a plant in the township that employed thousands and was soon taken over by the U.S. Navy.

As need for government workers ratcheted up for World War II, housing demands skyrocketed in direct correlation to the influx of workers. This flood of personnel to "Johnsville," as the Naval Air Development Center (NADC) became known, also generated increased need for educational institutions for workers' children, who multiplied exponentially during the postwar baby boom.

To accommodate Warminster's phenomenal growth during this period many local farms, owned by families for generations, were acquired by eminent domain for schools, housing, and even NADC runways. New commercial enterprises sprouted to support all the activity, and Street Road, Warminster's main thoroughfare, was widened several times to accommodate increased traffic.

Following World War II, the NADC transitioned from being a military arm to becoming one of America's foremost training centers for astronauts transporting America into the space age. Its days as the leading employer lasted into the late 1990s and left an indelible mark on the community and the generations of families who worked there.

Today Warminster is one of the busiest commercial centers in Bucks County. Its resident population exceeds 32,000, supported by the Centennial School District, numerous places of worship and community service organizations, police and fire protection services, a senior center, a recreation center, a public library, 409 acres of parks, a public golf course, public transportation, and a plethora of shopping centers.

As Warminster moves forward, it will continue in its tradition of making history and remain a community that remembers its unique and absorbing past.

# *One*

# Farms, Families, and Friends

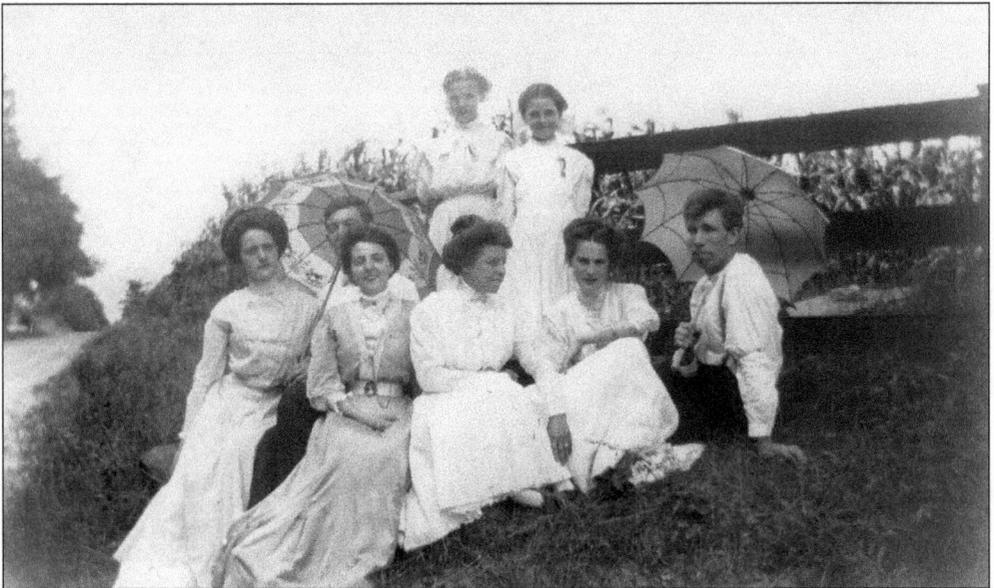

Many pleasant Sundays were passed with relatives and friends on the Conard family farm located on Newtown Road in Johnsville. Seated from left to right are unidentified, James and Florence Conard Search, Sallie Conard Walker, unidentified, and Sallie's new husband, Samuel C. Walker, Sr; standing, Laura and Agnes Conard. The young girls are unidentified. (Courtesy Samuel Walker.)

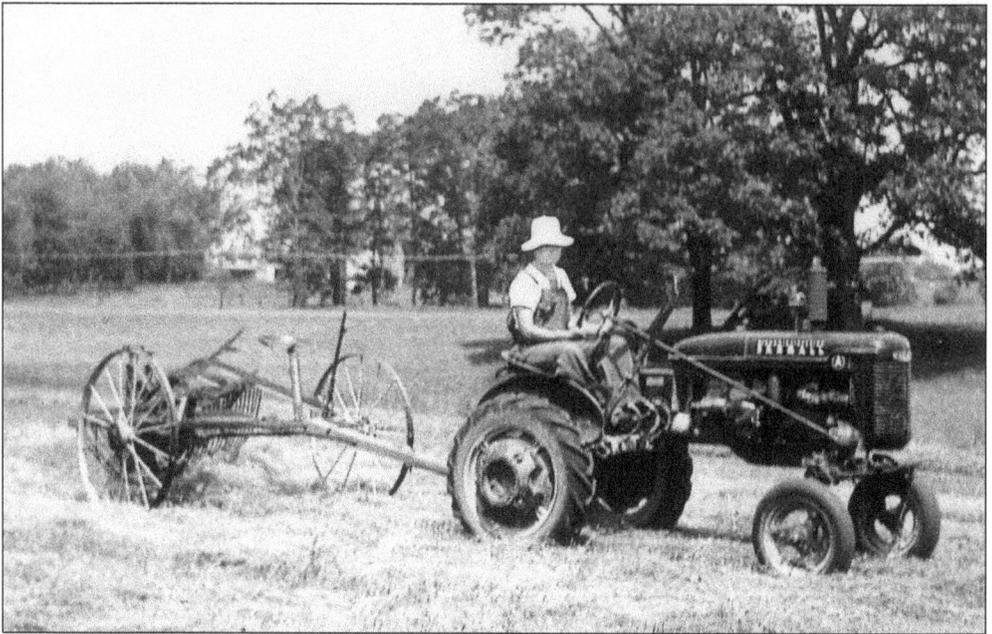

Paul Locke rides his red International McCormick Farmall Model A tractor, which was especially good for crops planted one row at a time, such as asparagus and tomatoes. Produced between 1939 and 1947, the Model A was described as a difficult tractor to mount. Nevertheless, during lazy Sunday afternoon social visits when Paul was a young teen, he and friends from Philadelphia found great fun in joyriding it around the farm together. (Courtesy Paul Locke.)

Shown here around 1946, Joseph Carosi's farm on Newtown Road, between Street and County Line Roads, produced spinach, turnips, beets, tomatoes, carrots, and other vegetables. Another family farm at Street and York Roads included a historic landmark building with two apartments, known for years in the 20th century as Warminster Manor. The Carosi's sold most of their produce at Second and Dock Streets in Philadelphia or through the now defunct Philadelphia Vegetable Growers Co-operative Association. (Courtesy Tony Carosi.)

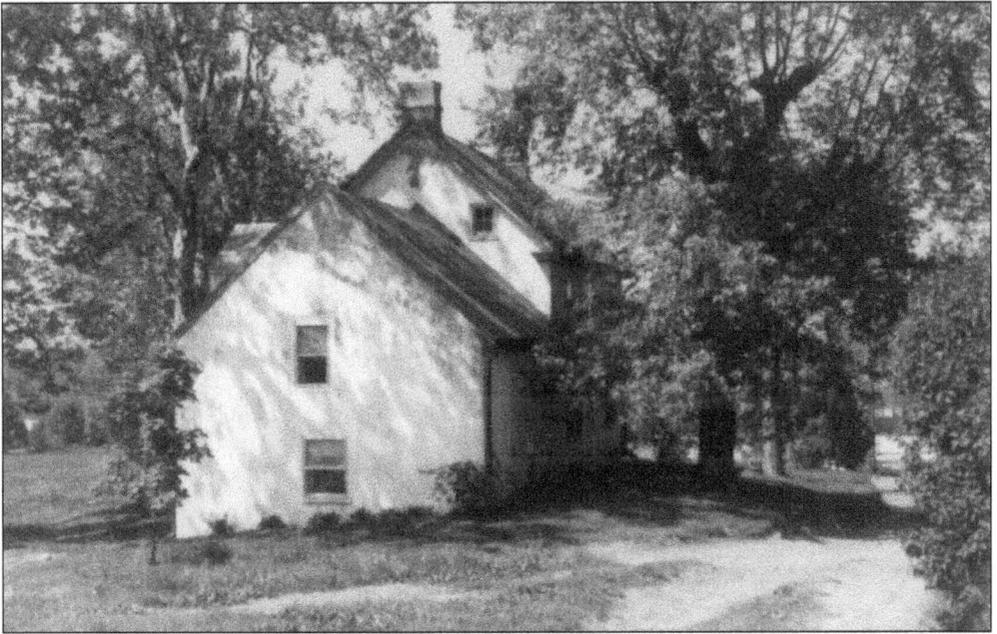

This beautiful farm property (above and below), among the oldest in Warminster, was on Cherry Lane (now Centennial Road) between County Line and Street Roads. It was originally part of a larger tract granted to an investor in 1684 by William Penn. Local historian Beverly Blackway determined the original portion was constructed between 1708 and 1732. Franklin Wright, who finished constructing Centennial Road to Street Road during the 1876 U.S. Centennial, purchased the home in 1874; his son Harrie sold it to Elsie and William Fulmor in 1928. Daughter Phyllis Fulmor Hurst remembered a sinking kitchen floor that exposed a subbase of logs. In 1968, Elsie, widowed and 84, lost two sons to natural causes and her home to eminent domain in a span of two weeks. The property and modernized farm were condemned by the Centennial school board to build William Tennent High School. (Both, courtesy Phyllis Hurst.)

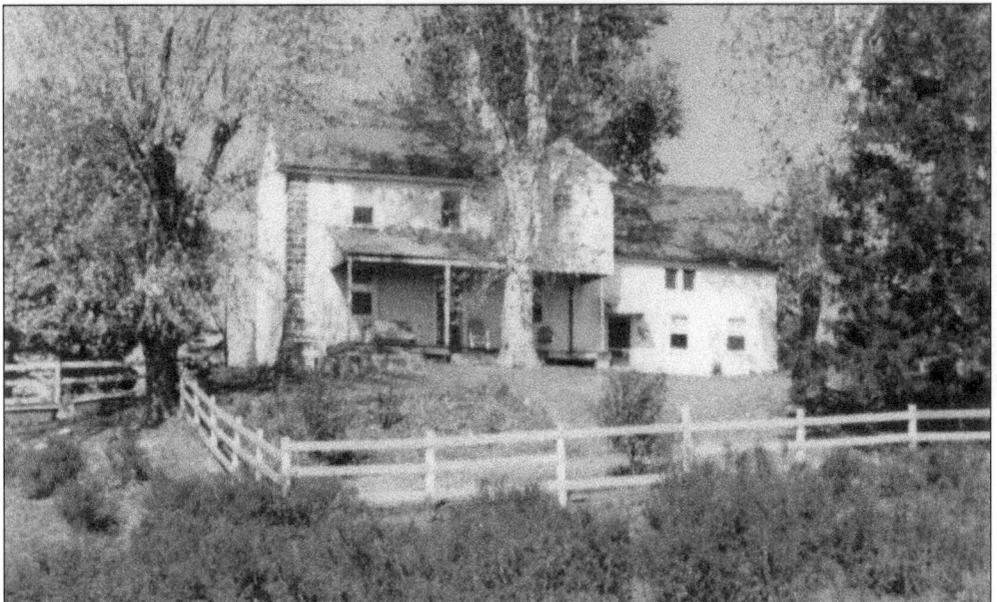

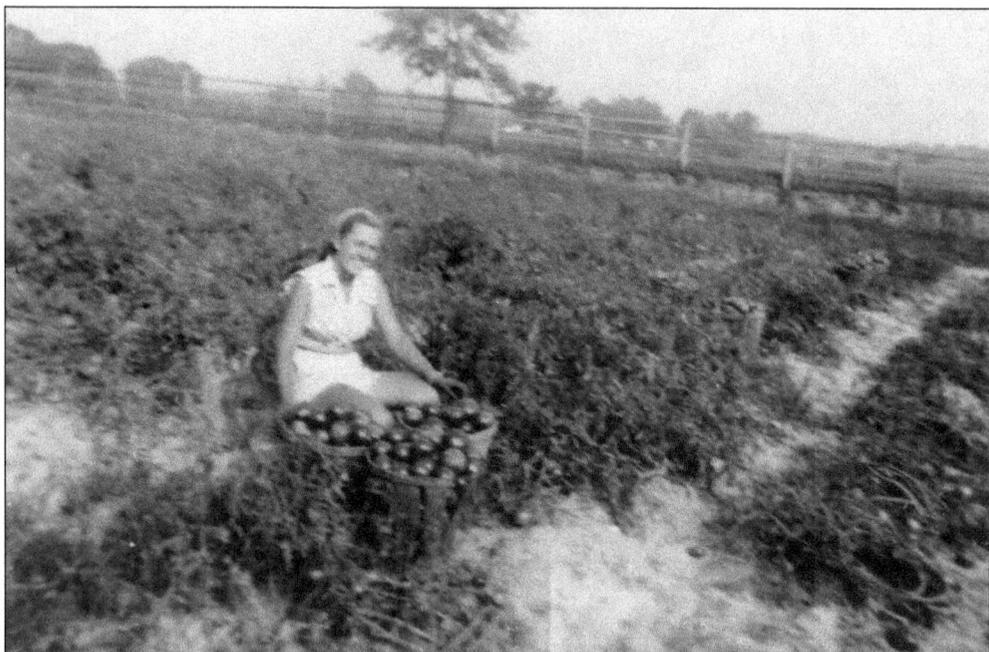

This former Lacey Park resident can be recalled only by the name "Texas." This photograph was taken around 1946 on the Carosi farm, established in 1938 in Johnsville, where she picked tomatoes for 10¢ a basket. Tony Carosi recalls her as "a real worker" with a great disposition. The only thing known about her today, ironically, is that she lives in Texas. (Courtesy Tony Carosi.)

These two massive trees on Ritchie farm were removed to widen the shoulders on Jacksonville Road soon after this photograph was taken around 1940. Looking west toward York Road is Harold Haines's farm. The oversized garage, or wagon house, left of the barn sheltered carriages, wagons, and farm machinery. Upstairs accommodations provided shelter to "Knights of the Road"—homeless men who periodically worked there, receiving "room, board and cast-off clothes" for their efforts. (Courtesy Paul Locke.)

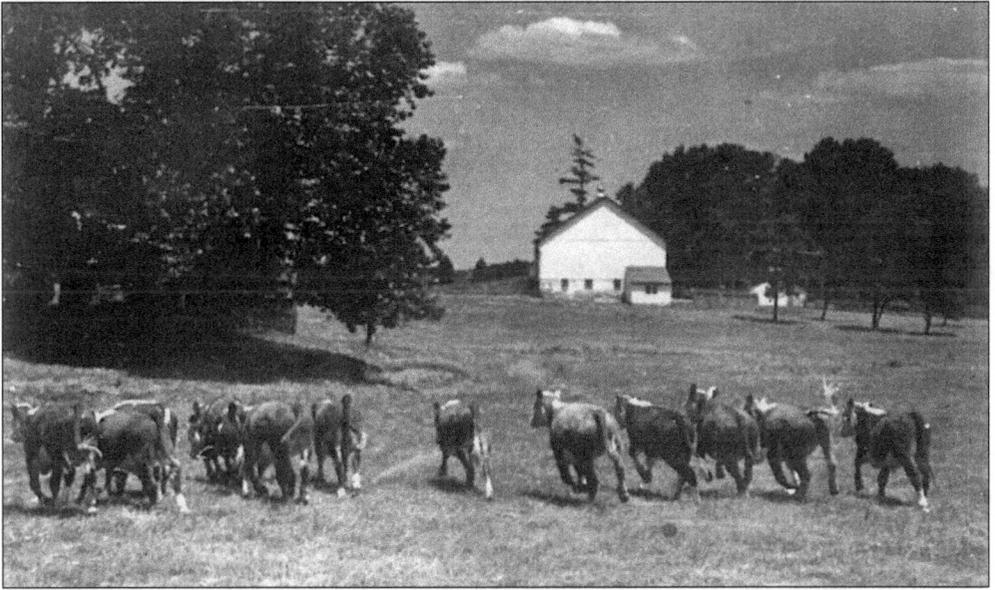

The above herd of steer on Belvidere Farm runs straight toward the present-day site of the Ben Wilson Senior Center. All livestock feed, including wheat, corn, oats, and soybeans, was raised here. Tenant farmers operated the farm owned by Wharton Sinkler. Charles Dudbridge, the "boss farmer," was fond of using Clydesdale ("beer and ale") horses for his teams. Dudbridge's son-in-law Wesley, his grandson Charles, and usually another man worked with him to keep the "beef" farm running smoothly. Street Road lies beyond the barn (above) and a tenant house (below), both of which still exist. Foxhunts once commenced here, being the drop point for the hounds and horses employed in the event. Belvidere Farm extended across Street Road. That portion was sold to Walt Lojeski, then to Miller and Company, before becoming township property and the highly rated Five Ponds Golf Course. (Both, courtesy CHHS, Inc.)

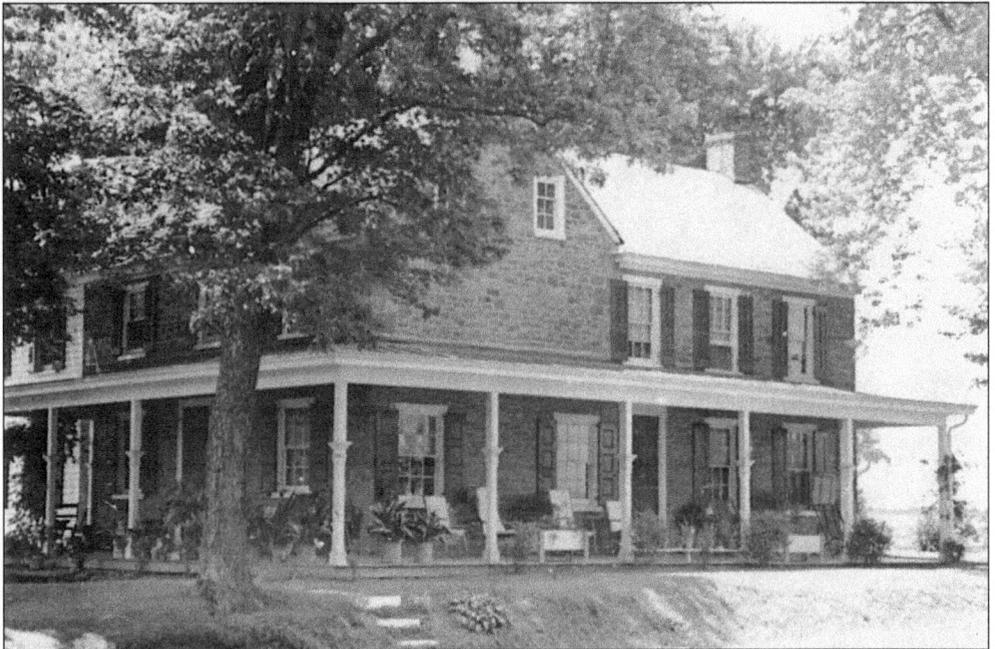

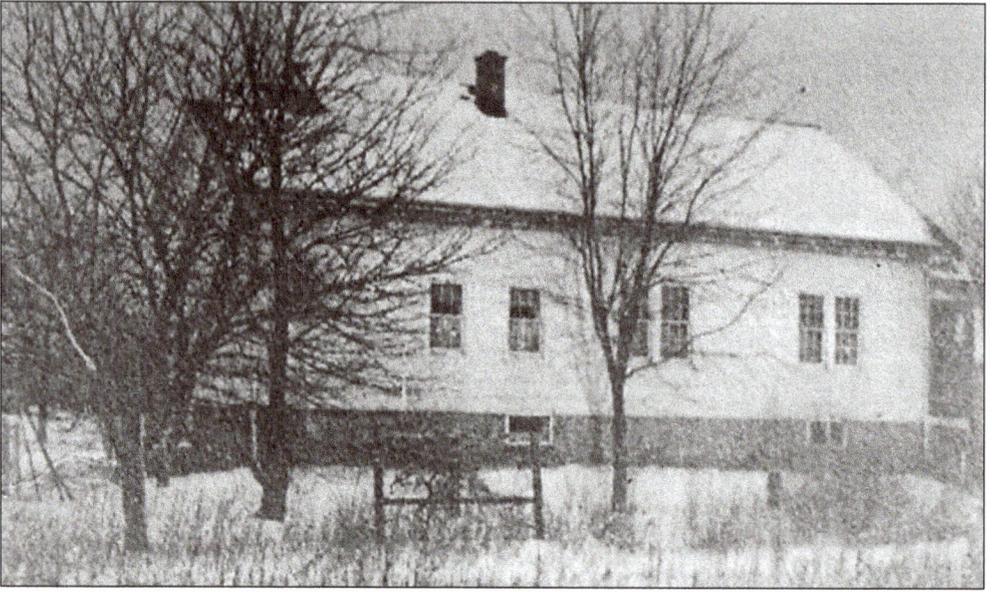

John P. Petry began Petry's Poultry Farm (above) on Norristown Road in 1942, maintaining 6,000 chickens and supplying all the grocery stores in the area. He is seen below using a "chicken picker." The machine consisted of a quickly rotating drum with protruding hollow rubber "fingers." Although it reduced the cleaning effort, Petry's wife, Helene, manually removed any remaining fine hair and feathers in a process called "pin" feathering. Although the cost of grain around 1946–1947 pushed the family out of the poultry business, John, also a NADC worker, started a fruit and produce business. Locals particularly enjoyed the raspberries, blueberries, and corn sold seasonally at the Davis Market stand on York Road. Sales of live Christmas trees began in 1958, and John, who lived until age 94, planted upward of 500 per year. (Both, courtesy Joan Fanelli.)

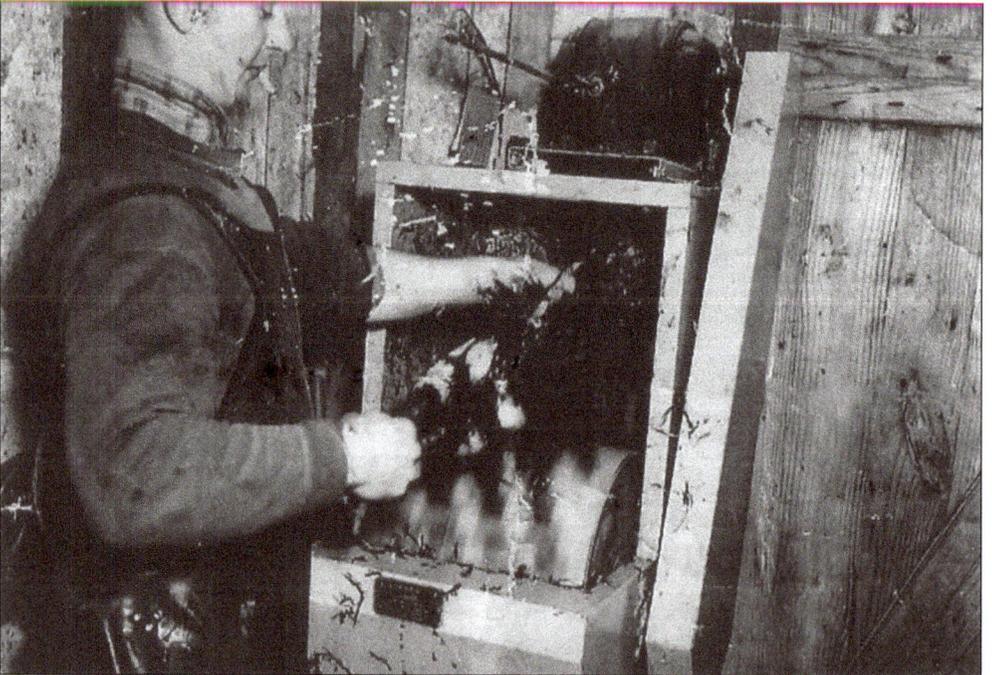

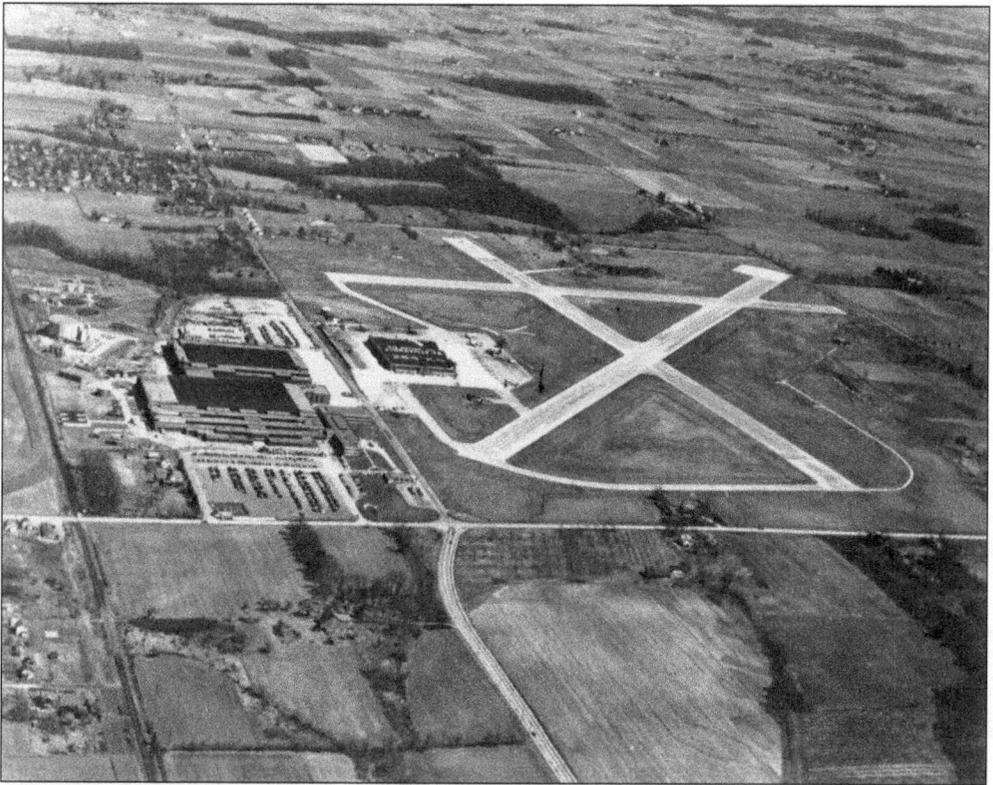

Many beautiful farmsteads, like the one that once belonged to the Yerkes family (left forefront), were lost as Warminster grew and developed. The Duval family moved here in 1953 from Buckingham so patriarch Georges could walk to his job as superintendent of the NADC Weapons Division. Notice the centrifuge at center left and Ivyland above it. Street Road runs across the lower quadrant, and the lone building beneath the airstrip is the Quaker Meeting House. (Courtesy Dr. Laure Duval.)

In the waning days of Warminster Friends Meeting its small congregation honored lifetime member, Sallie Walker, seen here on Sallie Walker Day with son Samuel Walker Jr. Today, at 90, Sam still maintains the family's Jamison farm, where he and wife Margaret raised four daughters. Besides farming, Sam, a baseball enthusiast, also drove school buses for Centennial and Central Bucks School Districts and was a head custodian at Tamanend Junior High. (Courtesy Dr. Laure Duval.)

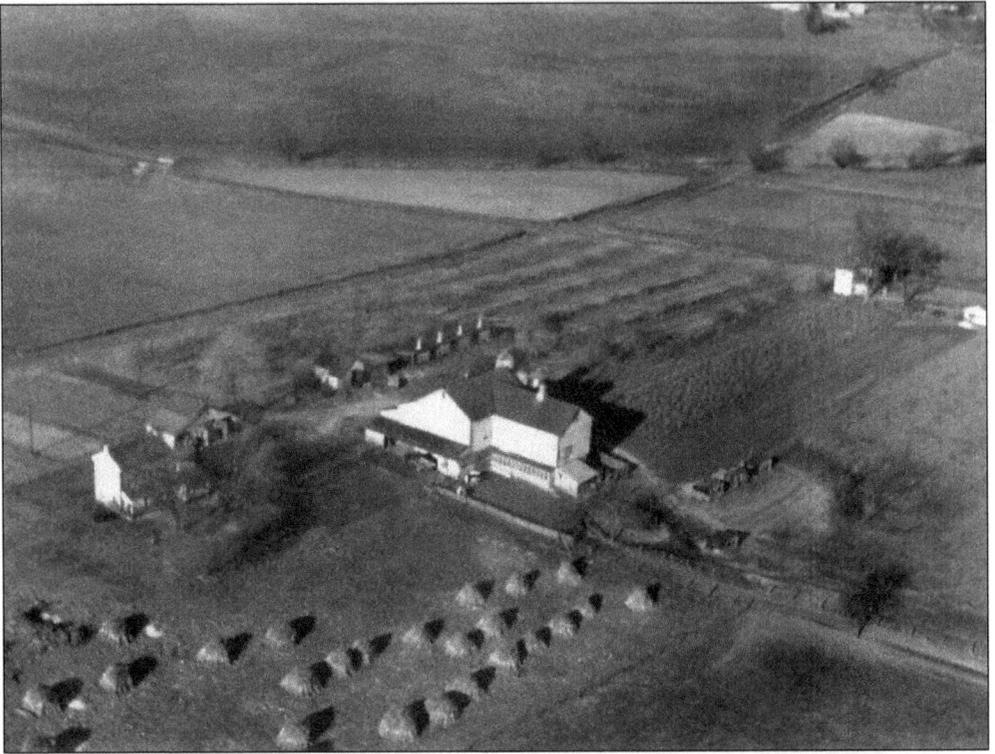

Joseph and Elizabeth Hallowell acquired this 67-acre farm fronting Mearns and Bristol Roads around 1920. Primary products were dairy, poultry, and vegetables. Until 1941, Joseph operated a produce truck route through Hatboro and Philadelphia selling farm-fresh goods, including 30-pound baskets of potatoes for 25¢. The family prided itself on using cost-efficient and progressive farming methods. (Courtesy Penrose Hallowell.)

Holstein breeders created the Holstein-Friesian Association of America in 1885. It registered ownership, pedigree, and graphic identity markings of members' purebred cows. Dairy farmer Joseph Hallowell purchased five purebred Holsteins on the day his son Penrose ("Penny") was born in 1928. Today the lineage of Penny's own herd can be traced back to Seguis, one of his father's cows. (Courtesy Penrose Hallowell.)

In addition to receiving an elementary and secondary education, some boys who lived at Christ's Home for Children also gained skills suitable for the farming life. The home supplied most of its own food into the 1970s and could feed up to 300 people. They raised livestock and butchered the meat, milked their own dairy cows, raised chickens, and ate field-fresh produce daily. They also collected honey from their beehives and made bread from wheat grown on the farm. (Both, courtesy Christ's Home.)

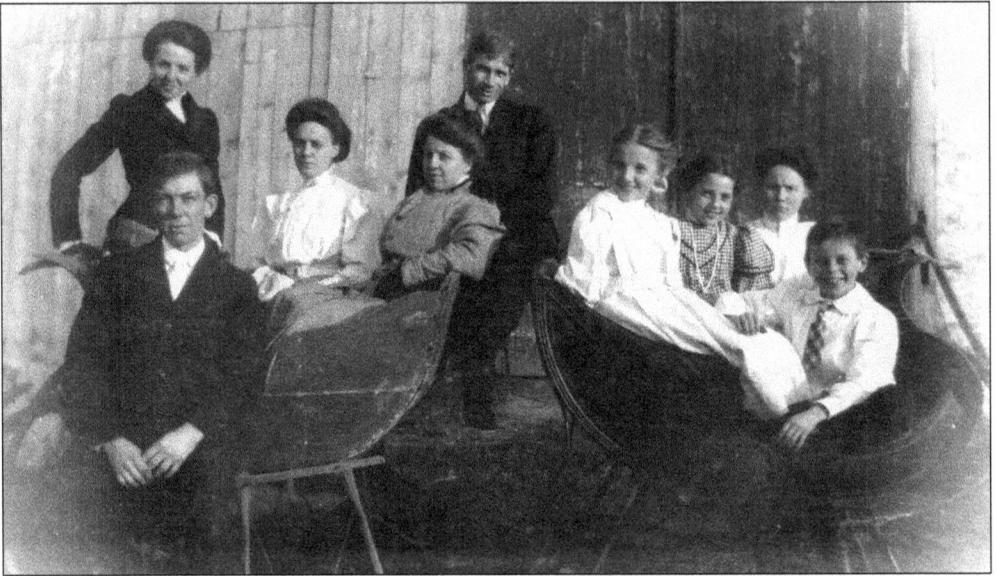

Florence Conard Search (standing), and left to right, huband James, mother Jennie, siblings Sallie, Laura, Agnes, and Fred pose in the family sleighs (Adults in rear are unidentified). One snowy Easter Sunday after she married, Sallie and husband Samuel C. Walker took one of the sleighs to visit relatives in Bryn Athyn. Midway through their journey, the spring snowfall stopped and melted. Forced to abandon their sleigh (and their plans), they mounted their horses, rode home through slush and mud, and returned with a wagon to retrieve their otherwise reliable conveyance. (Courtesy Samuel Walker.)

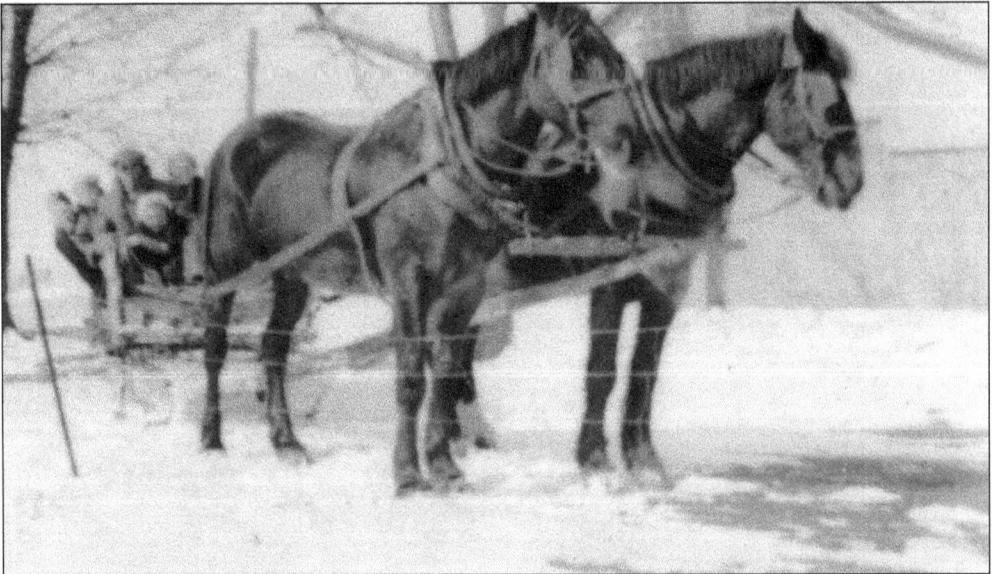

Joseph and Elizabeth Hallowell and their children—from left to right, Katherine, Joseph Jr., and Penrose—enjoy an excursion around 1936. Their favorite horses, Pete and Dick, and this sleigh sporting extra-wide runners were utilized by Joseph on several occasions when snow storms prohibited normal milk pickup by Frankford Dairies. By traversing otherwise blocked roads, he personally delivered his filled milk cans to the Philadelphia-bound train, avoiding costly spoilage and losses. (Courtesy Penrose Hallowell.)

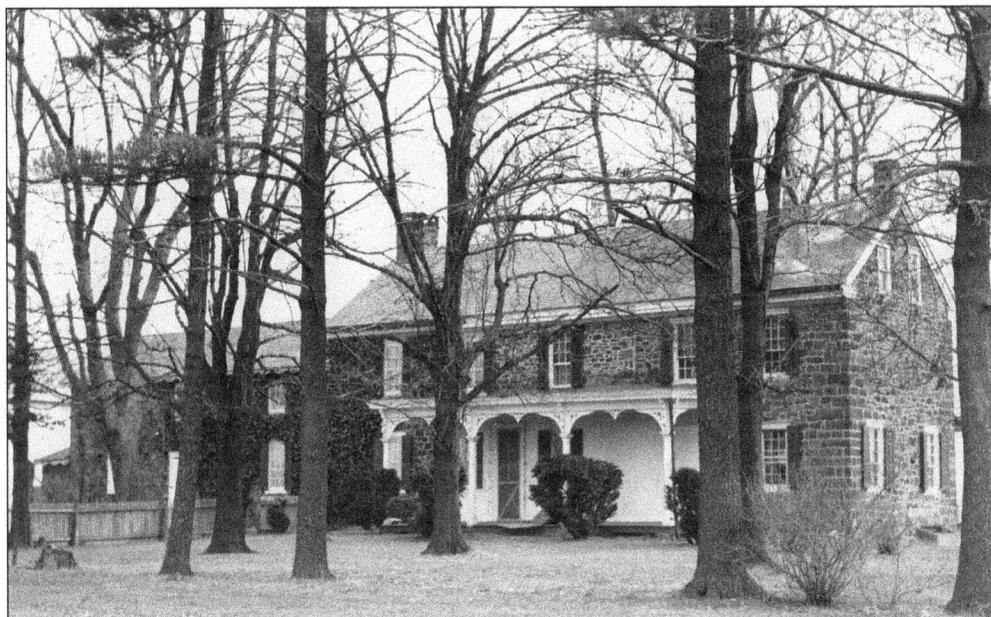

This home, built in the late 18th century by John Longstreth (great-great-grandson of Bartholomew and Ann Dawson Longstreth) was purchased in 1865 by Samuel Walker, former owner of Blair Mill. The farm included a "stone house [above], large barn, hog pen, ice house, granary and 93 acres." To beautify his property, Samuel hired a Philadelphia landscaper to line the entry lane with pine and maple trees (below). In 1951, Walker's grandson, also Samuel, was notified the adjacent navy base wanted the land for a runway extension. After a four-year court battle with the government, he lost the farm to eminent domain in 1955 and died in 1956. Navy pilot Tom Broadhurst and his family subsequently lived in the home for a number of years, and his wife, Betty, graciously worked with the Walkers to compile the home's history. (Both, courtesy Samuel Walker.)

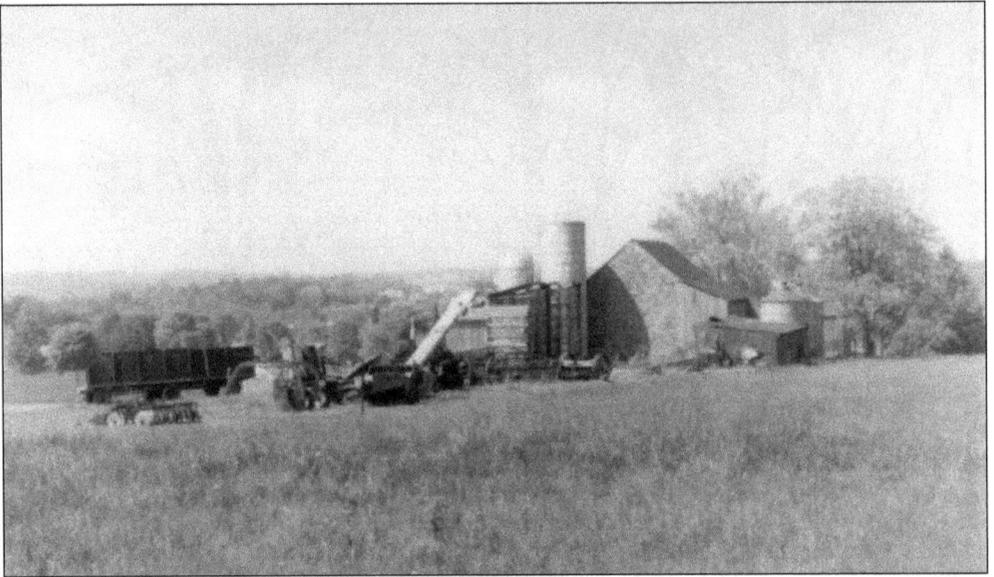

The stone barn above, flanked by massive equipment and twin silos, was built in 1812. It was owned by the Fulmor family, who grew wheat, barley, oats, hay, and corn on their 51-acre tract and 130 adjacent acres. In the early 1960s, vibration damage from plane activity at the nearby Johnsville Naval Center was blamed for the collapse of the outer barn wall (below). Carl Fulmor rebuilt the wall himself over the next several months. In 1968, the modernized barn boasted "cow stanchions, running water, electric barn cleaner, and a new concrete milk house which met every state requirement." Nevertheless, the farm, owned at the time by widow Elsie Fulmor, was taken through eminent domain to build William Tennent High School. It had processed over 400,000 pounds of milk, 10,000 bales of hay, and 1,000 bales of straw only the year before. (Both, courtesy Phyllis Hurst.)

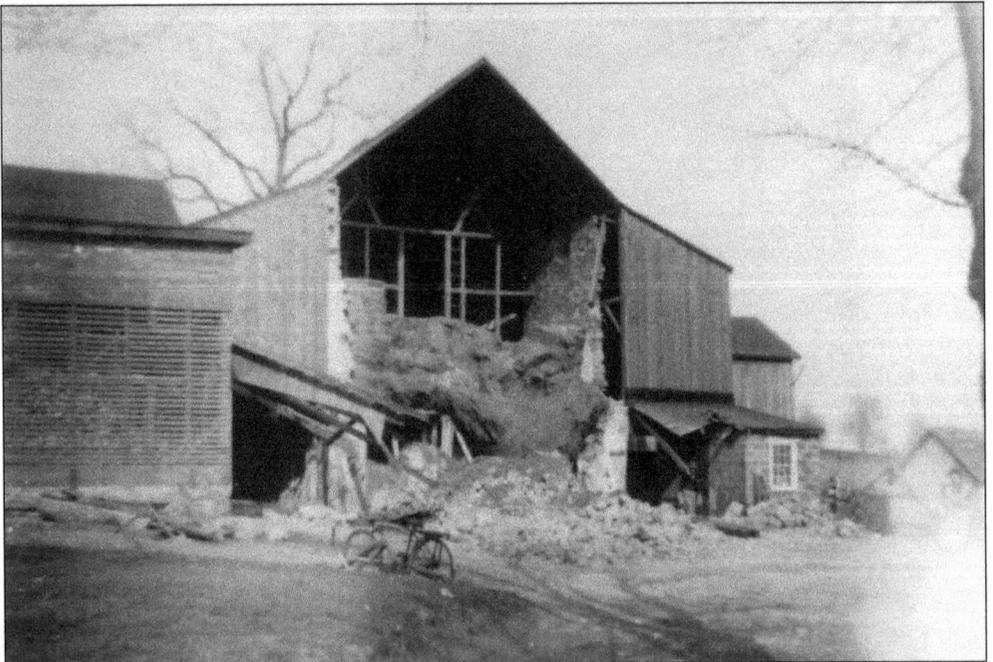

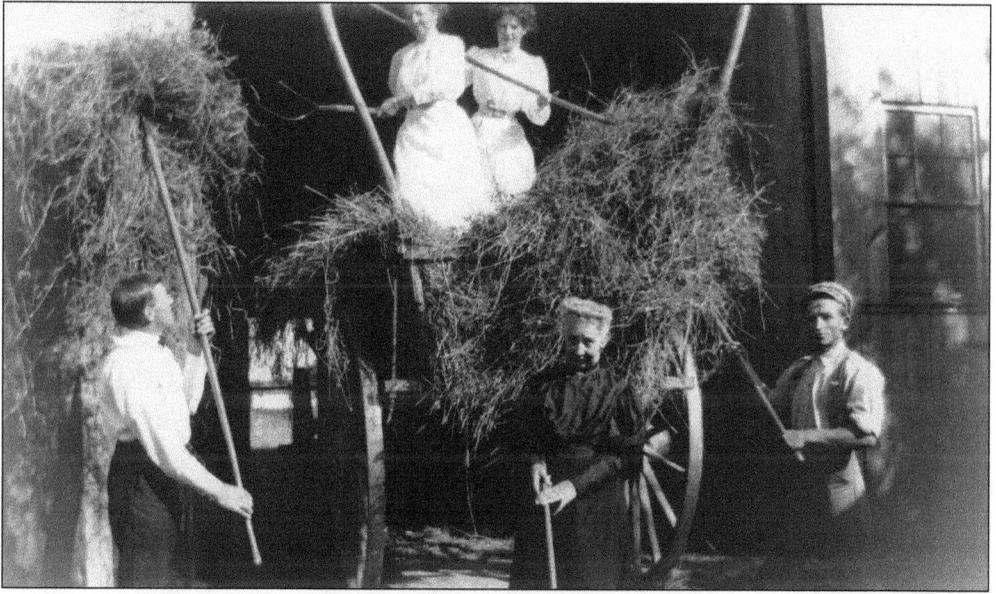

From the many photographs that have survived through the generations, the Conard clan appear to have been a fun-loving and close-knit bunch. In what appears to be a staged photograph above, Sallie Conard Walker (left atop hay wagon) wields a pitchfork aside an unidentified woman doing the same. Sallie's mother, Jennie, stands in front. In the early 1900s, when the photograph below was taken, family and friends sport Easter bonnets and hats, stiff Arrow collars, and tight corsets, all fashions of the day. The adults are, from left to right, Florrie and James Search, unidentified, Joe Conard, and sisters Sallie and Agnes. The children are unidentified. (Both, courtesy Samuel Walker.)

Margaret and Alphonso Casele were tenant farmers around 1944–1947 on Walt Lojeski's farm at Street and Newtown Roads. Margaret picked spinach, rhubarb, tomatoes, and other produce, which Alphonso transported to Dock Street for sale. They shared the home (today Craven Hall) with the Yanagihari's, a Japanese family whose elderly mother worked a large spinning wheel upstairs. From left to right are (first row) Margaret Casele, Frank Garappo, Frank Delagol, and unidentified; (second row) Caroline and Thomas Garoppo and Mary Salemno. (Courtesy Mary Ann Casele.)

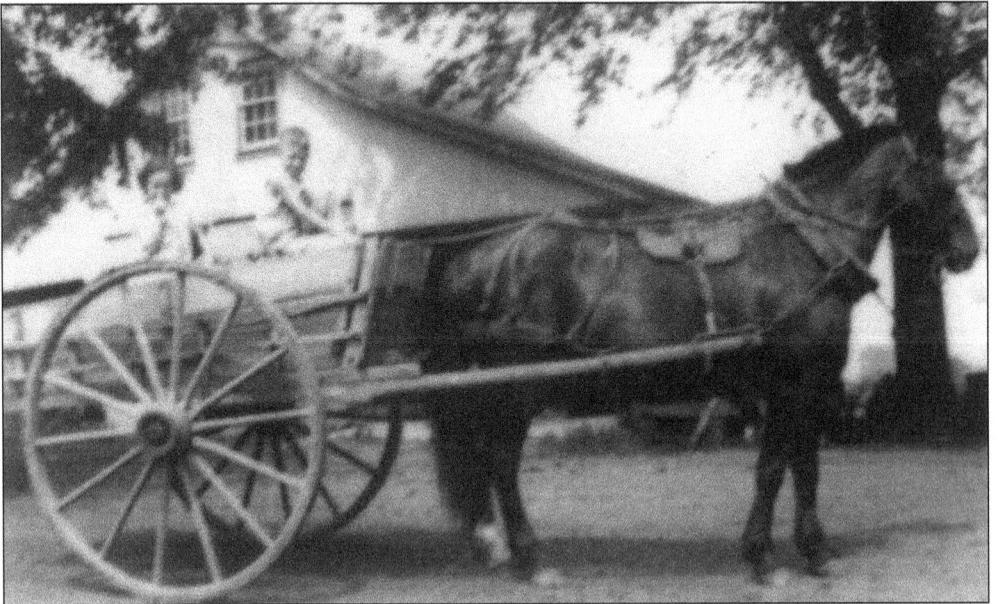

Dorothy Hallowell and her brother Penny, raised on the family farm, enjoyed being pulled in this wagon by Dick, one of several farm horses. Penny went on to become Pennsylvania Secretary of Agriculture and presently owns another dairy farm in Tinicum; Dorothy lives in Colorado. Penny and Dorothy are 11th generation Quakers. (Courtesy Penrose Hallowell.)

The Carosi's owned and operated two farms in the area, including this farm in Johnsville that they operated for 22 years. In 1955, Tony Carosi contracted to grow 10–12 acres of tomatoes for Campbell Soup Company, and records show almost 18 tons per acre were delivered to them the following year. By the late 1950s, the Carosis were among approximately 150 regional farmers with membership in the Philadelphia Vegetable Growers Co-operative Association. Collectively the group reserved roughly 900 acres of land exclusively for Campbell's. Tony Carosi, above in 1948, is preparing fields for planting. The woman below, photographed in 1949 on a new tractor, was employed by the Carosis as a tomato picker. She is recalled only as "Texas" and was a resident of neighboring Lacey Park. (Both, courtesy Tony Carosi.)

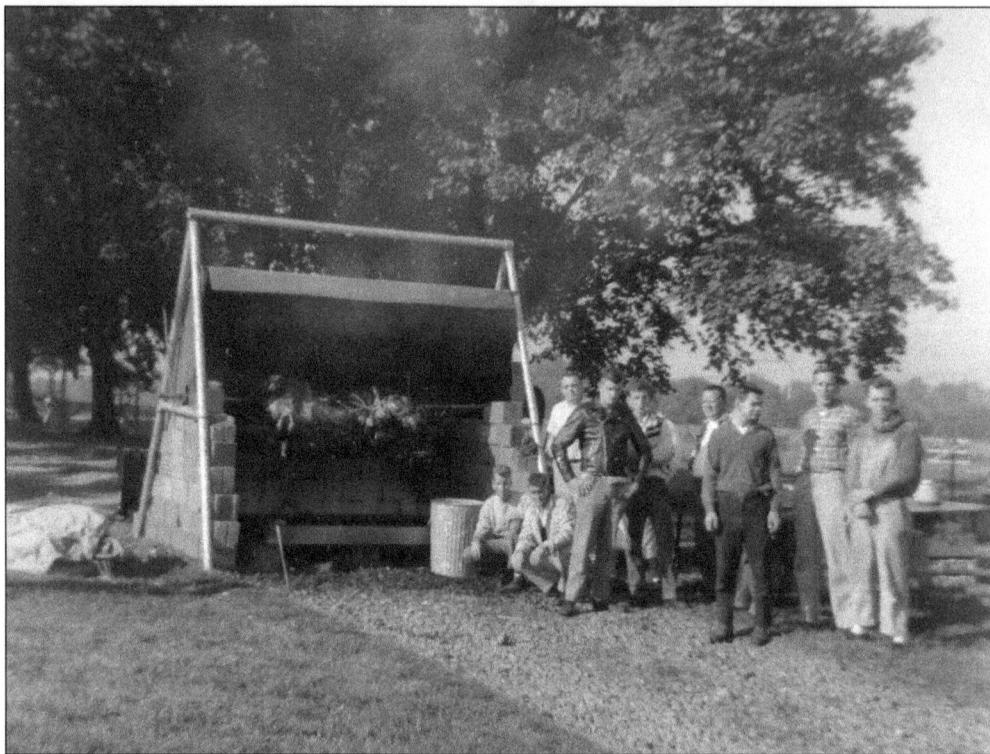

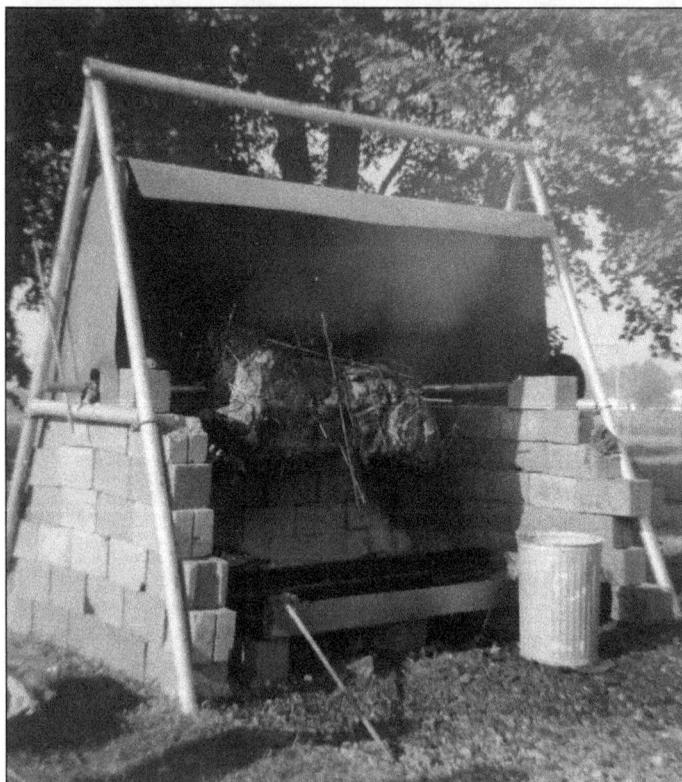

Warminster's 250th anniversary was commemorated by several events held on June 10, 1961, including a community ox roast. Warminster Fire Company firefighters (above) roasted the beast for two days on this homemade spit, a repurposed swing-set frame. They used the floor mop propped up on the left as a brush and basted the ox with Texas barbecue sauce stored in the metal trash can. The Firemen's Parade ended in a field at the Street Road home of Elizabeth and Georges Duval Jr. with the community picnic and "lots of beer" imbibed from commemorative drinking glasses. (Both, courtesy Dr. Laure Duval.)

Time on a farm was frequently spent maintaining fences meant to keep animals from roaming off the property. Many farmers made their own rails and also kept spare or reusable rails for replacements of rotted and broken sections. This abundant supply stored under a massive tree on the Walker farm includes three-hole fence posts drilled with an auger. From left to right are Sallie Conard; her mother, Jennie; and her sister Agnes. The men above are unidentified. (Courtesy Samuel Walker.)

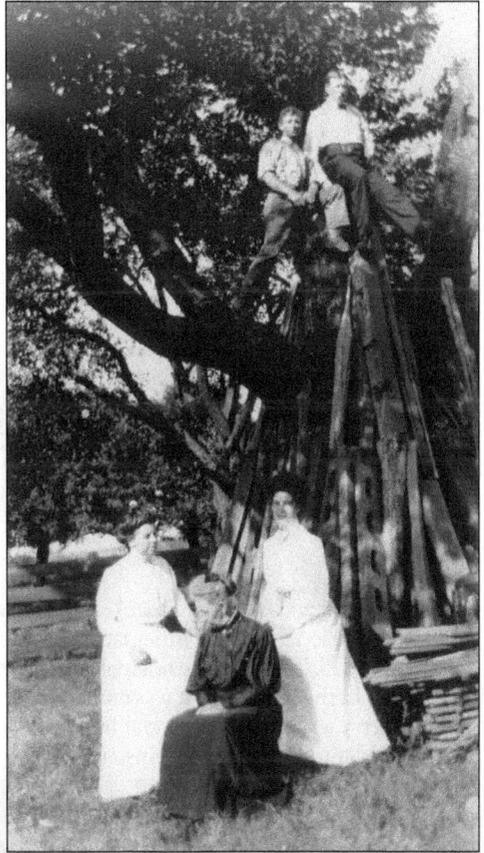

Paul Locke, whose family had a small farming operation in Warminster, said he "always loved playing with hay and was fascinated by it." Although he enjoyed pitching hay as a boy, as an adult he utilized machinery and hired help for baling. (Courtesy Paul Locke.)

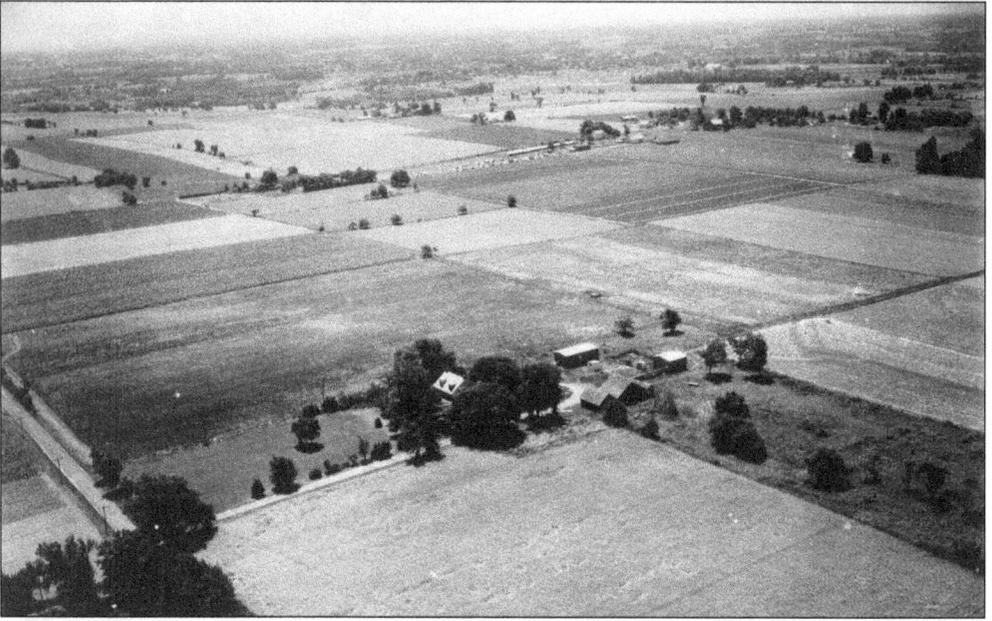

This late-1940s aerial view of Finney farm includes Bristol Road (left) and looks south toward Davisville Road. It shows 75.25 acres of the original 95 acres owned by the family. Nearby was Breadyville, an active community in the late 1870s. It was named for sisters Margaret and Catherine Bready, who developed their property with the commercial buildings and homes that became the village. Breadyville was consolidated into Ivyland, Warminster Township, in 1891. (Courtesy Anna Mae Finney Fretz.)

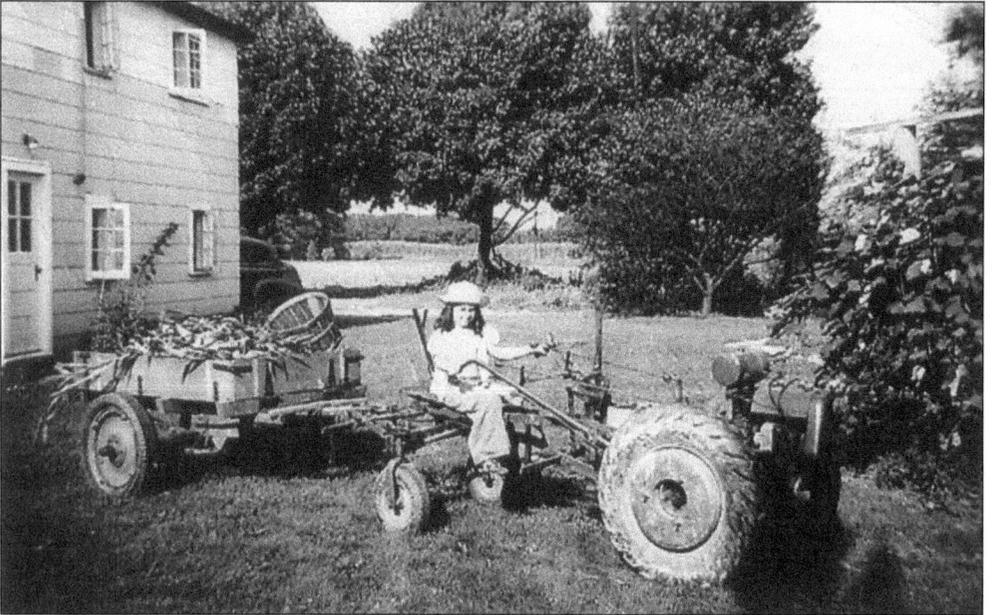

Joan Petry Fanelli was 11 when this photograph was taken on the family farm in 1951. She is sitting on a small tractor pulling a wagon loaded with fresh corn handpicked that morning. Within two hours, it arrived at local markets along with other freshly picked goods from Petry's fields, such as raspberries and blueberries. The farm was sold in 1972 to the Eastern Star Home. (Courtesy Joan Fanelli.)

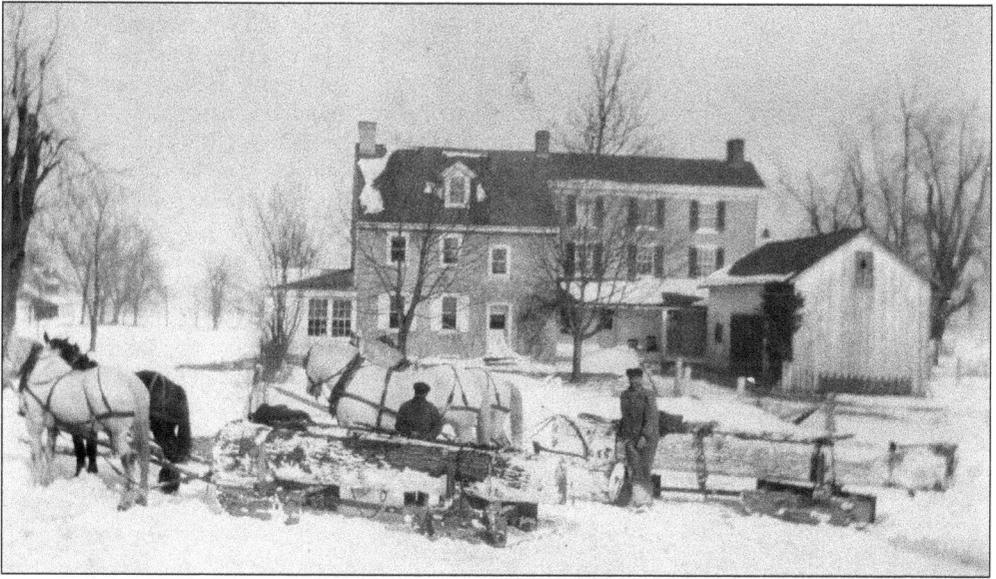

Additions in 1862 and 1865 to the Bennett/Finney home (above and below), built in 1810, resulted in an 18-room abode. Each room had its own fireplace, several finely crafted. Family and many boarding vacationers lived congenially together on the farm, prompting one bard to write a lengthy ode to the beauty and happiness found there. A fire in 1948 destroyed the barn despite the intervention of fire companies from Richboro, Ivyland, Hartsville, Warminster, Horsham, Feasterville, Trevose, and Trevose Heights. In 1951, the U.S. government confiscated the property, along with the Walker, Hobensack, and part of the Munro farms, for a NADC runway extension. (Both, courtesy Anna Mae Finney Fretz.)

While mother Antonia was cooking, the rest of the Carosi family enjoyed their Sunday rest on a hot summer's day in the late 1930s. Posing for Dominick Carosoi, from left to right, are sisters Anna and Mary, brother Tony, and father Joseph. As lack of refrigeration caused vegetables to have a short shelf life, Joseph would be back to work by night to prepare his produce for the Monday morning market. (Courtesy Tony Carosi.)

Tony Carosi raised six pigs as a boy, feeding them and the chickens every morning before school. Eventually these piglets grew to 250–300 pounds before being killed by relatives during the full moon according to the custom of their home country. At a time when people "ate everything but the squeal," Tony said, at least 2–3 inches of fat on the pig was desired to make lard (versus only one inch today). (Courtesy Tony Carosi.)

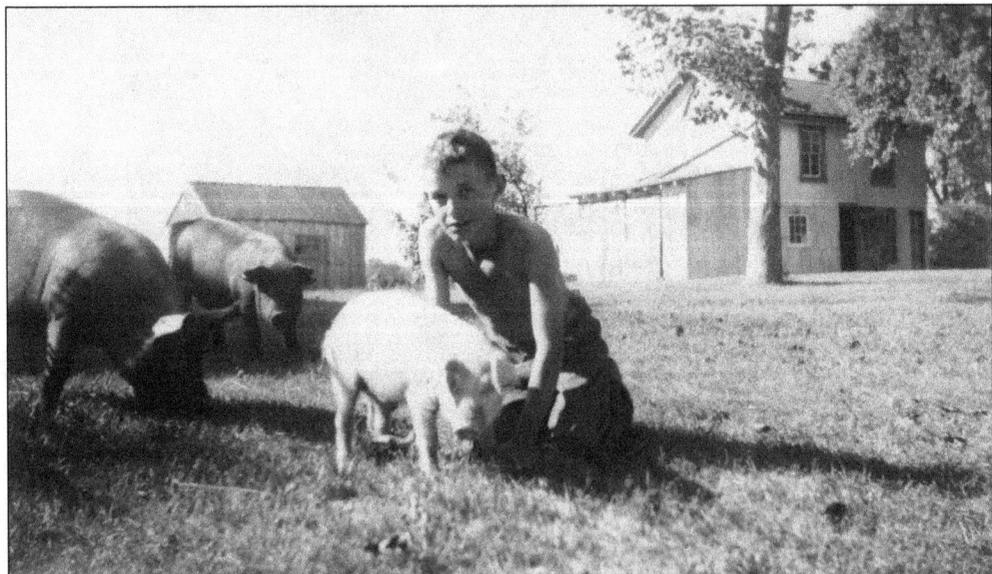

**237 Years**
**Continuous Possession**

1707                                                              1944

Through the Courtesy of Mr. and Mrs. W. Raymond Finney
the 44th Annual Reunion of the Carrell Family Association of the
Descendants of James and Sarah (Dungan) Carrell
Will be held at the

CARRELL HOMESTEAD
Warminster, Bucks County, Pennsylvania
on
SATURDAY, SEPTEMBER 23rd, 1944
10:30 A.M. TO 5:00 P.M.

Officers
*President,* R. T. Engart Campbell
*Vice President,* Leon Webster Melchor
*Recording Secretary,* Mrs. Leon W. Melchor
*Corresponding Secretary,* E. P. Carrell
*Treasurer,* Frank B. Carrell

Executive Committee
Mr. and Mrs. A. B. Geary              Mr. and Mrs. A. LeRoy Fetter
Mr. and Mrs. W. R. Finney             Mr. and Mrs. C. H. Meredith, Jr.
Mr. and Mrs. Benjamin K. Kirk

Carrell descendants held many reunions at the family's old Bristol Road homestead. The invitation at right for the gathering to be held September 23, 1944, invites all descendants of James and Sarah (Dungan) Carrell to the 44th-annual event at the Carrell homestead. At that point in time the home had been in the possession of the family for 237 years (since 1707). The esteemed "Aunt Mary" Bennett Opdyke, the "Grand Old Lady of Bucks," is the elderly woman in white seen below in the front row. She lived to age 99 and presided over many of the reunions at her home before her death in 1937. (Both, courtesy Anna Mae Finney Fretz.)

Wharton Sinkler, an investment broker and member of a prominent Philadelphian family, owned a good deal of property in Warminster and the surrounding region, including this grand old colonnaded building and an adjacent farmhouse (both demolished for Five Ponds Golf Course). Sinkler lived in Elkins Park but used this property for foxhunts with his friends. Three generations of Charles Wesley Gerhart's family lived and worked here from the early to mid-20th century. Seen below enjoying a picnic in the backyard of the tenant house are Charles's wife, Bertha, and their oldest son, Charles. (Left, courtesy CHHS, Inc.; below, courtesy Charles Gerhart.)

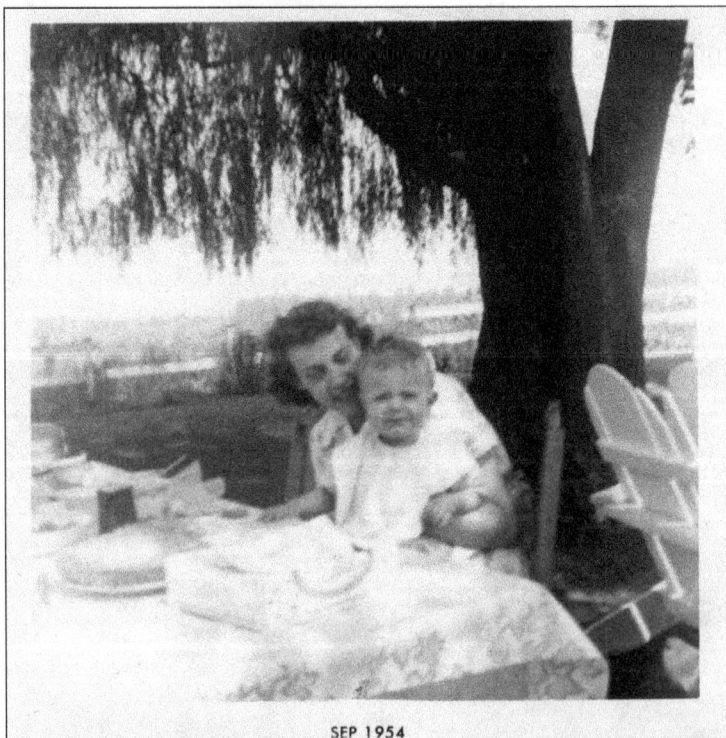

SEP 1954

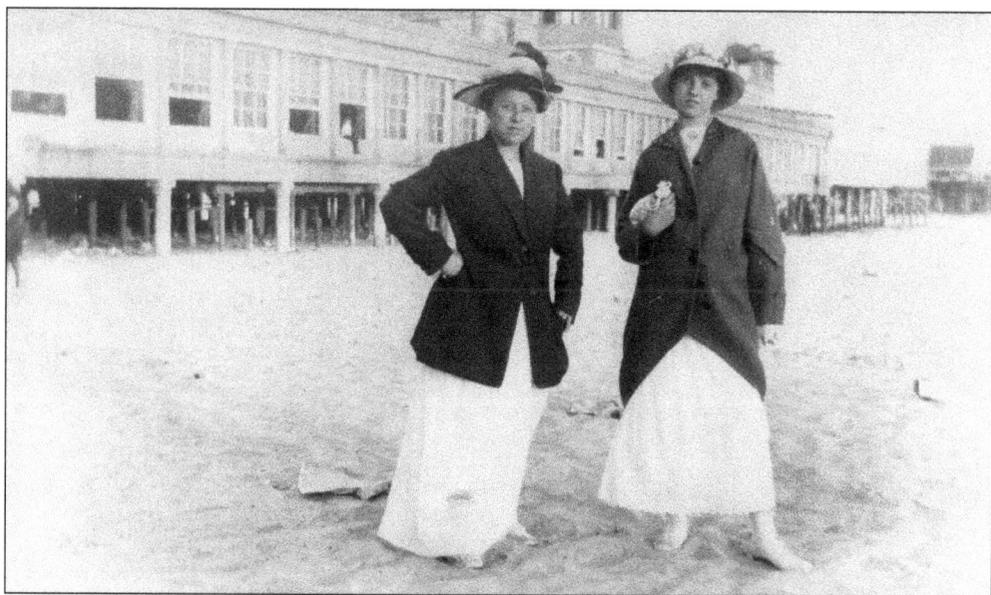

Sisters Sallie (left) and Agnes Conard are seen here enjoying a visit to the shore at Asbury Park. This photograph was taken when they were still single gals. After her marriage to Ben Valentine, Agnes moved to Ivyland, while Sallie remained in Warminster following her wedding to Samuel C. Walker. (Courtesy of Sam Walker.)

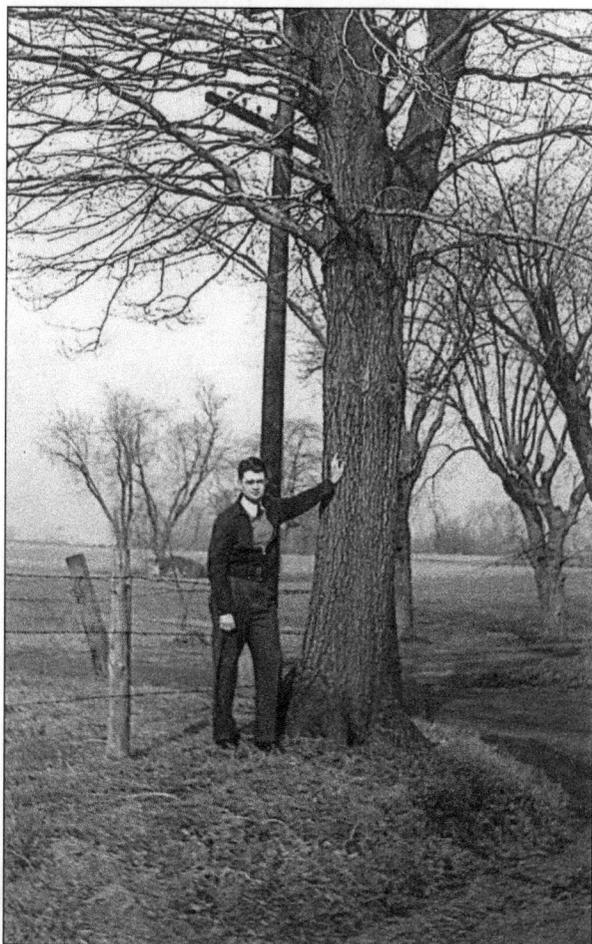

Four generations of Mary Ritchie Locke's family, back to the Mantzes, lived on a 30-acre property located between Street and County Line Roads on the Revolutionary War's Battle of Crooked Billet line of retreat. Son Paul stands at the Jacksonville Road entrance about 1940, shortly before this tree was removed for highway expansion. The farm was lost to eminent domain around 1943 for Lacey Park, a housing development for government aircraft workers during World War II. (Courtesy of Paul Locke.)

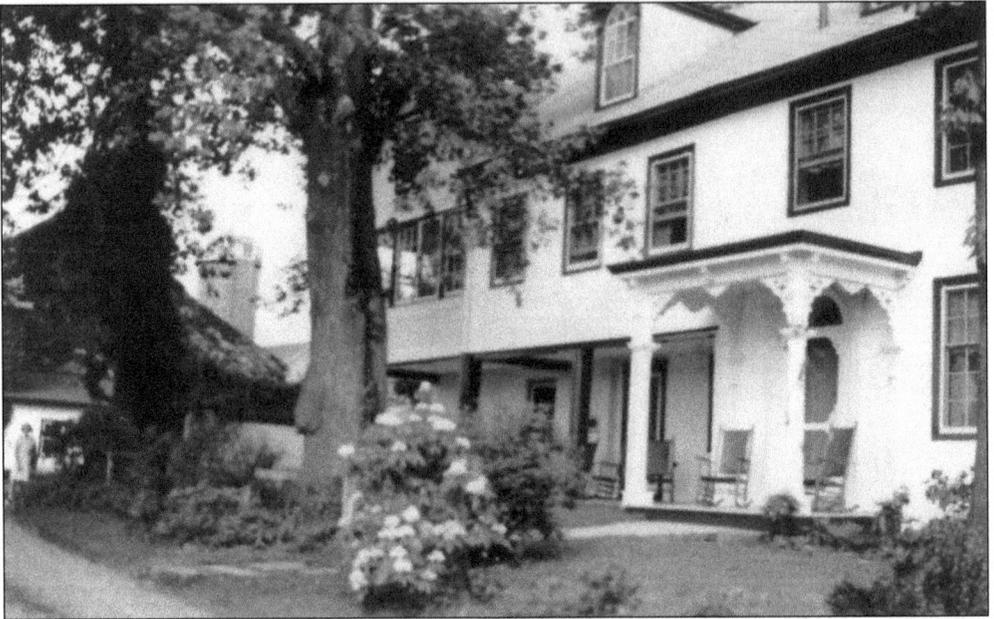

John Hart III built this home five years after fighting in the War of 1812. Later owners Charles and Elizabeth (Conard) Kirk are believed to have opened their domicile to runaway slaves. Numerous owners followed, including the Cliffes (1915–1941). Daughter Evelyn recalled playing in the hidden cellar and floating watermelons in the underground stream there. She also remembered a musket ball found inside a black walnut tree that had been struck by lightning, cut down, cured, and sent to the sawmill to be planed for flooring (a young George Nakashima crafted end tables from two of the tree crotches). Brewster Aircraft subsequently owned the property, followed by the navy. Today fellowship and support are again offered to others here through Gilda's Club. The family pictured below is unidentified. (Both, courtesy Douglas Crompton.)

The Yanagiharas, interned with other Japanese American families at Arizona's Gila River Relocation Center, were released after World War II and followed friends to Warminster. Kay (pictured with son Richard) recalled living from 1945 to 1951 at what is now Craven Hall. She remembers a lilac-and-wisteria-lined drive; picking "tender, sweet, and delicious" wild asparagus; gathering blackberries, elderberries, cherries, and black walnuts for baking; and chopping wood to start the coal furnace for hot water. (Courtesy CHHS, Inc.)

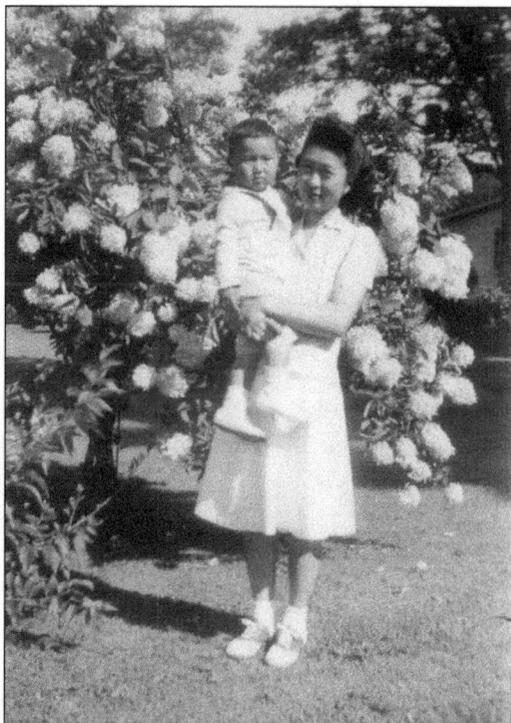

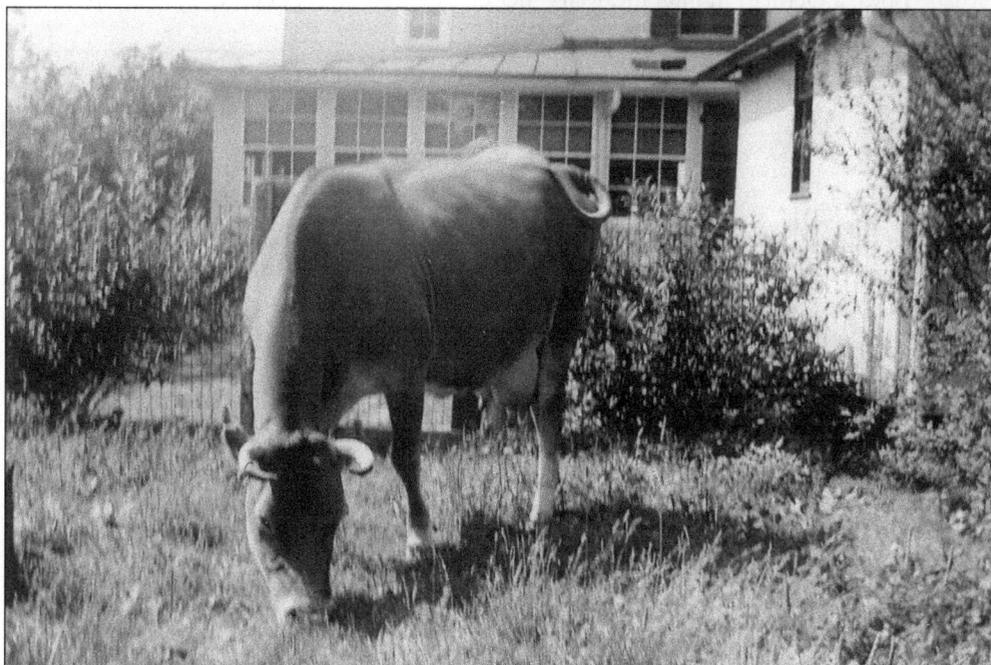

This Guernsey cow that wandered into the family yard was one of 6–10 raised on the Ritchie farm. At the time, consumers sought the richer milk with higher butterfat content Guernsey's produced compared to Holsteins. The glass-enclosed porch in the rear housed a hand pump, washboards, and laundry tubs, all used into the 1930s. The nearby summer kitchen contained a large cast-iron cook stove used into the 1950s. (Courtesy Paul Locke.)

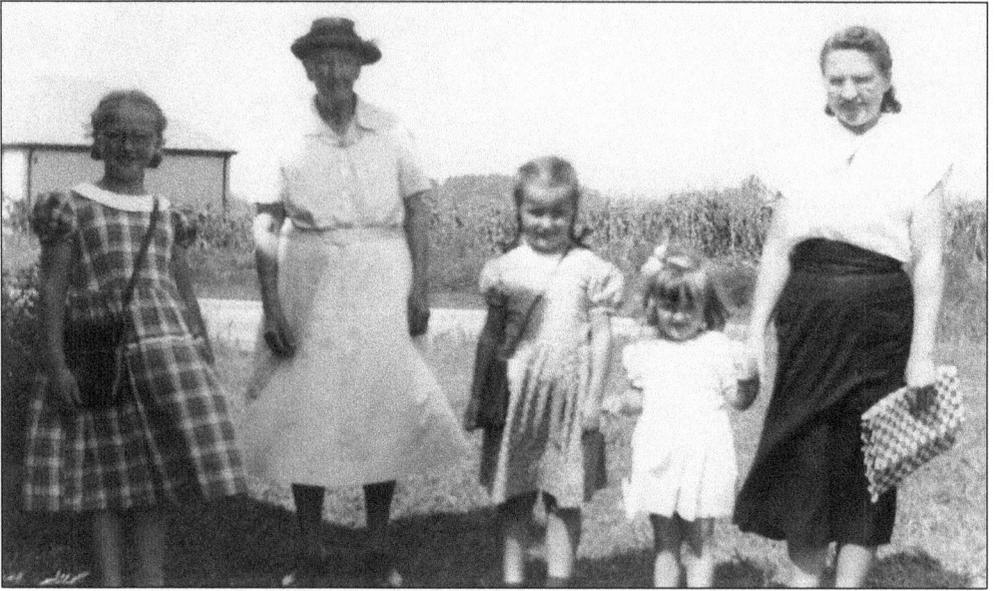

Street Road has figured prominently into Mary Boyd Esbenshade's life. She grew up on Street Road in a house her father built, attended Warminster Elementary School across the street (seen in background), and today operates her own business, Boyd's Barber Shop, just down the road. In this late 1940s photograph are, from left to right, Mary's sister Jeanne; grandmother Johanna Gruebe Boyd, a German immigrant; Mary; her other sister, Alice; and her mother, Margaret. (Courtesy Mary Esbenshade.)

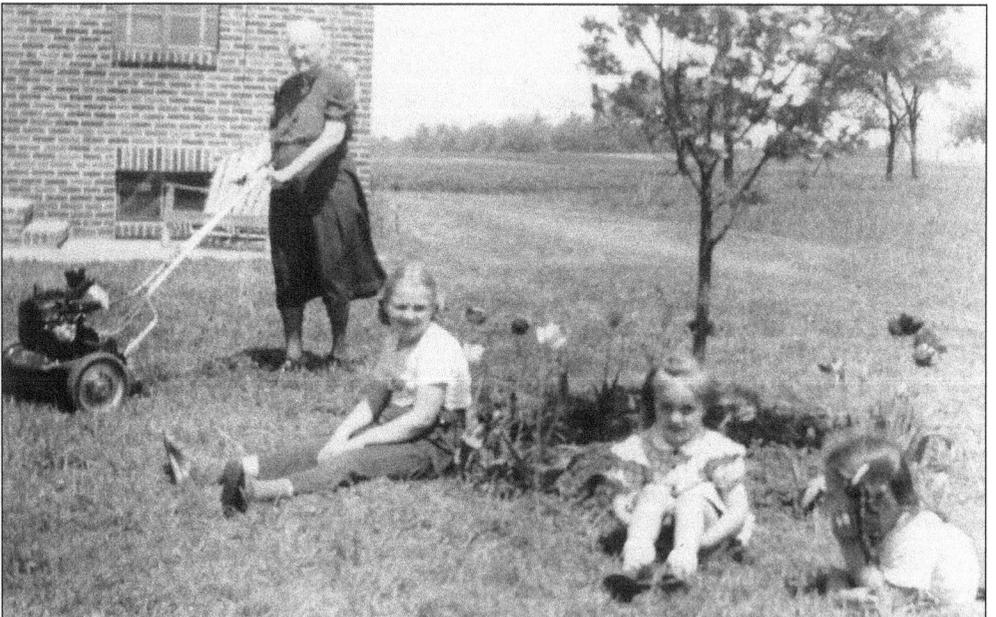

In 1947 little Jeanne Boyd had to walk a considerable distance to class daily. Her parents, frustrated with the lack of school bus service, sold their 20-acre Norristown Road farm and bought property across from Warminster School. David, her father, built the brick home behind his mother, Johanna Gruebe Boyd, seen pushing an early power-driven lawnmower. The cornfields behind the Boyd girls— from left to right, Jeanne, Alice, and Mary—border Street Road. (Courtesy Mary Esbenshade.)

34

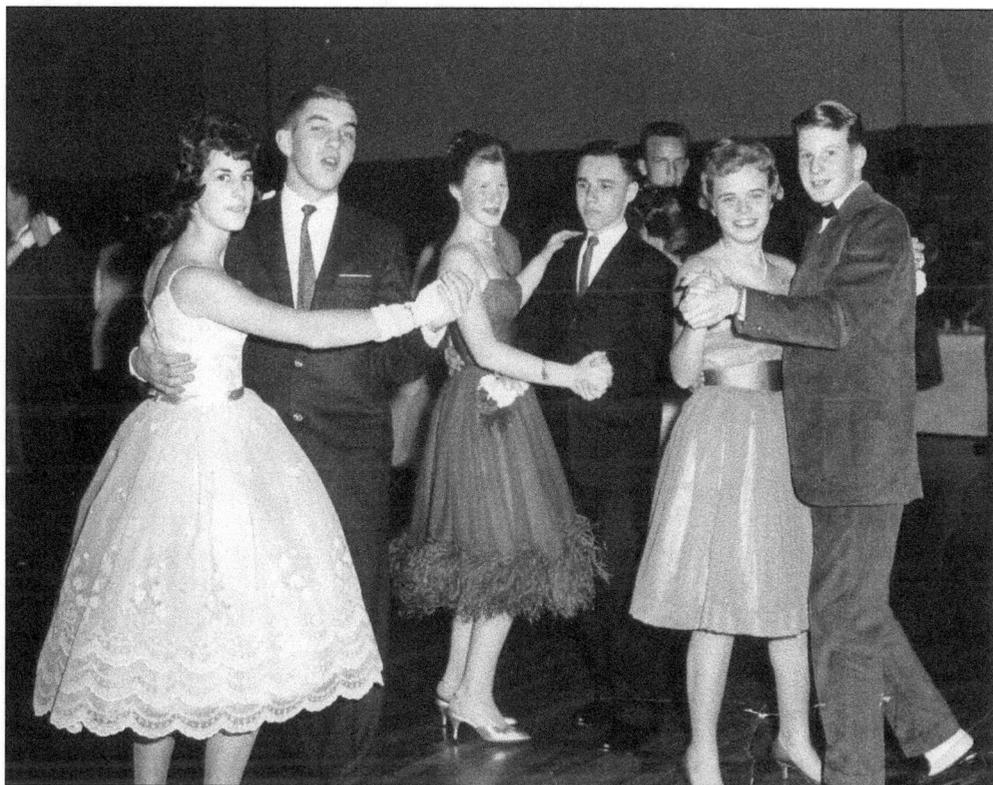

This formal dance held in William Tennent High School's gymnasium around 1960 gave these students an opportunity to hone their social graces. Girls clad in semiformal dresses, spiked heels, and white gloves mingled with boys who wore suits and bought corsages for their dates. In this photograph taken by Willard Crumrine of Richboro are, from left to right, Marlene Heidenwag and her unidentified date, Laure Duval and Bill Stock, and Lynne Miernicki and Peter Duval. (Courtesy Dr. Laure Duval.)

Elizabeth and Georges Duval Jr. purchased the Yerkes homestead (since demolished) at auction in July 1953. During restoration, they eliminated unoriginal walls, replaced floors, and scraped and repainted the early-19th-century fireplace and hand-beaded moldings. Their children, Georges III (on sofa) and Laure and Peter (on floor), are pictured with them around 1954. Old notes on the photograph mention neighbors being "amazed" when the Yerkeses "gave a funeral to a black farm hand" in this living room. (Courtesy Dr. Laure Duval.)

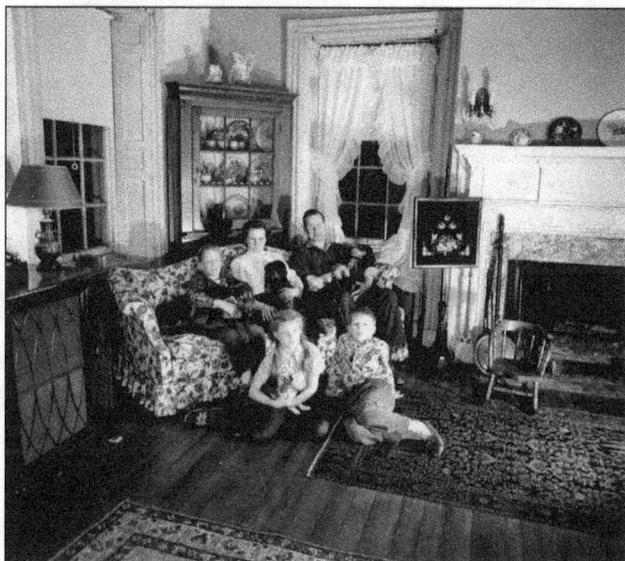

Charles Gerhart owned several horses as a boy, including this one named Wally. Gerhart worked most of his life in Warminster, including many years on Belvidere Farm at Street Road and Delmont Avenue with his father and grandfather who managed the farm. He recalls foxhunts on the property, currently Five Ponds Golf Course, and also an old stagecoach that was sheltered in a wagon house. (Courtesy Charles Gerhart.)

Richard Noble, a land surveyor under the Duke of York, was among Bucks County's earliest pioneers; his son Abel was among Warminster's earliest settlers. Able owned almost 700 township acres by 1702. His son Job, who fed birds by leaving grain in field corners for them, lived on part of the original tract. Job's home eventually became the Fireside Inn. It was later lost to fire and replaced by Altomonte's Italian Market in 1972. (Courtesy Jack and Ann Regenhard.)

# *Two*

# PEOPLE, PLACES, AND EVENTS

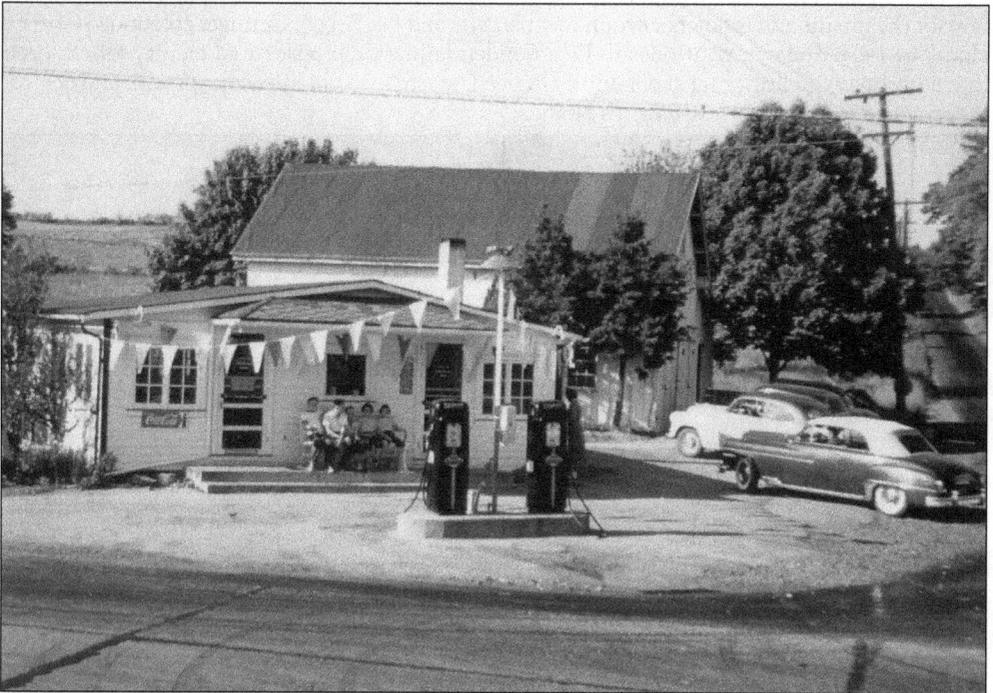

Sisters Margaret, Ruth, and Clara owned and operated Lang's Lunch Room at Street and Davisville Roads (bottom and right respectively), staffing the counter and pumping Mobil gas for customers. Local children enjoyed walking here to buy ice cream and penny candy. After selling the store around 1954–1955, Margaret opened a dress shop in Southampton, since moved for preservation. Pictured from left to right are Don Grabner, Roy and John Viehweger, and Carol and Joan Grabner. (Courtesy Jean Rice.)

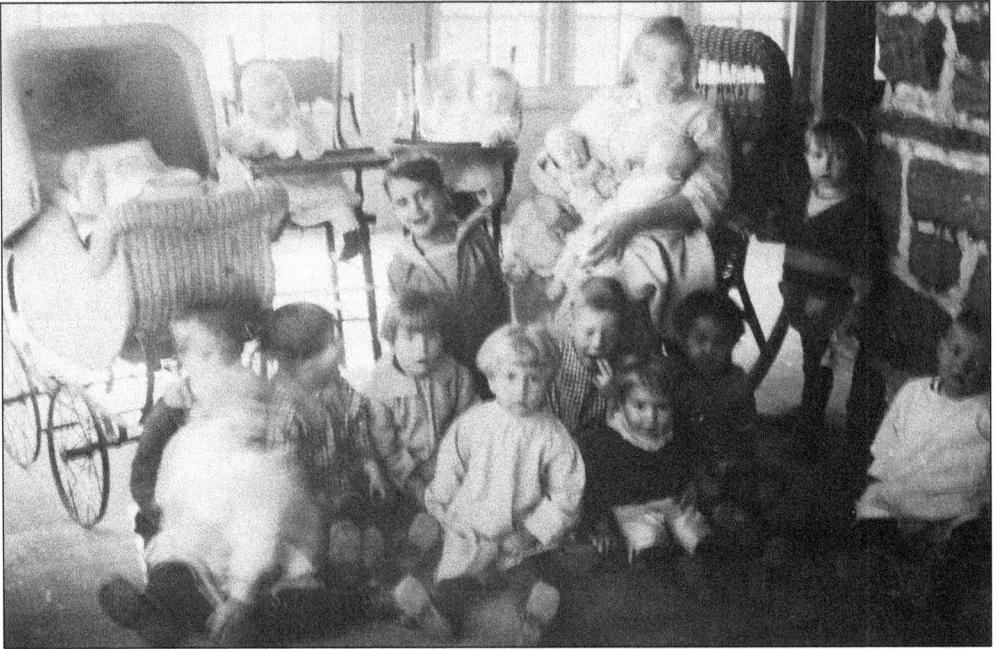

Katharina Juliana Krausslach, known as "Mother" to the children of Christ's Home, had an obvious love for the infants and toddlers surrounding her. She and Dr. Albert Oetinger cofounded Christ's Home in 1903. Today it continues to be a nondenominational residential facility for children (including many sibling groups) of families in need, where love, dignity, compassion, and respect are provided to all. (Courtesy Christ's Home.)

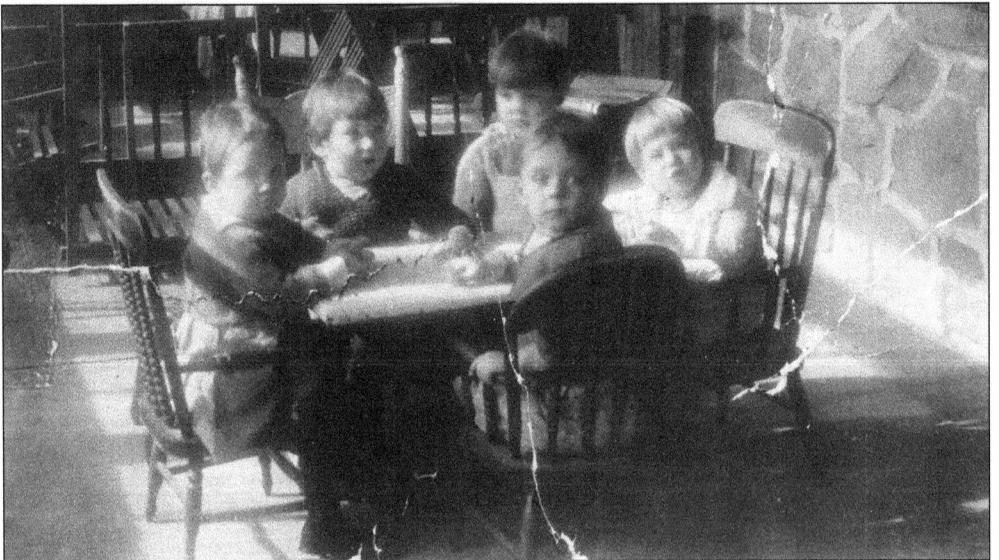

These well-scrubbed toddlers anticipating snack time, around 1920, little reflect the neglect, malnourishment, abuse, and abandonment experienced by many orphans and unfortunates before their arrival at Christ's Home. Since opening, several thousand have graduated from the home's care and guidance to live productively and contribute to society. Support from countless Warminster businesses, residents, public and community organizations, churches, and schools have enabled Christ's Home to operate for over 100 years. (Courtesy Christ's Home.)

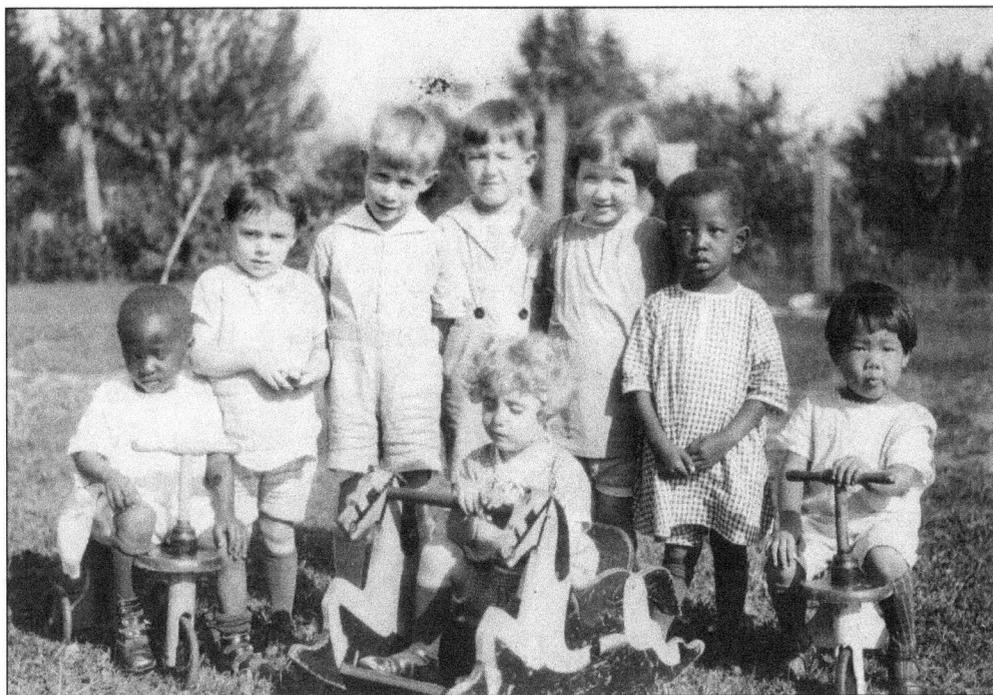

Christ's Home not only offered their young charges the love, care, and protection of dedicated staff and house parents, but plenty of fresh country air and childhood fun. As with many Warminster youngsters, baseball was particularly popular, especially among older boys who played competitively in the community. All the children enjoyed biking, skating, swimming, snow play, and sleigh rides. Raising pets, music, and art were also favorite pastimes, as was going to summer camp when sponsored by a generous benefactor. Today children living at the York Road facility participate in church youth group activities, organized sports, scout programs, and community swimming activities. (Both, courtesy Christ's Home.)

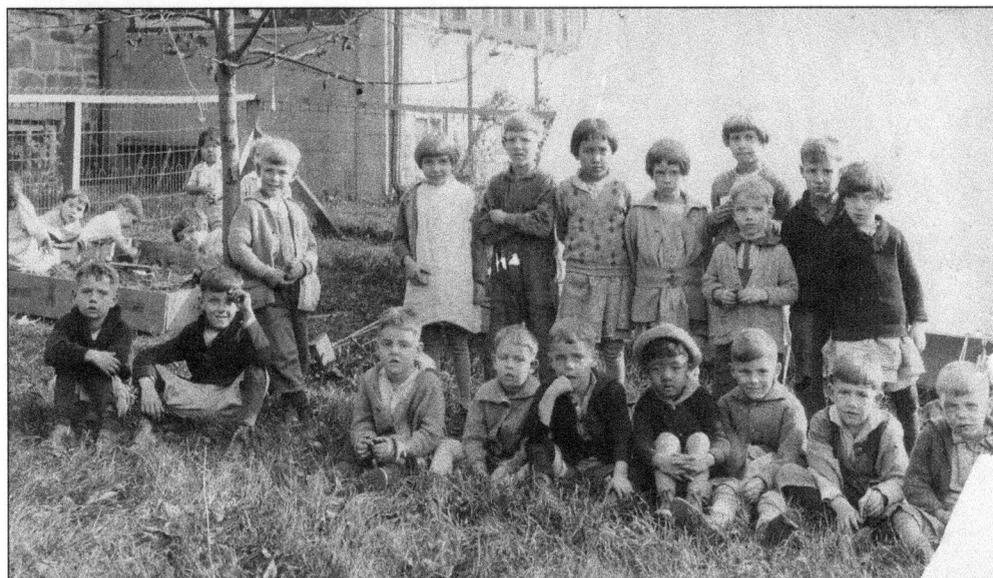

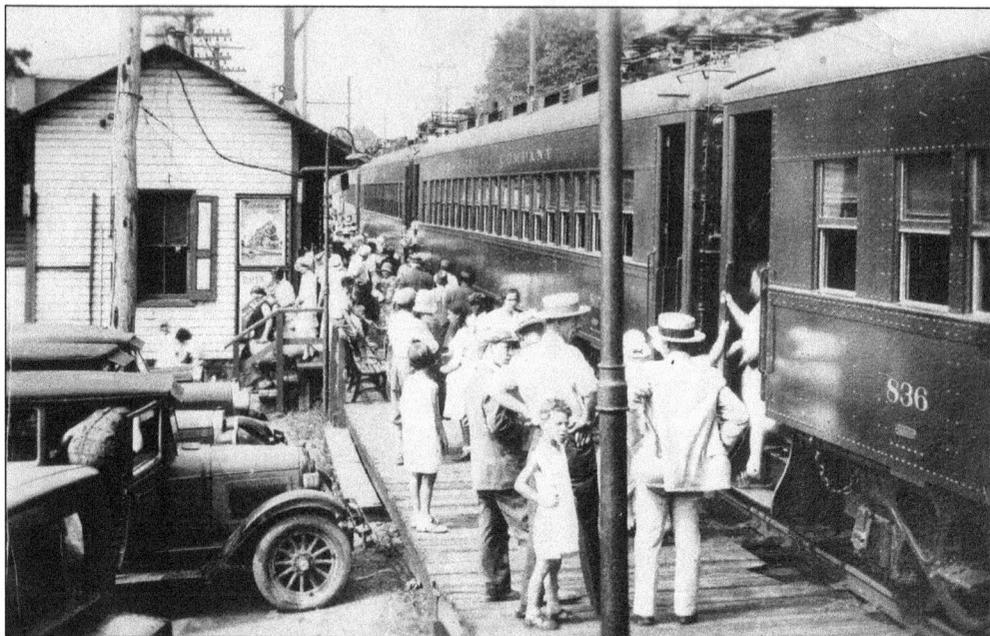

In 1874, the steam train arrived in Ivyland (station shown above, early 1930s) and was used by many Warminster residents. One hundred years later, a gas crisis increased ridership for the Reading Railroad by 15 percent, spurring an expansion of services. On July 29, 1974, an "attractive, highly useful station complex" at Warminster (below) and 1.8 miles of electrified track from Hatboro opened to much acclaim. Warminster commuters to Philadelphia now had an "easy, economical, convenient alternative to driving" and could avoid the traffic and parking headaches then associated with using the Hatboro train station. The boy in the photograph above is Robert Van Pelt; his father, Seth C. Van Pelt, stands to his right, and ticket agent K. Patterson stands behind him. (Above, courtesy Millbrook Historical Society; below, courtesy Jack and Ann Regenhard.)

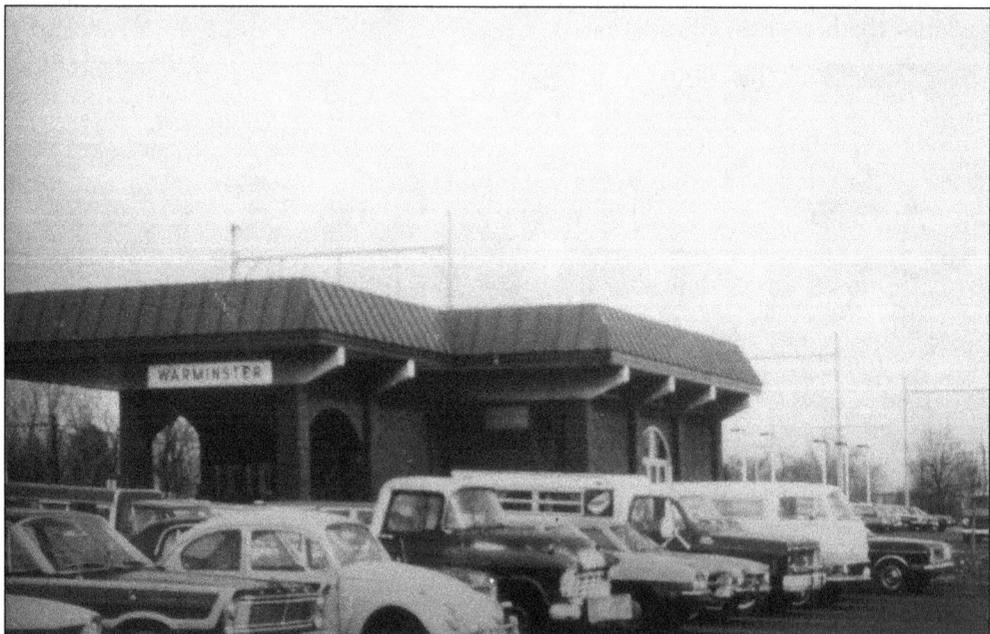

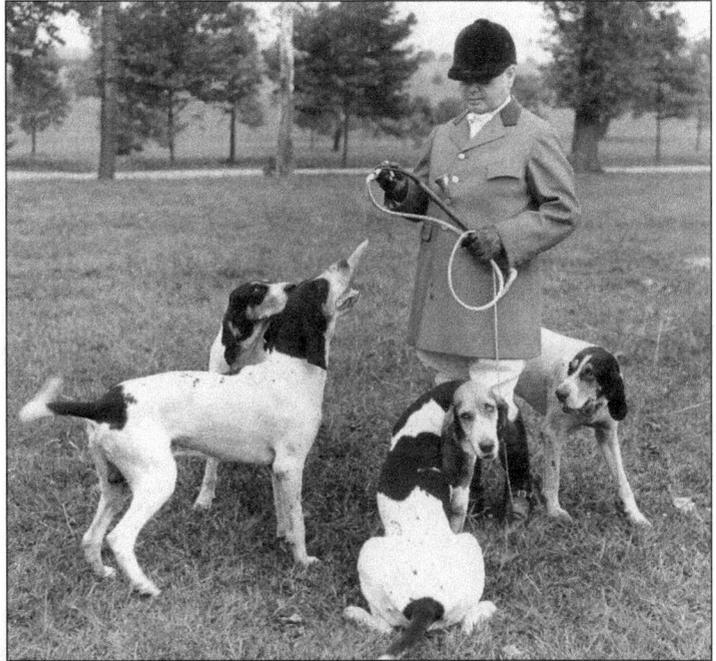

Master of foxhounds Clifford Brumfield was responsible for kennels and stables on Jacksonville Road where hounds and horses used in local hunts were maintained. Wharton Sinkler, a member of the Huntingdon Valley Hunt Club, allowed private hunts on his property during the fall. Participants spent three to four hours, sometimes longer, traversing long distances through open countryside with 40–50 hounds in their effort to capture a fox. (Courtesy Charles Gerhart.)

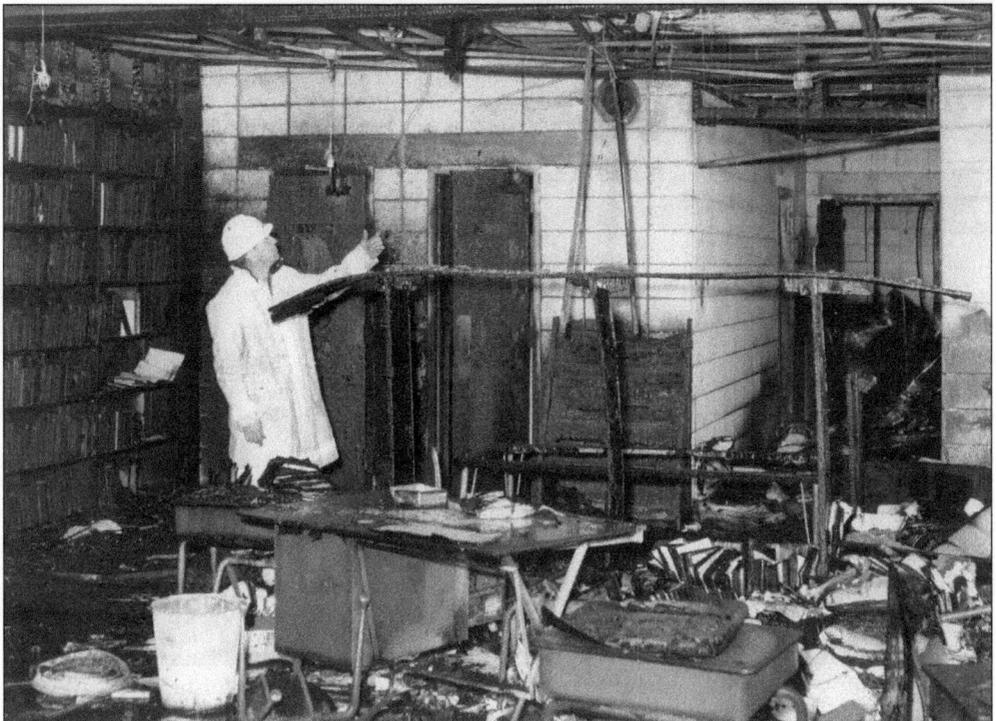

The inferno started in the library of the Alta S. Leary School before midnight on Wednesday, December 18, 1966. It quickly raged down three hallways. Seven Bux-Mont fire companies battled the blaze and were credited with limiting damages to the library and one classroom. Still, property losses were estimated at over $500,000. Warminster's then incumbent fire chief, Walter Curley, is seen conducting a post-fire inspection. (Courtesy Jim Krueger.)

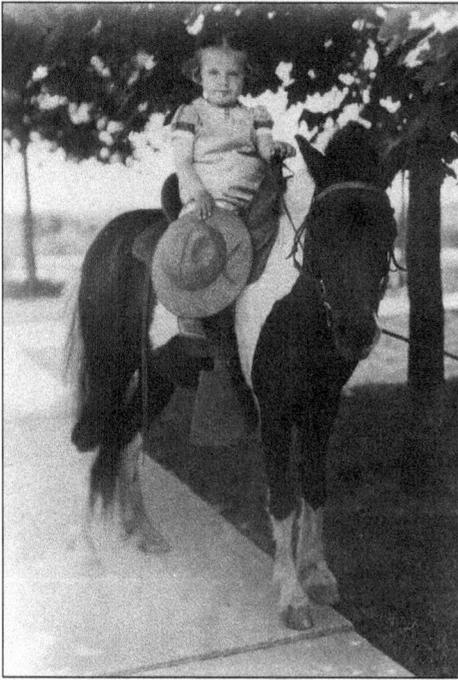

Young Virginia Dare briefly lived in "Babytown" (a Bristol Road section once claiming 32 babies between six neighboring homes) before moving to Hartsville, where a traveling family offered neighborhood children pony rides in the mid-1930s. Dare loved animals and was later given her own horse to raise. She became one of 94 teachers hired in the mid-1950s for William Tennent High School, briefly taught at overcrowded Craven Hall, and ultimately became a respected counselor. (Courtesy Virginia Dare.)

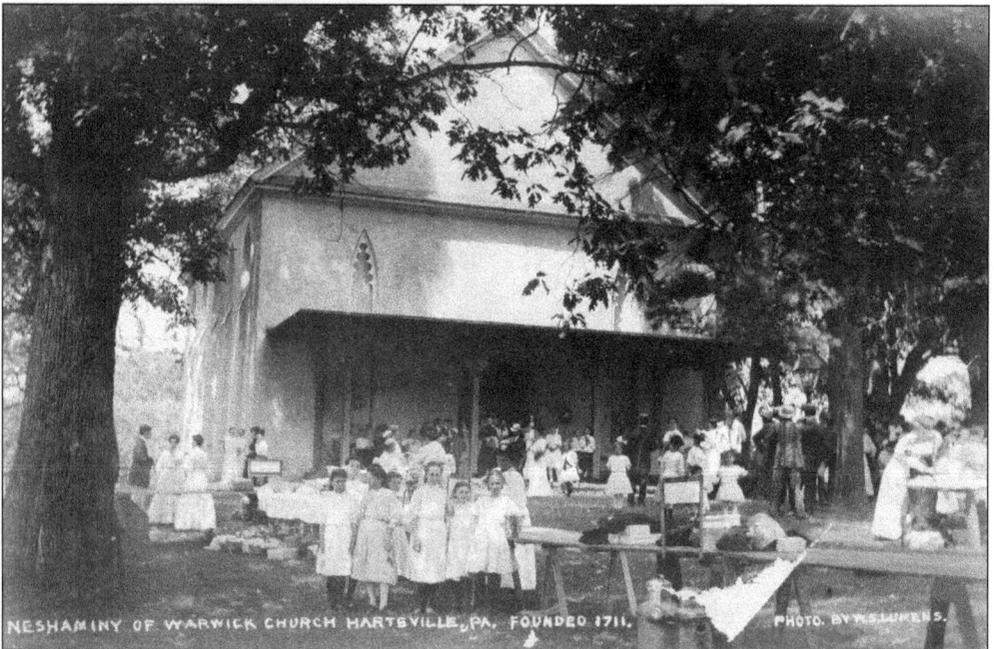

NESHAMINY OF WARWICK CHURCH HARTSVILLE, PA. FOUNDED 1711.        PHOTO. BY W.S.LUKENS.

The Neshaminy-Warwick Church began in late 1726 under the distinguished Rev. William Tennent. In 1739 and 1740, during the Great Awakening, Tennent drew 3,000, then 5,000 people respectively to his remote "Meeting-House Yard" to hear the illustrious English preacher George Whitefield. The evangelical movement led to a schism, with Tennent's successor, Rev. Charles Beatty, representing the New Side. After reuniting, another rift occurred around 1842, and a second church was erected nearby. Following yet another reunification, it was removed in 1939. (Courtesy Jack and Ann Regenhard.)

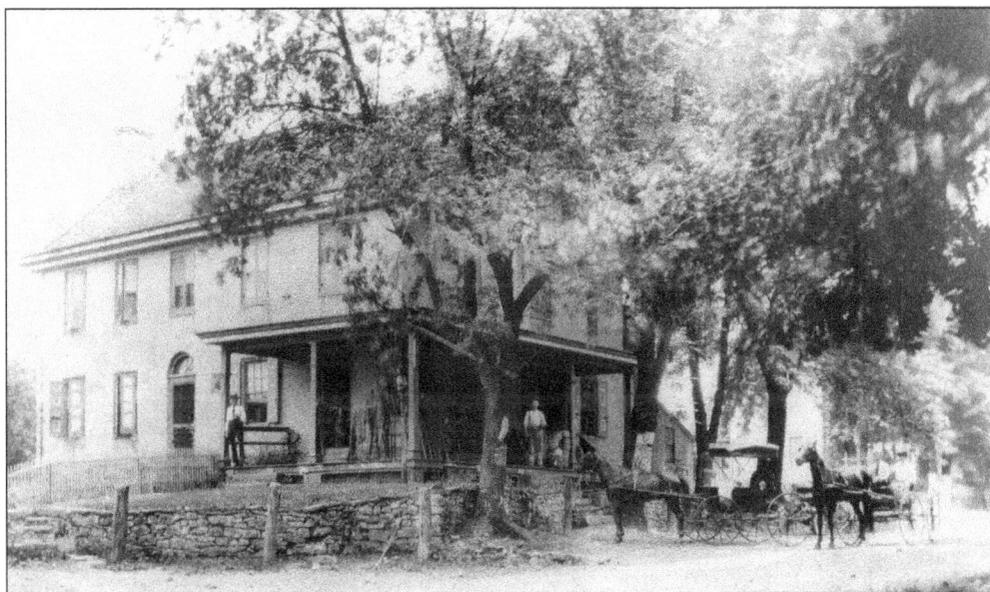

Virginia Dare grew up across from Eddie Carr's store on Bristol Road in Hartsville. She fondly remembers bringing her own bowl there to fill it with 5¢ balls of ice cream for her family. She also recalled her childhood dismay when candy counters emptied during World War II because the government had appropriated the factories. All manner of goods, including grain, animal feed, and in later years, gas, could be purchased here. (Courtesy Rick Parker, Inc.)

Rev. Charles Beatty, who joined Benjamin Franklin's military campaigns and was on friendly terms with him, built this Hartsville home's original portion. He later added the second floor, allegedly because his wife was "afraid of Indians." William Hamilton Dare purchased the home in 1903 (seen around the 1940s). He operated a produce business from its south side and also Dare's Express, a moving and hauling business utilizing his mules, horses, and later trucks. (Courtesy Virginia Dare.)

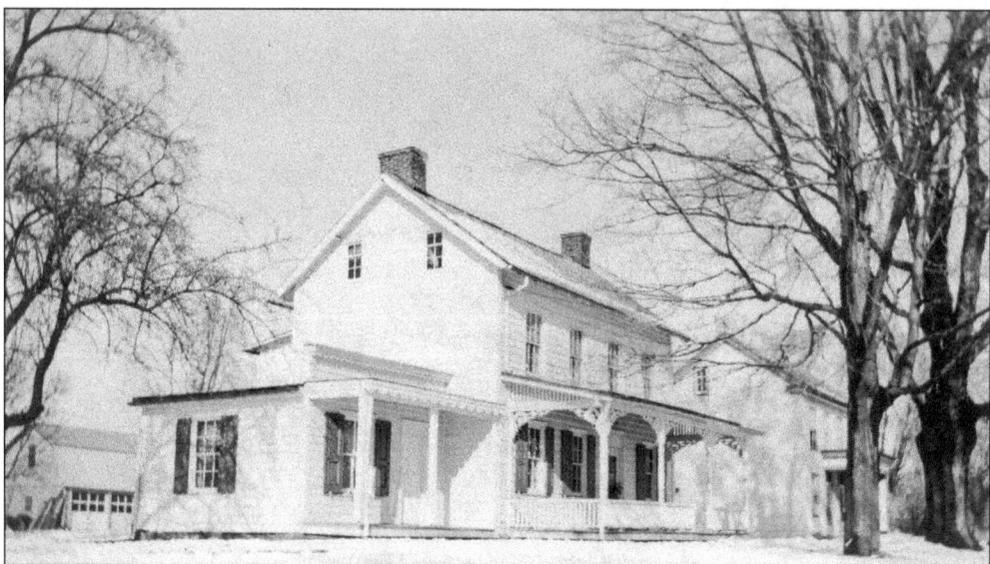

The c. 1890 addition to the c. 1846 Blackway home in Johnsville was a millinery shop operated by Mary Sutch and Sarah (Sade) Sutch Young into the early 1900s. The late educator Alta Sinkler Leary, for whom a school was named, spoke of childhood carriage rides from Southampton to her aunts' shop every spring and fall to buy a new hat and freshen old ones with new ribbon. Original glass display cabinets remain today. (Courtesy Beverly Blackway.)

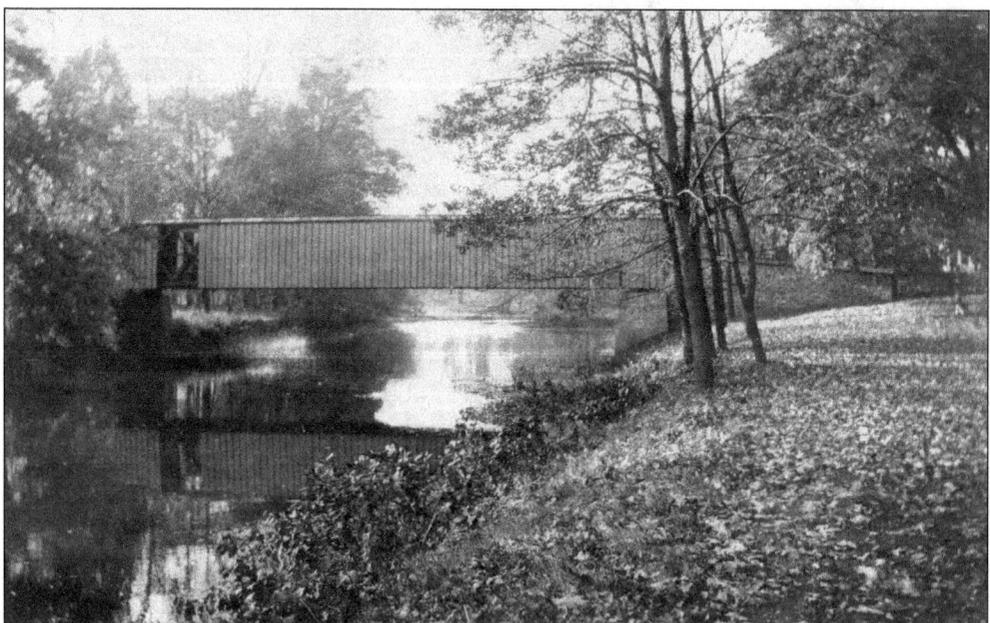

Hartsville store owner Eddie Carr amused friend and neighbor Virginia Dare with stories about the local covered bridge(s) being the lover's lane of the horse-and-buggy days. Darrah Bridge was below the Moland House. The other, believed to be this one on Bristol Road, crossed the creek near Neshaminy-Warwick Church. (Courtesy CHHS, Inc.)

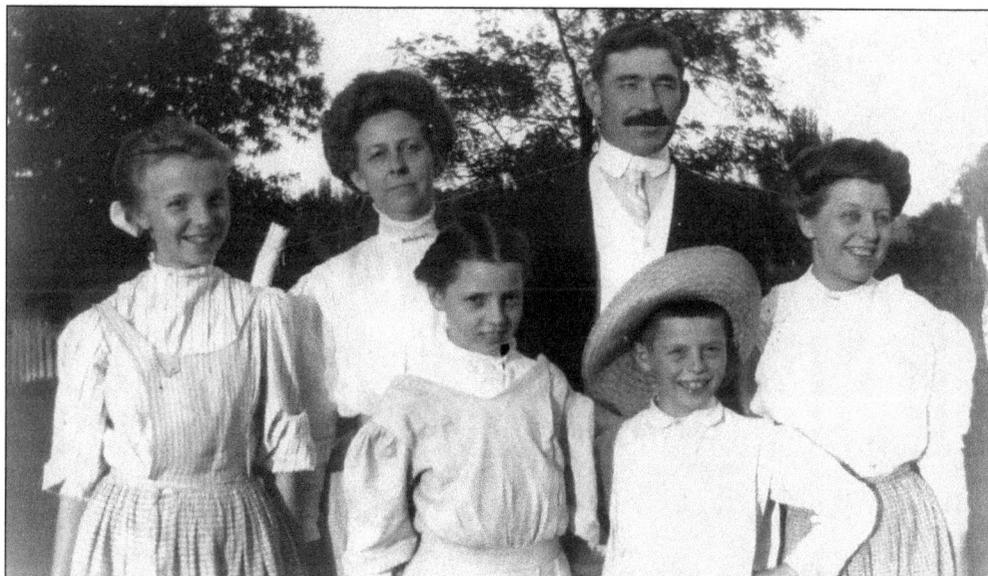

Jennie (née Kline) and Israel Conard are pictured in the early 1900s with children, from left to right, Laura, Agnes, Fred, and Sallie (future mother of Sam and Clarence Walker). Israel was road master in charge of Warminster's road crews. His family can be traced back to Thones and Elin Kunders. The Kunders were among the founders of Germantown who, upon arrival from Germany in 1682, settled in caves along the banks of the Schuylkill River. (Courtesy Samuel Walker.)

28 BUCKS COUNTY (PA.) VIEWS.     WARMINSTER FRIENDS MEETING HOUSE
Chas. R. Arnold. Pub., Ivyland, Pa               Erected 1842.

Warminster Friends attended meetings in Horsham before erecting their own meetinghouse on Street Road. This preparative meeting was established 1841. Members worshiped and met to prepare business for Horsham's monthly meeting and buried their families in the rear graveyard. The first elders were Seth and James Davis, Thomas Parry, and Elizabeth Townsend. The preparative meeting was discontinued in 1953 and worship at this location ceased in about 1962. It is now an Assembly of God church. (Courtesy Jack and Ann Regenhard.)

45

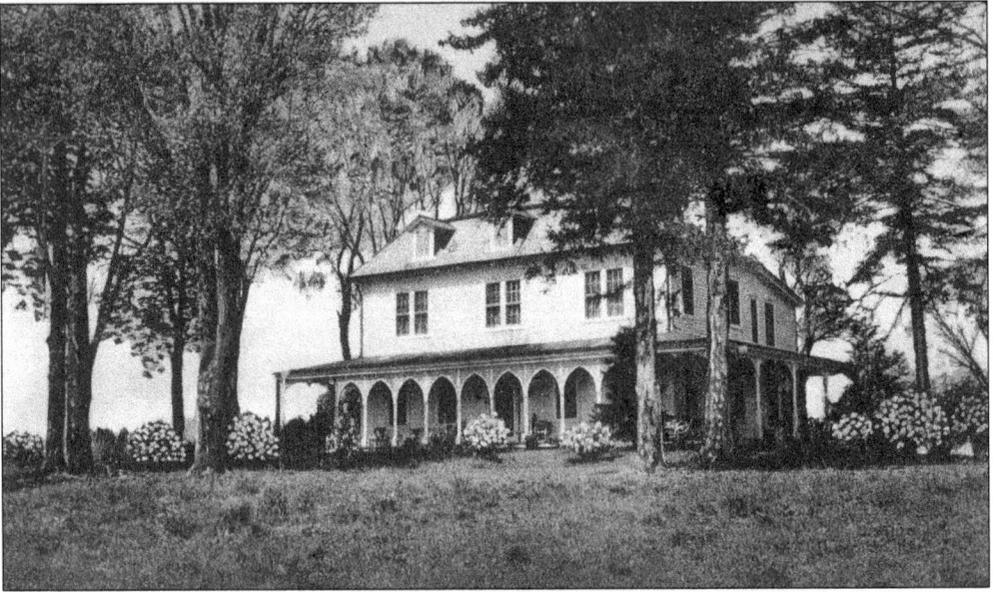

Rev. Jacob Belville and Harriet McElroy of Lambertville, New Jersey, founded Roseland Female Seminary on James Wilson's beautiful Hartsville property in 1850. Reverend Belville soon became sole proprietor. Tuition and room and board in 1855 were $75 for 21 weeks. During the Civil War, every student joined the Ladies Soldiers' Aid Society to support the troops. Before closing in 1863, the institute hosted a major fund-raising event for the war effort. (Courtesy Jack and Ann Regenhard.)

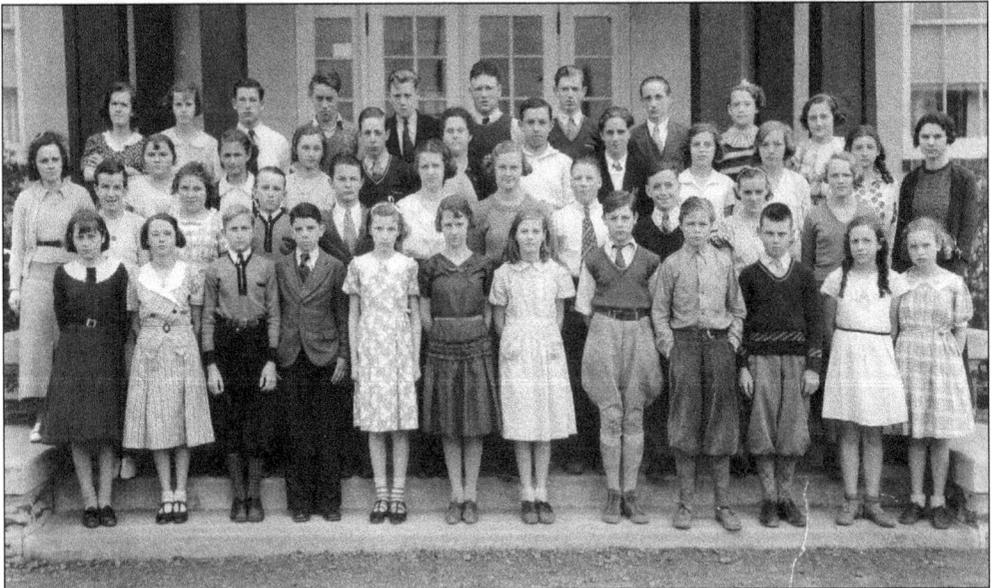

Recently deceased Alta S. Leary began teaching at Warminster Elementary School when it opened in 1927. She stands far right with the school's seventh and eighth graders in 1935. Leary, both teacher and principal in township schools for many years, also served as elementary supervisor. In recognition of her leadership in local, county, and state education, a new 18-classroom elementary school named in her honor opened in 1959 at Victoria and Henry Avenues. (Courtesy Centennial School District.)

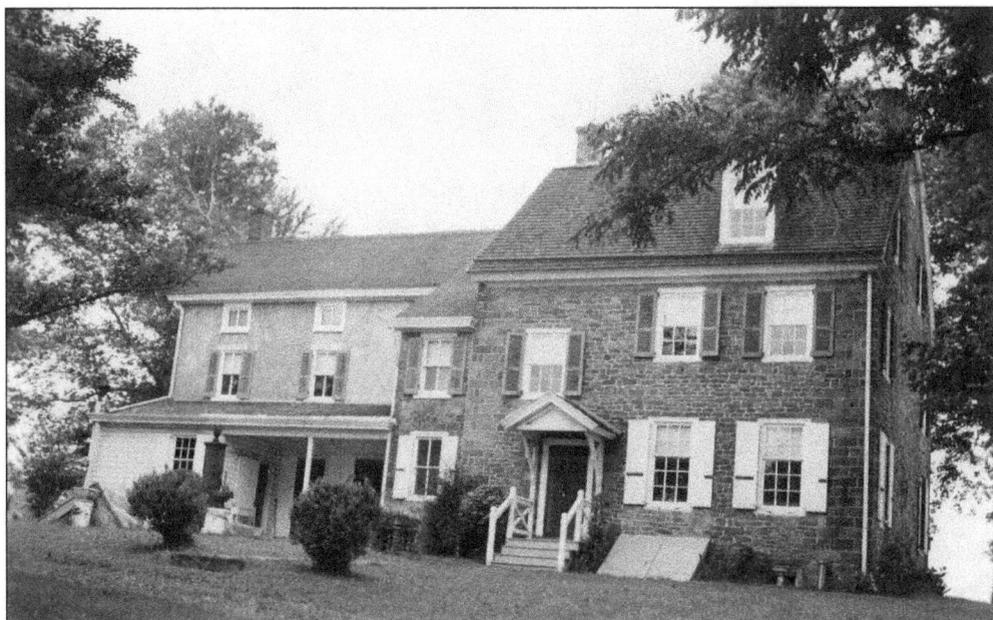

This 1762 Colonial mansion with an 1810 fieldstone addition (right) and massive barn on Street and Jacksonville Roads once belonged to the Yerkes. During the Battle of Crooked Billet, Mrs. Yerkes allegedly saved a soldier from the British at this site. When purchased by the Duvals in 1953, the original woodwork and fireplaces, carved doorways, fanlights, wrought-iron latches, paneled shutters, and the old dinner bell, spring cellar, and pump seen left at the home's rear were all still there. (Courtesy Dr. Laure Duval.)

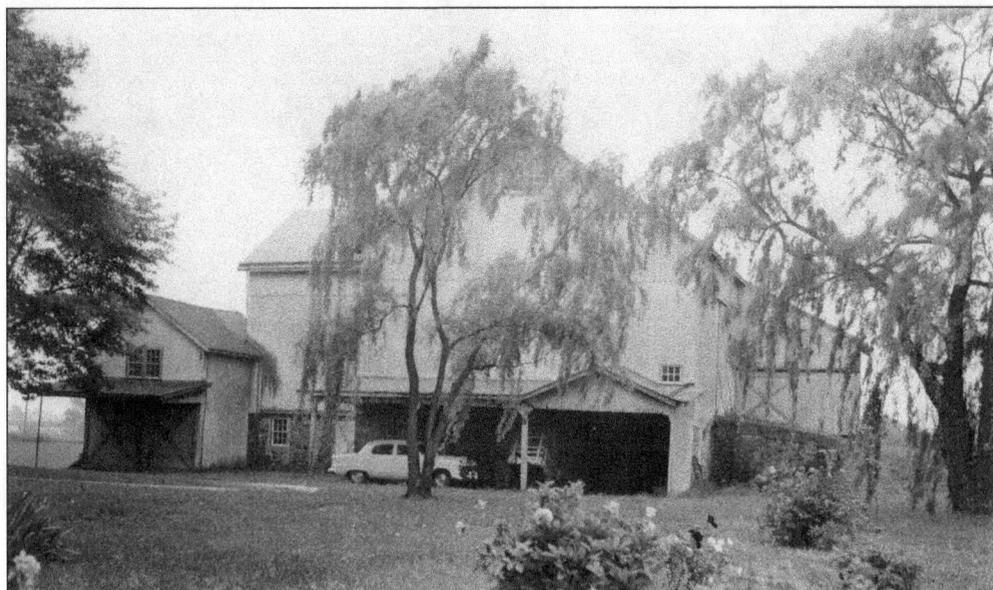

This beautiful barn facing Street Road and photographed in July 1953 belonged to the Duvals. Along with the carriage house, it fell victim to Hurricane Hazel on October 15, 1954, but was later rebuilt. The Duval family raised goats, sheep, chickens, ducks, and lambs and generously allowed Lacey Park children to add their Easter chicks and rabbits to the menagerie. A pony won by a local boy was even given a home here. (Courtesy Dr. Laure Duval.)

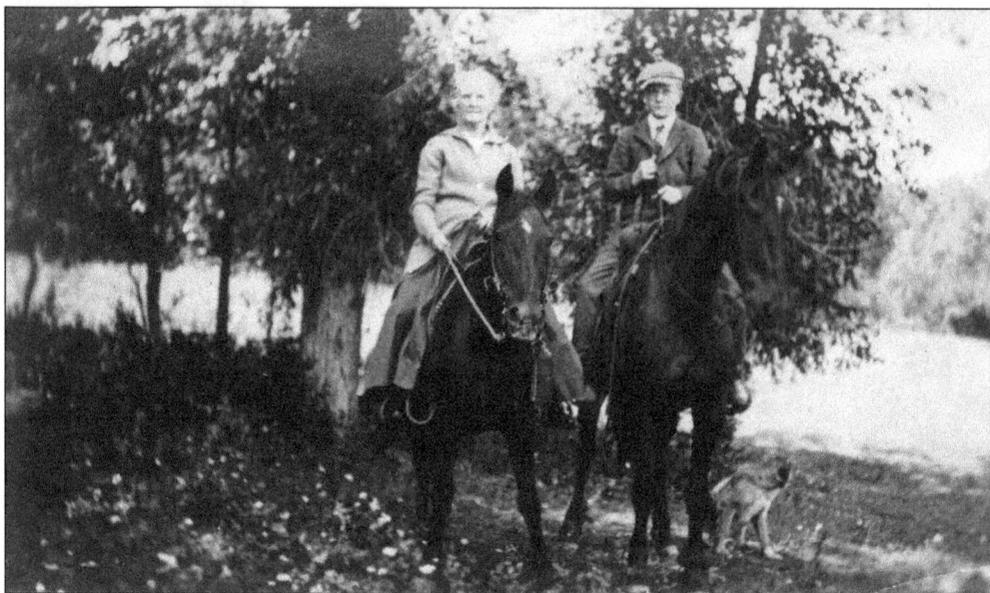

Mary Bennett Opdyke descended from Carrells who settled in Bucks County in 1707. She celebrated her 80th birthday in Montana horseback riding with her nephew and lived almost 100 years in a home built by her mothers kin, Lot Bennett, in 1810. She was active until the very end. She read several newspapers daily, maintained a model flower garden, fashioned hand-sewn quilts, managed her own business affairs, and enjoyed automobile and train travel. (Courtesy Anna Mae Finney Fretz.)

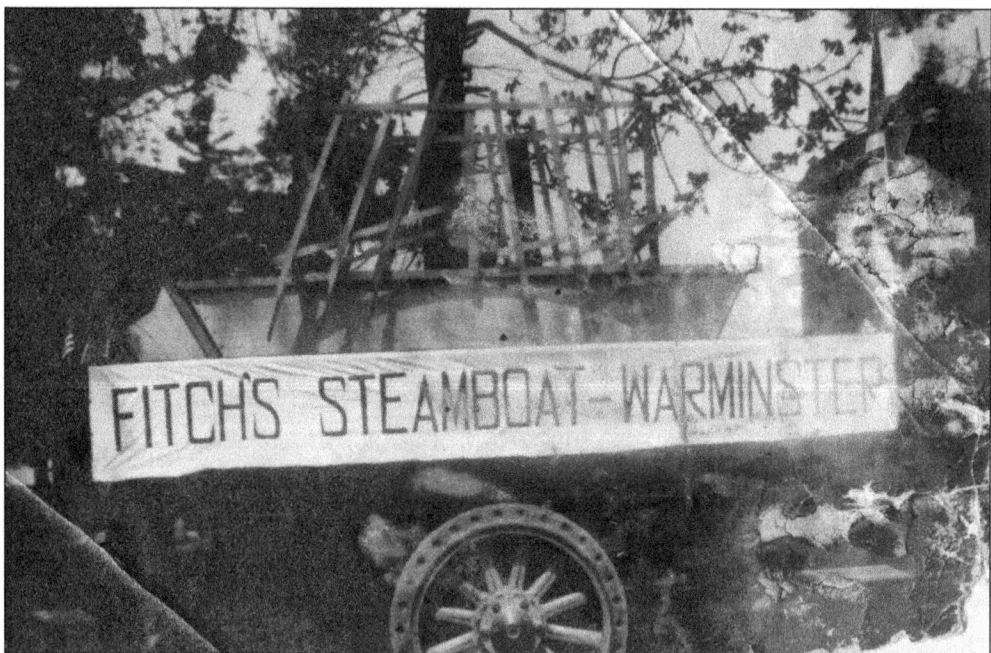

Samuel C. Walker, father of Sam and Clarence Walker, enjoyed using his woodworking skills to create this model of a c. 1785 steamboat design by John Fitch. Walker's model was mounted on farmer Frank Oehrle's truck and entered into a Hatboro parade during the late 1920s or early 1930s. (Courtesy Samuel Walker.)

Navy photographer Edwin Calhoun met and photographed numerous heads-of-state and VIPs. He is seen in 1954 with movie personality William Boyd, who played Hopalong Cassidy. After working for Warminster's Parks and Recreation Department in the 1960s, Calhoun served 33 years as director of audio-visuals for the Centennial School District, including 10 as an instructor in television production. He has been photographing and filming important community events and managing local television programming for Warminster Township since 1993. (Courtesy Edwin Calhoun.)

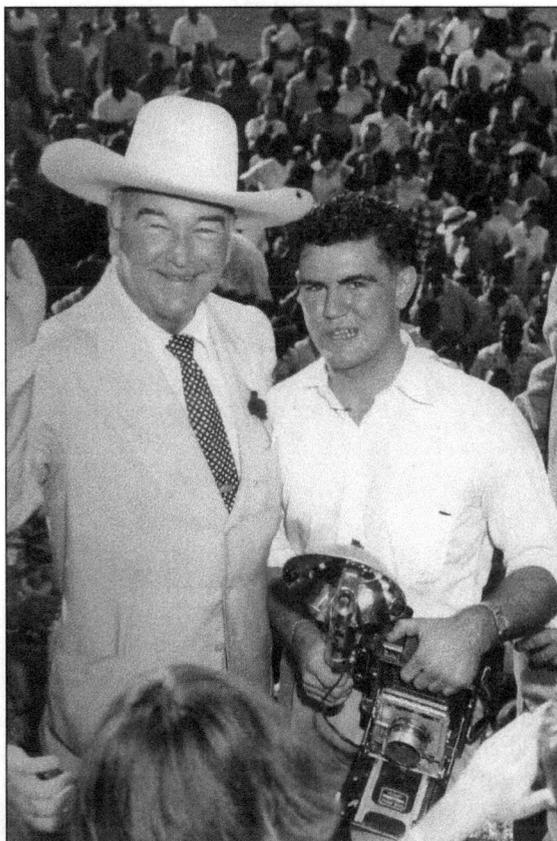

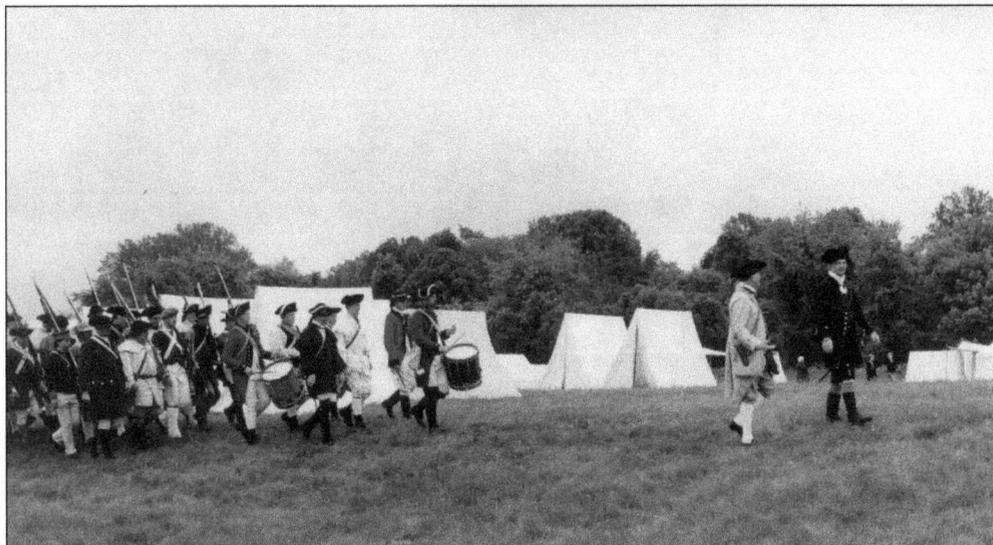

Besides tours, slide shows, and colonial cooking demonstrations at Craven Hall by members in period garb, Warminster residents have been treated to several realistic reenactments of the Battle of Crooked Billet. In both 2003 and 2005, at least 400 reenactors participated in commemorative programs held at Warminster Community Park on hallowed ground, the line of retreat for General Lacey and his men fleeing British attack on May 1, 1778. (Courtesy CHHS, Inc.)

In 1780, the year Pennsylvania's Act of Gradual Emancipation passed, 580 men, women, and children were listed on Bucks County's first public slave registry. In 1845, Samuel Hart recollected looking out from his father's Old York Road property around 1795 and counting 16 farms "on every one of which were more or less slaves." This image shows the names of Joseph Hart's slaves listed in his will dated February 25, 1788. (Courtesy CHHS, Inc.)

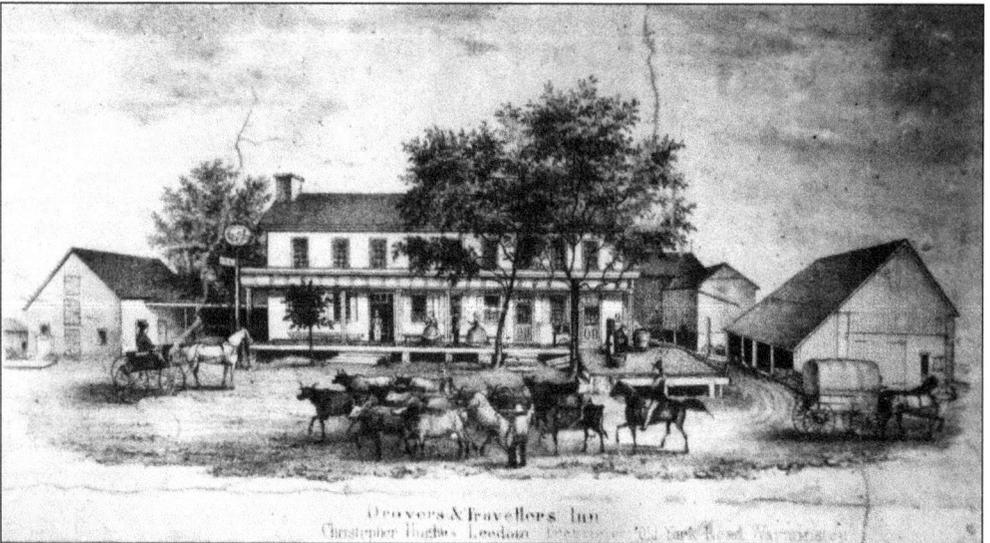

Thomas Beans held horse races on his farm in the late 1700s. They were stopped by court order for being a demoralizing influence on the men and boys who attended. Beans subsequently laid a half-mile track on Street Road, sponsoring several races annually. The track was conveniently located near his Old York Road tavern, depicted here and kept as early as 1800, making him proprietor of perhaps America's first sports bar (now Mike's Bar and Grill). (Courtesy CHHS, Inc.)

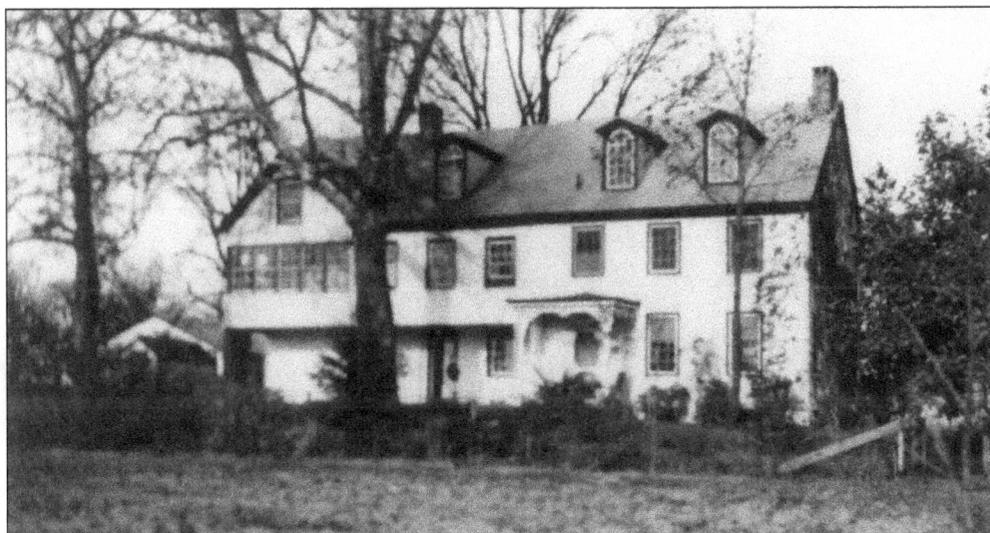

This notable Kirk Road home lies on property owned by generations of Harts instrumental in Bucks County growth and development. John Hart was among Warminster's earliest landowners. Son Col. Joseph Hart Sr. was Bucks County sheriff and a Revolutionary War officer; grandson Joseph Jr. was the state senator and power behind the relocation of the county seat from Newtown to Doylestown. Joseph Jr.'s son John III built this home in 1817. Charles Kirk purchased it in 1840 and is credited with sheltering and helping hundreds of fugitive slaves travel the Underground Railroad in the 1850s. The home, a "safe house," was entered through the small outbuilding seen at left. Stairs leading to a cavern-like cellar (below) connected to several underground tunnels (note walled doorway). It was navy commander headquarters in the mid- to late 20th century. Gilda's Club, a compassionate support organization for those impacted by cancer, now operates here. (Above, courtesy Douglas Crompton; below, courtesy Gilda's Club.)

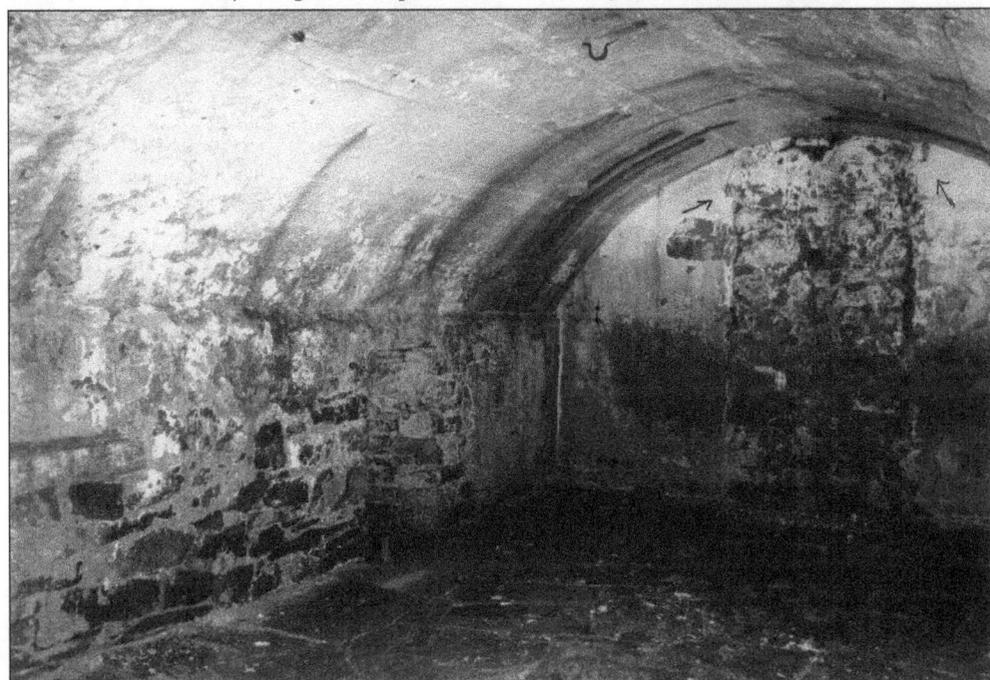

Elizabeth Duval (center) originally taught music education at Centennial School but quickly obtained the credentials necessary to teach the general curriculum. She is seen here around 1960 with her fourth-grade class. After additional training, she later became one of the first teachers in special education. She raised three children with her husband, Georges Duval Jr., and eventually obtained a pilot license to fly a private plane they owned. (Courtesy Dr. Laure Duval.)

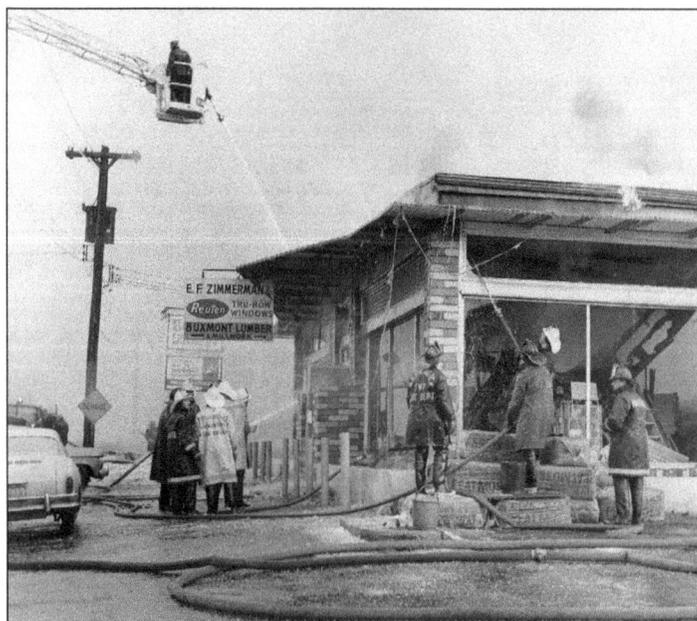

Through roaring winds on February 25, 1967, this Street Road building fire was valiantly fought by 150 firefighters. The blaze, fueled by cardboard boxes of insulation in the Bux-Mont Lumber and Millwork Company, destroyed the contents of the business and that of a storm window and screen company, E. F. Zimmerman's. Firefighters, however, were able to save a major part of the adjacent Sam Evans Transmission Service business. (Courtesy Jim Krueger.)

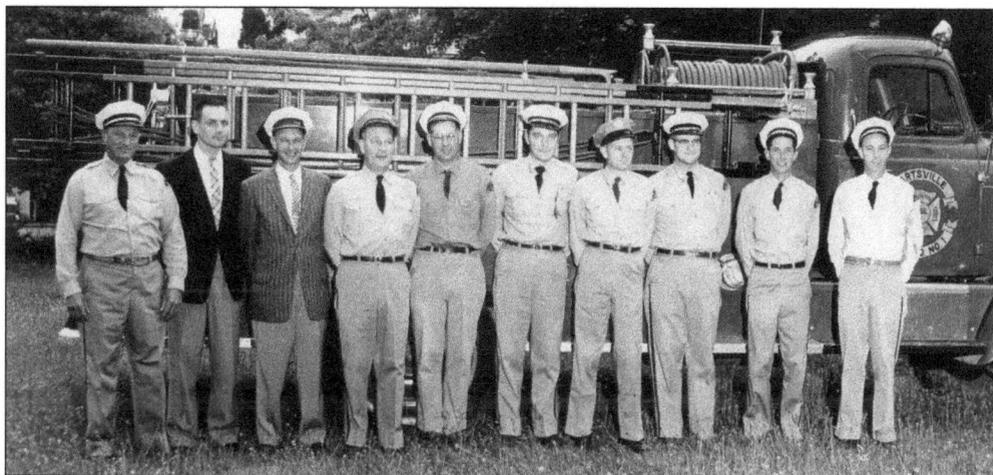

Approximately 30 volunteers served Hartsville Fire Company in 1959. Pictured above, from left to right, are Jay Hall, Ed Roberts, Bill Mullen, Henry Hannon, George Pfaustiel, Larry Brinkmann, Charlie Boston Sr., Harold Geatrell, Bud Schleyer, and Rudy Dager. Emergency calls were routed to Charlie Dugan's bar (Hartsville Hotel) and a member's home. Future assistant chief and president Larry Brinkmann and his wife, Chris, were among those who took calls. Chris was active in the Ladies Auxiliary (below) that helped organize fund-raising dances and semiannual ham dinners. Auxiliary members also coordinated communications between the firehouse and trucks at the fire site on a rotating basis. Pictured below, from left to right, are (first row) Helen Wallace, Phyllis Boesch, Ruth Hannon, and Chris Brinkmann; (second row) ? Collier, Mabel Hall, and Betty Dager; (third row) Thelma Tobar, Mildred Rinck, Ann Frekoff, and Laura Gerard; (fourth row) Betty Geatrell, unidentified, and Marion De Coursey (hidden). (Both, courtesy Hartsville Fire Company.)

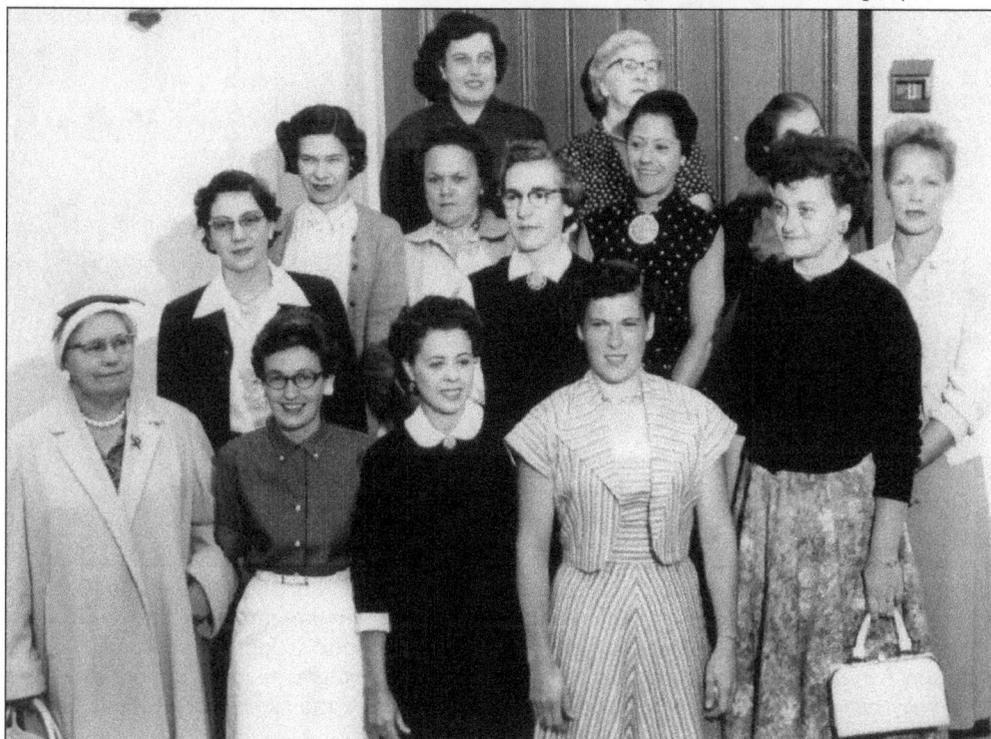

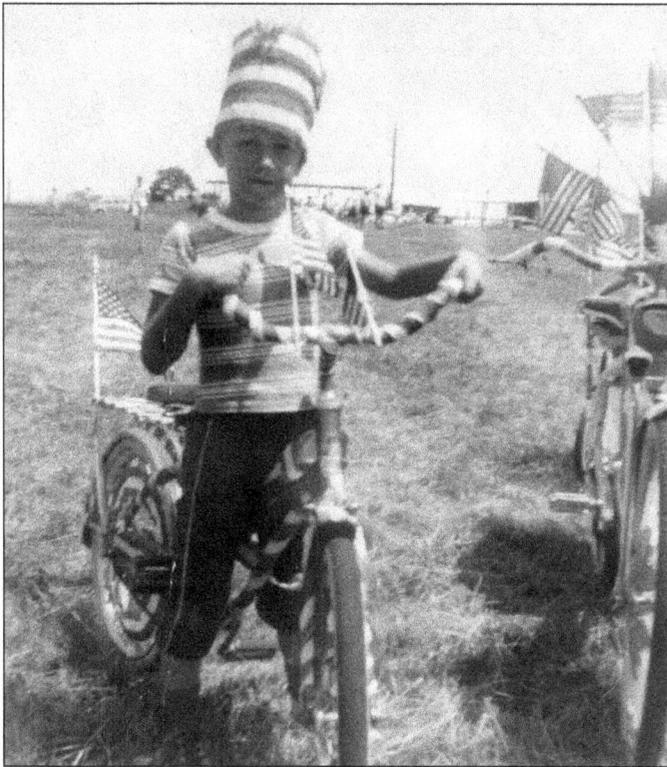

Like so many others, Ken Tangye moved to Warminster with his parents and siblings in the early 1960s, a period of significant growth for the township. He is seen here as a contestant in a 1965 Fourth of July neighborhood picnic bike-decorating contest. Like many other Warminster kids, Tangye attended Longstreth Elementary, Log College Junior High, William Tennant High, and Middle Bucks Technical School. (Courtesy Diane Tangye.)

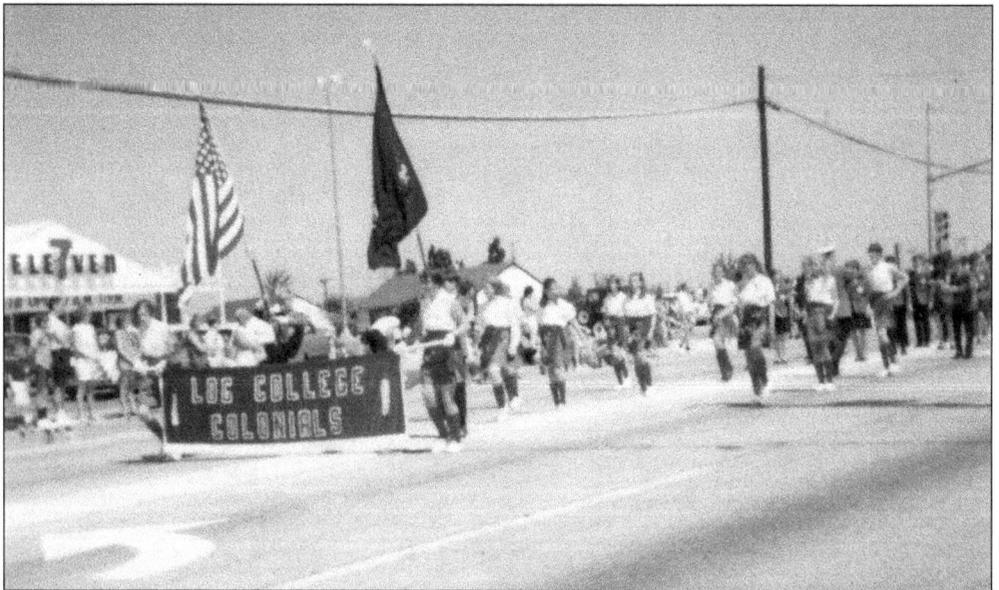

Warminster's 1969 annual Memorial Day parade included several fire departments and schools, the ambulance corps, politicians, and other proud community representatives. The route began at the Henry Avenue police station, passed down York Road to County Line Road, then up Madison Avenue to the fire station for ceremonies. It was photographed here at York Road and Henry Avenue. The 7-Eleven is now the site of Rita's Water Ice and Papa John's Pizza. (Courtesy Diane Tangye.)

The students of Log College Junior High School were delighted when their faculty challenged the Warminster Police Department to a friendly game of basketball. The police team, seen here fortified in Converse sneakers, played against their competitors in front of a crowd from the school and community at an evening event held in the late 1960s (1967 or 1968). (Courtesy Diane Tangye.)

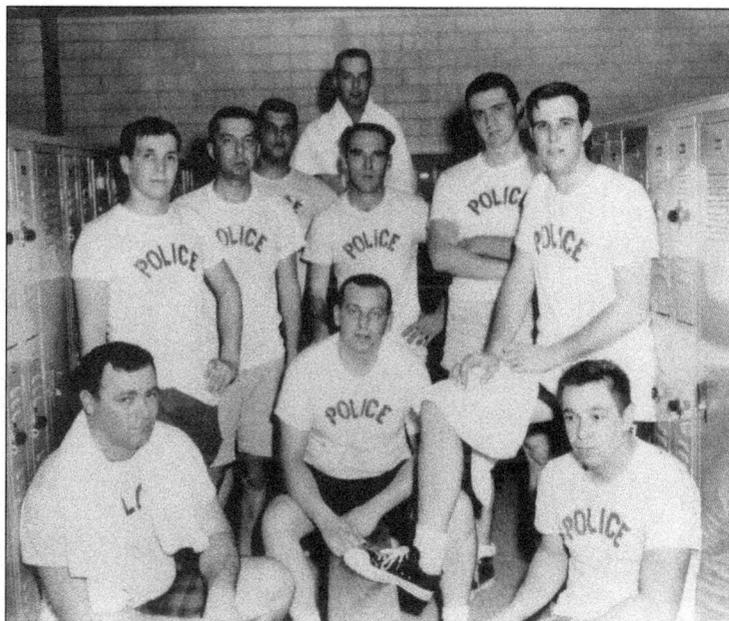

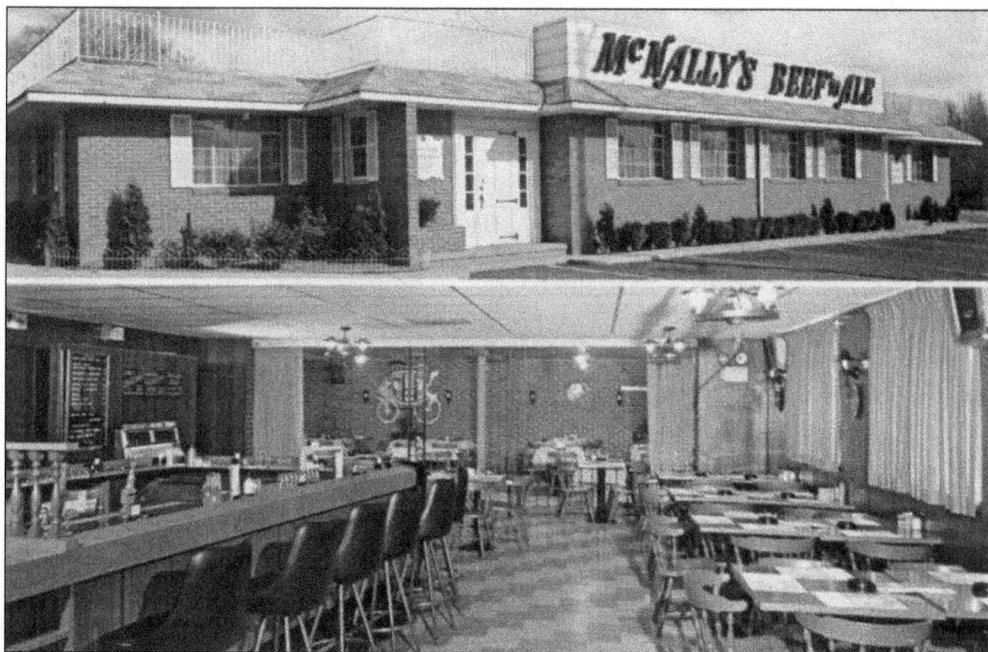

McNally's on York Road was a popular restaurant for young people in the early 1960s. They were known for their hot roast beef sandwiches and freshly sliced hot ham sandwiches that were described as "out of this world." The restaurant also specialized in business luncheons, small banquets, and private parties. The building later housed Philly Crab and Steakhouse for many years. (Courtesy Diane Tangye.)

Tony Carosi (seen c. 1946) grew up on the family farm in Johnsville and attended Warminster School on Street Road (now a daycare center). Like many boys of his era, he left school in the seventh grade to work the farm full time. Tony jokingly refers to his being a "wintertime" Catholic with the other family men and attending the chapel on Madison Avenue heated by a potbellied stove fueled by corncobs. (Courtesy Tony Carosi.)

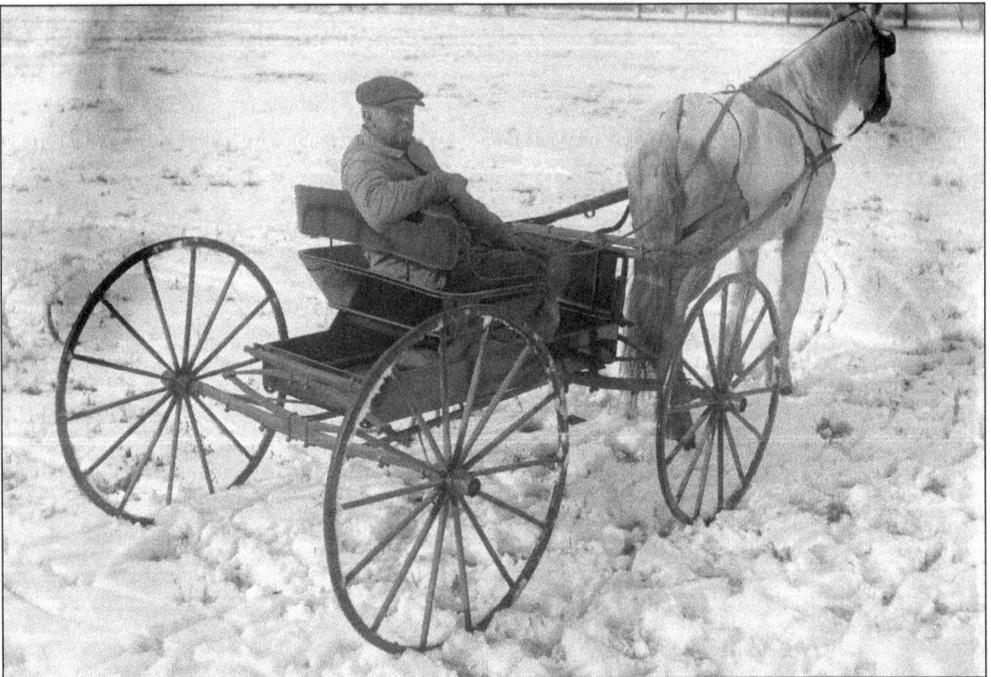

William Warner Opdyke Finney lost his mother three days after his birth and was raised with his sibling, Emma, by their mother's sister Mary Bennett Opdyke. He was Warminster Township's road supervisor in the 1930s and is seen here on the family farm on Bristol Road between Newtown and Davisville Roads. Four generations of Finneys were raised at the homestead, which was later confiscated by the NADC for runways. (Courtesy Anna Mae Finney Fretz.)

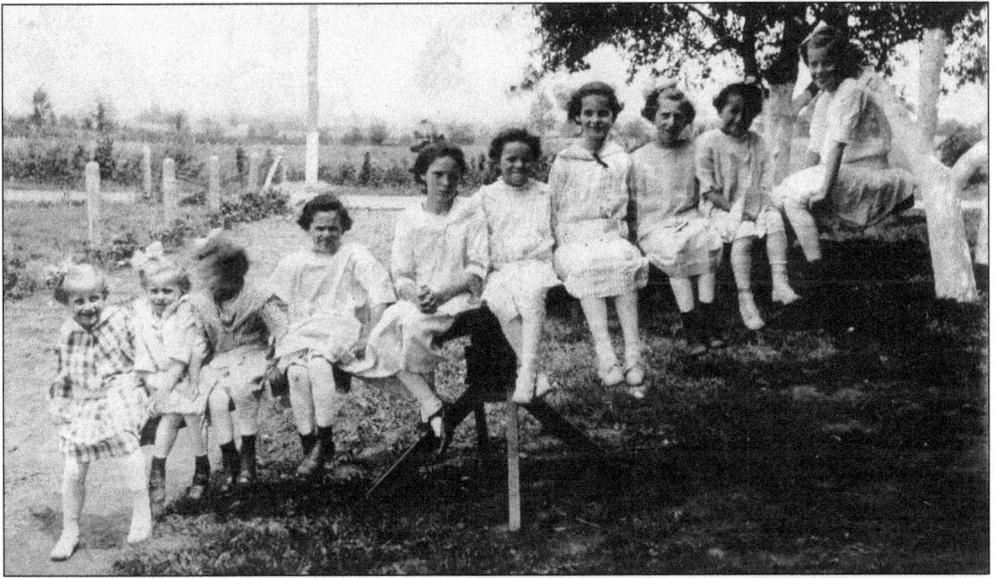

Two thousand years after Archimedes proposed the mathematical principle behind the lever, these young girls at Christ's Home in the 1920s used their seesaw to demonstrate the principle in action. During the decade this photograph was taken, Christ's Home Retirement Community opened, the administration building was erected, and an on-site sewage disposal plant became operational. (Courtesy Christ's Home.)

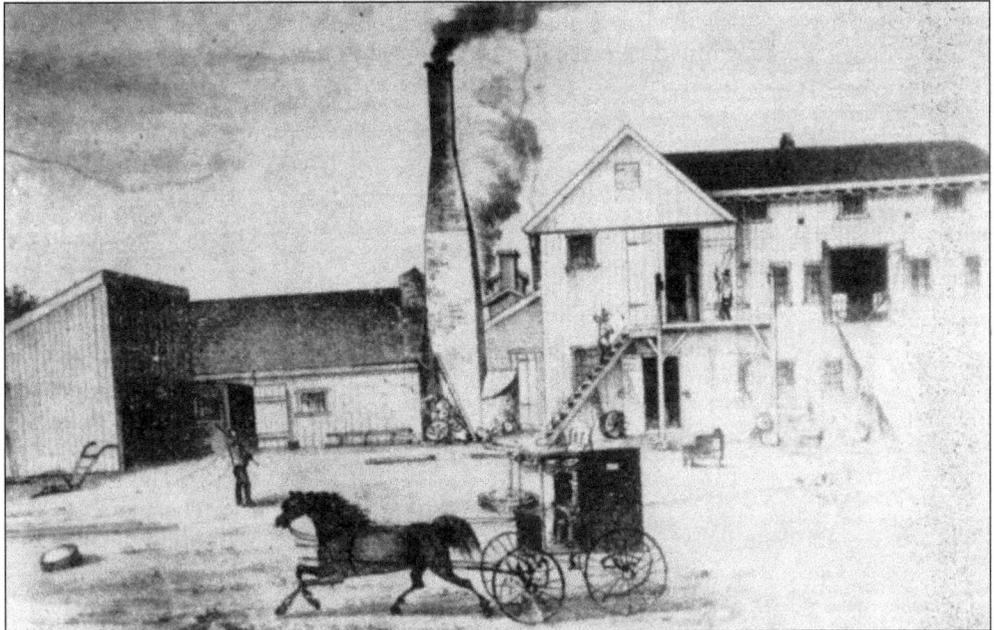

Beans Agricultural Implement Factory in Johnsville, specializing in farm equipment such as labor-saving mowers and reapers, was established in the early 1850s by Robert Beans. The 100-foot-long frame factory on Street Road across from the general store included a foundry and employed, at its peak, 50–60 workers, many of whom were trained under an apprenticeship program. Two years after selling the business to O. W. Minard, it was lost to fire on July 12, 1870. (Courtesy Beverly Blackway.)

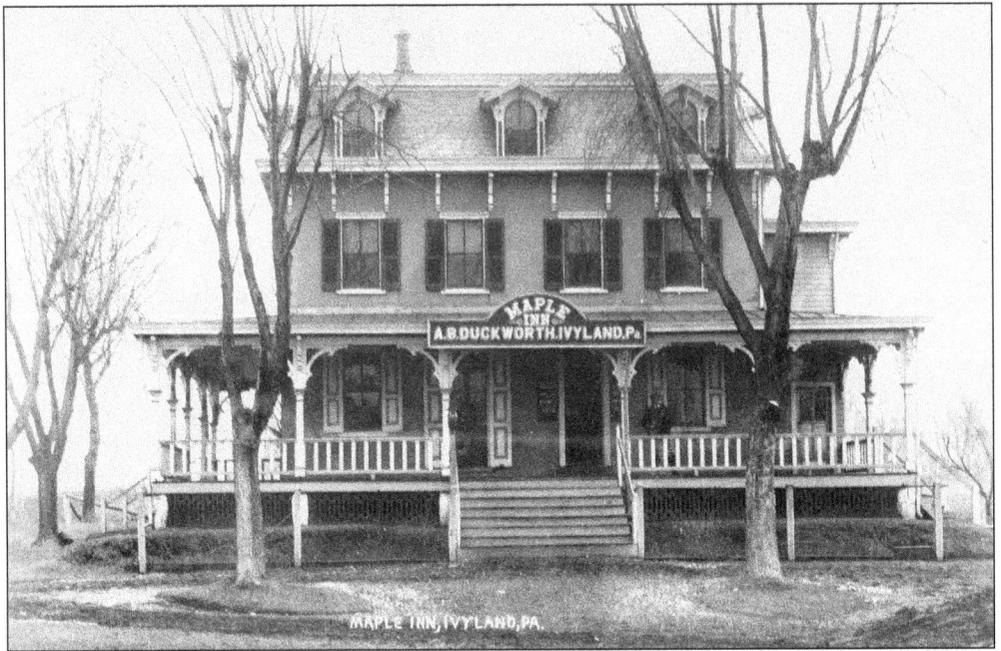

This inn was one of several buildings erected in 1877 by the enterprising Bready sisters on their property. Horse dealer Preston Price and his daughter Susan Yerkes were the first proprietors. Although a temperance house, the large rear shed provided perfect accommodations for cattlemen and horsemen moving stock. Adellah B. Duckworth was owner from 1902 to 1910. It later became the "notorious" Speedway Inn, then Ivyland Inn in 1946. (Courtesy Jack and Ann Regenhard.)

On May 1, 1778, this field was a bloody scene of terror for newly recruited militia assigned to General Lacey only the evening before. Brutally attacked at dawn by British soldiers and the Queen's Rangers (armed Tories under their command), they fled north from their encampment through woods and open countryside. Several were burned alive where today the Battle of Crooked Billet monument stands unnoticed by thousands of daily commuters on Jacksonville Road. (Courtesy CHHS, Inc.)

Kids love dressing up for Halloween, and Paul Locke, shown around 1928 as a boy in Native American regalia, was no exception. Although the custom of trick-or-treating did not gain national popularity until later, by the 1920s towns across America were organizing Halloween parades for community children. (Courtesy Paul Locke.)

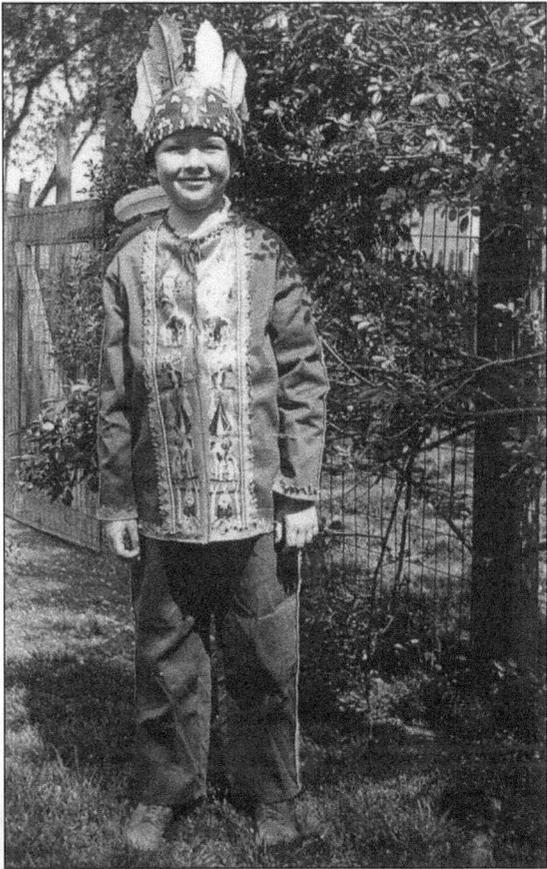

Helen Ritchie (with large bow on dress) attended this unidentified one-room schoolhouse in Warminster. Some years later, when a self-starting mechanism replaced the crank on Ford's popular horseless carriage, she wasted no time becoming one of the first women in the area to drive an automobile. (Courtesy Paul Locke.)

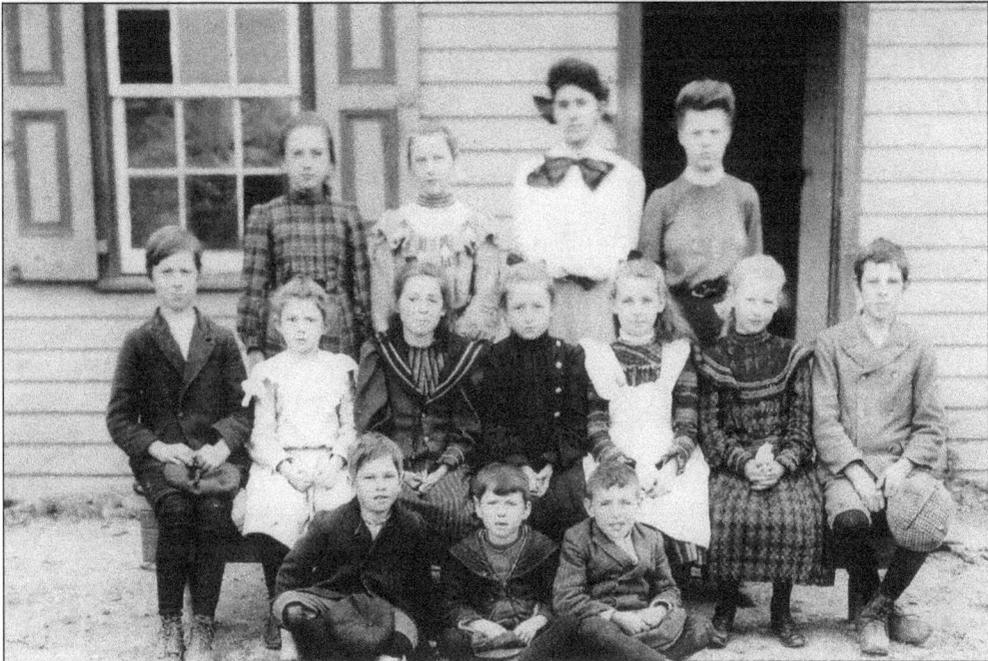

Best Wishes from
Johnsville, Pa.

I'm wishing for you all the
best of things, and heart for any fate,
And I'm hoping to hear great things of you,
As you travel the "street called straight."

Johnsville, first known as Upper Corner, then Craven's Corner, was one of Warminster's busiest communities. As early as 1730, Ann Longstreth, noted for her business acumen, operated a store here. After James Craven built a store in 1814 for his son John at the southwest corner of Newtown and Street Roads, the area became known as Johnsville. This historically significant community retains a charming enclave of original homes on Newtown Road. (Courtesy Jack and Ann Regenhard.)

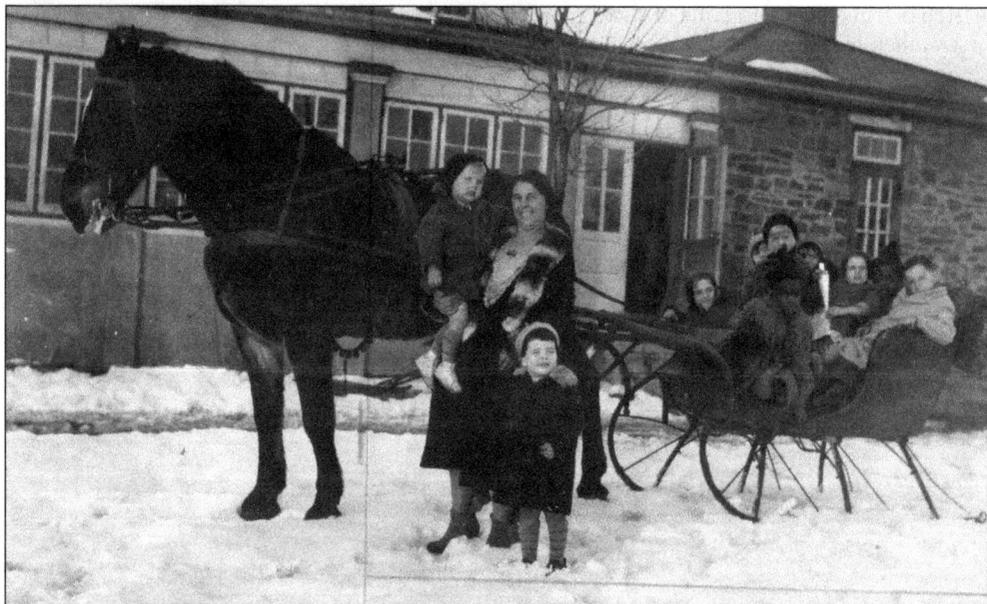

In the past, cold weather and snow kept neither adults nor the very young from enjoying the outdoors. Sleigh riding on the Christ's Home property was an especially favorite pastime, as shown in this 1932 photograph. Although sleigh riding is generally a thing of the past, today Warminster Township offers 14 parks (including ball fields) encompassing 409 acres for recreation all year round. (Courtesy Christ's Home.)

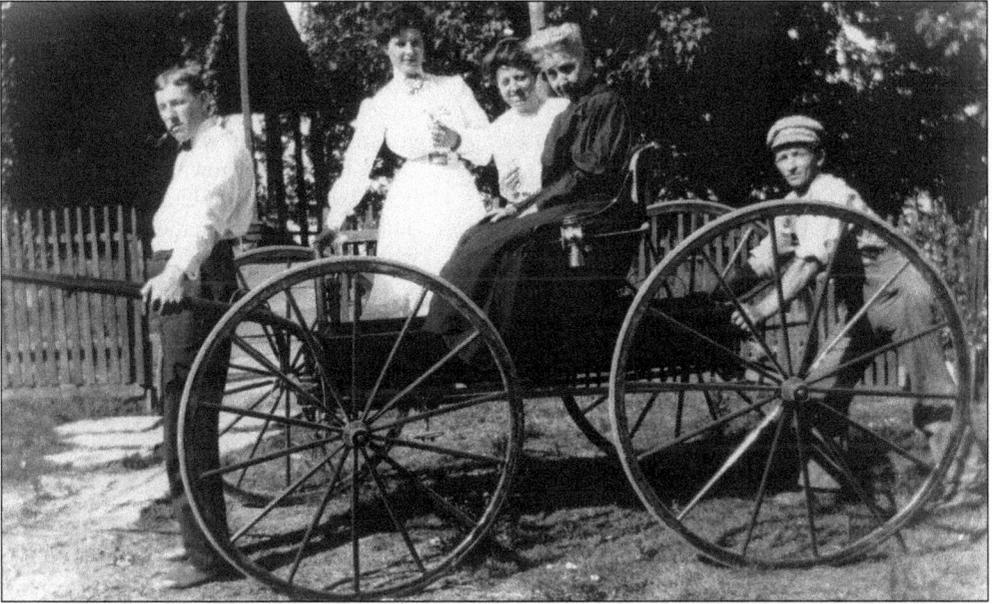

Sundays on the Conard farm were a time for gathering friends and family. This playful c. 1900 scene in the family "runabout" includes Sallie Conard (seated left) and her mother, Jennie (seated right). Sallie spoke of moving to their Johnsville farm as a child. While mother Jennie and father Israel transported household goods by wagon, she and brother Joe walked all the way from Ambler accompanying younger siblings riding in a goat cart. (Courtesy Samuel Walker.)

In the mid-1960s, local historian and *Spirit* journalist Beverly Blackway despaired of "any hope in the future about remembering [Warminster's] past." Political efforts to let the village names of Johnsville and Hartsville become lost to time were thwarted thanks in large part to Blackway's relentless letter writing, editorials, articles, and community action. Her historical research and writings comprise much of Warminster's history compiled by Paul Bailey and published by the township. (Courtesy Beverly Blackway.)

The Rorer family operated the Johnsville store and post office for 30 years. They lived in this home, once attached to the early-19th-century general store built by the Cravens when the corner of Newtown and Street Roads was known as Cravens Corner. The Rorers built a smaller store nearby when the former was demolished to widen Street Road in 1944. The lovely porch was later added to the remaining structure. (Courtesy Samuel Walker.)

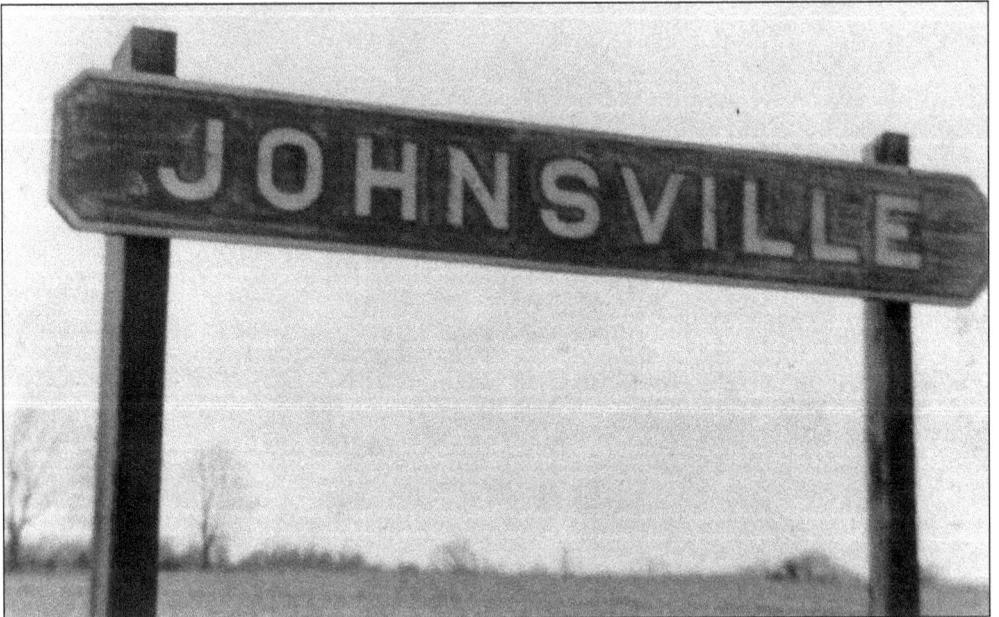

Street Road side

Best Christmas Wishes and
Happiness throughout the Year

The Rorers

Johnsville Station (sign pictured), erected following the 1874 County Line Road to Bristol Road rail extension, was reachable by a plank walkway along Street Road. Summer excursions to Willow Grove Park were so popular that an exclusive ticket agent was assigned to these passengers. In the winter, the tracks were sometimes rendered unusable. One old-timer recalled a 1917 snowstorm when stranded riders were graciously given overnight accommodations at local farmhouses. (Courtesy Andrew Zellers-Frederick.)

Richard and Beverly Blackway bought their first home in historic Johnsville following World War II in 1947. Soon Richard joined Fischer and Porter to work in research and development. Beverly, initially a homemaker, worked almost three decades in the newspaper field and gave much of her personal time to preserve Warminster's historic past. Her research, amassed purely "for the love of the area," ultimately became a significant part of published Warminster history in commemorative books and articles. A quiet but successful preservation advocate and award-winning journalist, she retired in 1991 as associate editor of *Today's Spirit*, the *Spirit of Bucks County*, and the *Willow Grove Guide* after 28 years of professional reporting. Richard is seen above with the first of their five sons, Glenn. Below, from left to right, Glenn, his brother Lee, and Beverly are seen strolling on Newtown Road (looking north) in 1951. (Both, courtesy Beverly Blackway.)

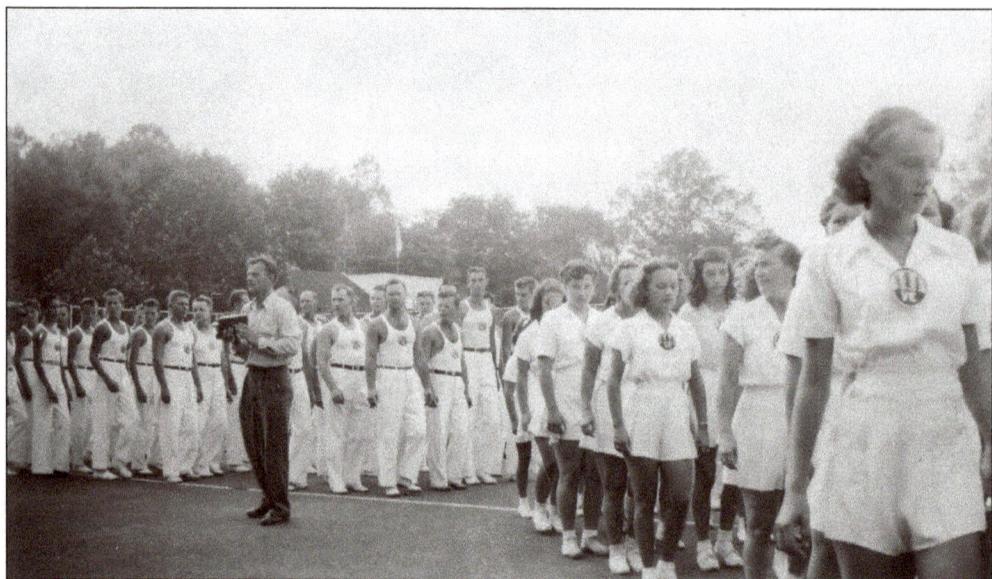

Sportsfest, a September event held by the Vereinigung Erzgebirge German Club, began in the mid-1930s as a way to gather friends and family together in friendship and community. Every year for the next half century, the Warminster club featured several dozen limber men, women, and children called Sportlers, who performed callisthenic exercises complementary to music and each other in a much anticipated show. This part of the program was described by a member as "the highlight of the year." Today Sportsfest has been combined with Octoberfest, one of many events, dinners, and programs offered by the group to its 1,100 members, their friends, and family. (Both, courtesy Vereinigung Erzgebirge German Club.)

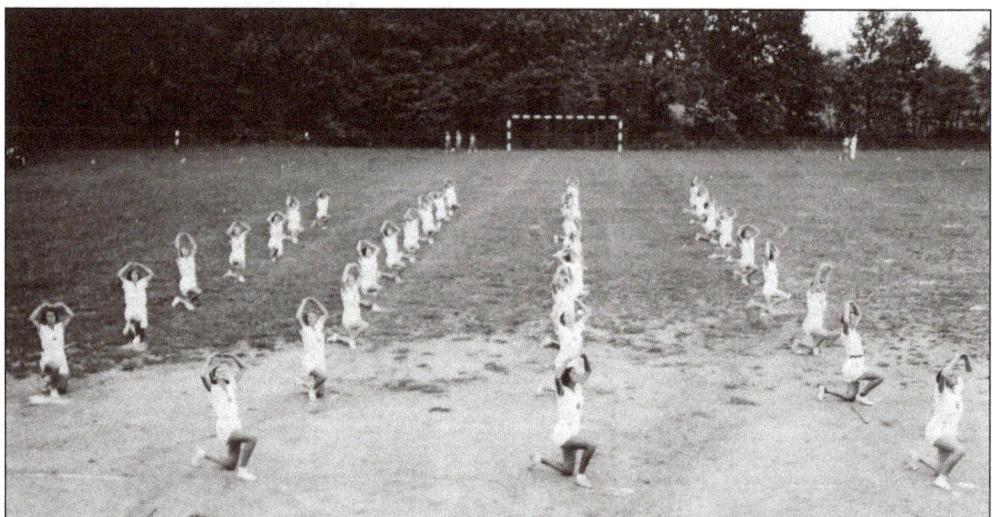

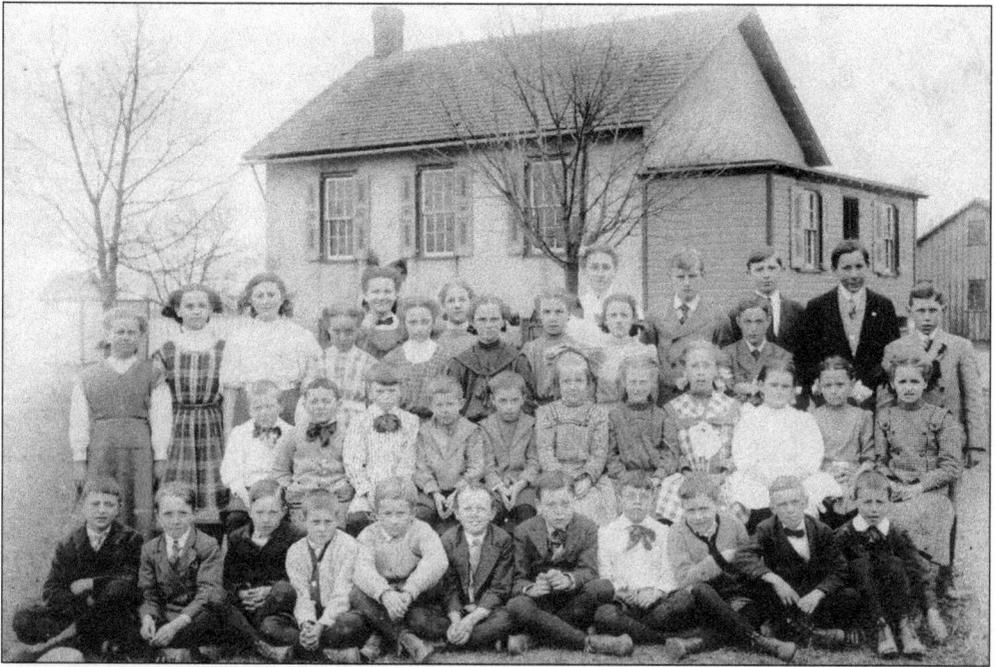

Future school board official Joseph W. Hallowell Sr. (third row, far right) received his early education in Ivyland's one-room schoolhouse, seen behind the students around 1906. The school was built in 1895 on the northwest corner of Chase and Mason (now Pennsylvania) Avenues; a new building on Twining Avenue replaced it 20 years later. Note the outhouse at left in the rear. (Courtesy Penrose Hallowell.)

Alvin Knight was a mason, carpenter, and general handyman in Johnsville in the early 1900s. He was photographed taking a break from repairing the old graveyard wall at the Craven/Van Sant burial ground. The large cans are filled with water for mixing cement in the wooden trough visible behind them. Two walls have recently been rebuilt by the Craven Hall Historical Society, Inc., while the other two, in disrepair, await funding. (Courtesy Samuel Walker.)

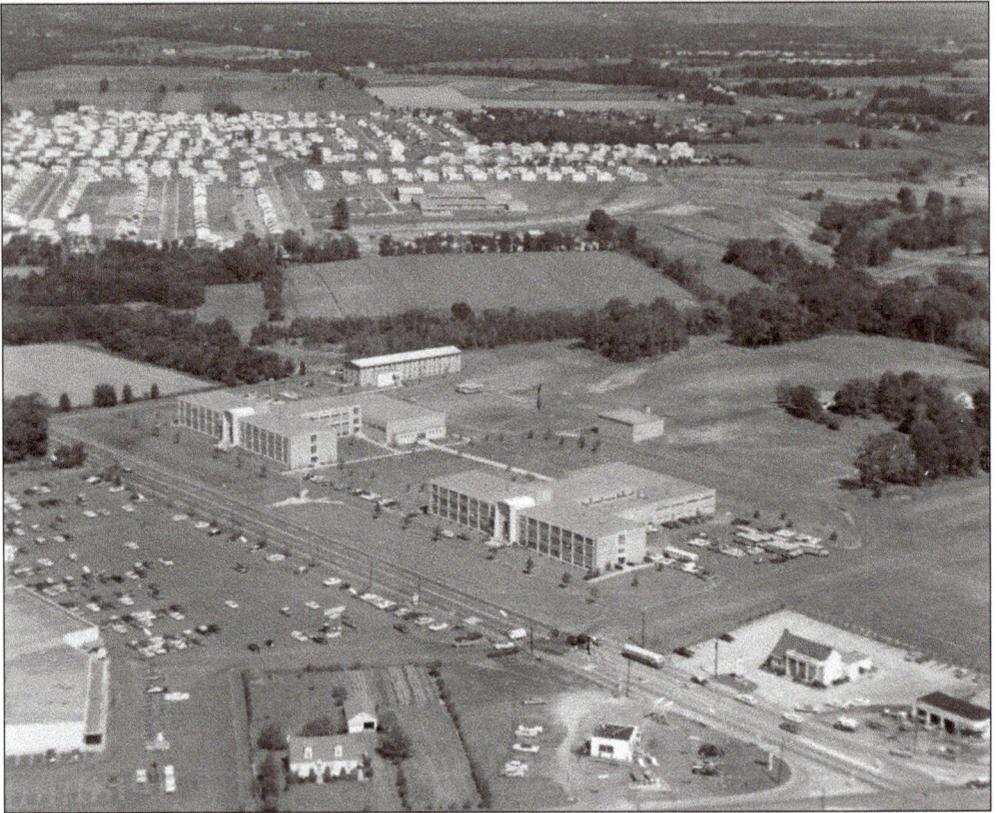

Offering tuition-free education, Archbishop Wood High School on York Road opened for ninth- and tenth-grade students in 1964. Eleventh- and twelfth-grade classes were added as these students moved up. Separate buildings were created for girls and boys, each having capacity for 1,500 students, a library, cafeteria, medical suite, gymnasium, and television studio. By 1972, language, science, fine arts, and occasionally religion classes had become coeducational, and tuition cost $300 per year. (Courtesy Nativity of Our Lord Church.)

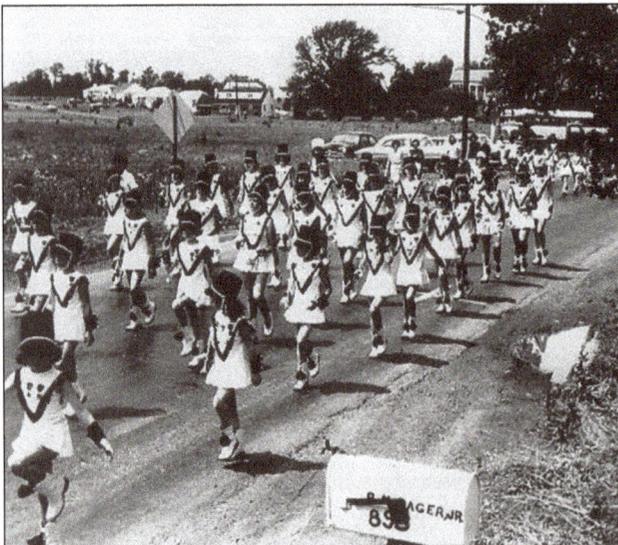

The Fourth of July parade in the 1950s was a much anticipated community event. These majorettes are twirling their way down York Road just south of Norristown Road. The Kline home (upper right with columns) is partially seen behind them. New homes under construction on Emma Lane are also visible. Skilton's gas station was just north but cannot be seen in this image. (Courtesy Joan Fanelli.)

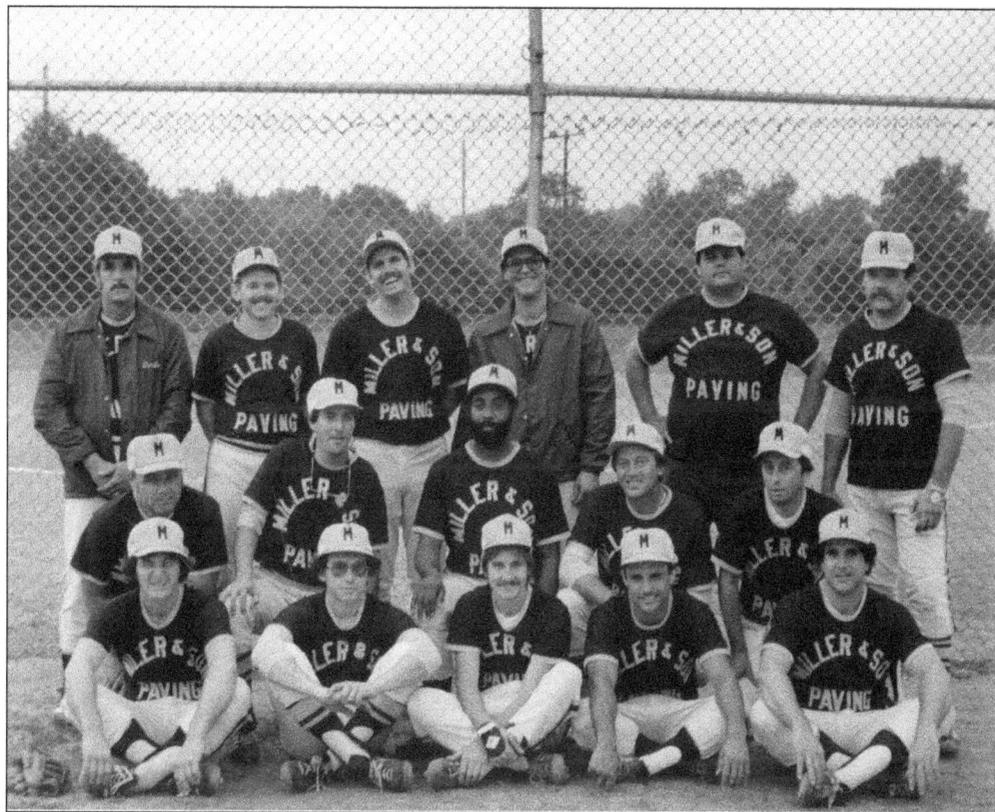

When the Warminster Police Department's fast-pitch softball team acquired a sponsor, Miller and Son Paving, the team was able to move from the Police League to the National Amateur Softball League. They eventually merged with the Bux-Mont League and, ultimately, the Bi-County League. The team competed up and down the Eastern Seaboard and built two ball fields in Warminster. Manager Clarke Tangye is seen in the second row at far left. (Courtesy Diane Tangye.)

Diane Tangye was a crossing guard for Longstreth Elementary School for 15 years (early 1960s to mid-1970s). Duty posted her at the intersection of Ivyland and Roberts Roads to guide children and direct traffic three times daily. She recalls meeting thousands of students over the years, including some whose parents she had greeted and guided when they were children. Tangye was among the founders of Warminster Township's union for crossing guards. (Courtesy Diane Tangye.)

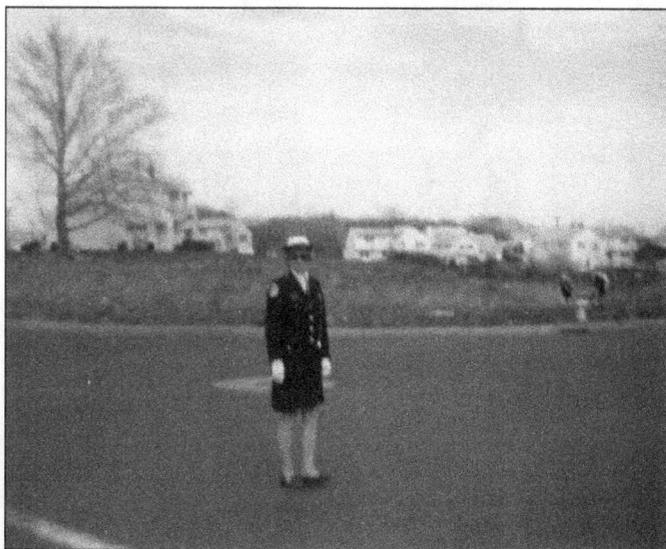

This beautiful stone-and-frame colonial home on Old York Road (left) was built around 1835 by Benjamin Wright. The flagstone floor and fireplace pictured below are part of the original keeping room. Longtime Neshaminy church pastor Rev. Douglas Turner, who married into Hartsville's prominent Darrah family, purchased it from Jane Krusen Craven in 1875. He performed marriage ceremonies and wrote a church history in this home. Over the years, owners have included a farmer, builder, and several teachers, including current resident Pauline Bush, who has tastefully decorated the residence in charming period pieces. The Neshaminy Presbyterian Church in Warminster, built in 1842, was located on the lot adjacent to this Hartsville property (only a partial cemetery remains). An auxiliary lyceum built across the street in 1849, later known as the "Lecture Hall," subsequently became the community's social center. (Both, courtesy Pauline Bush.)

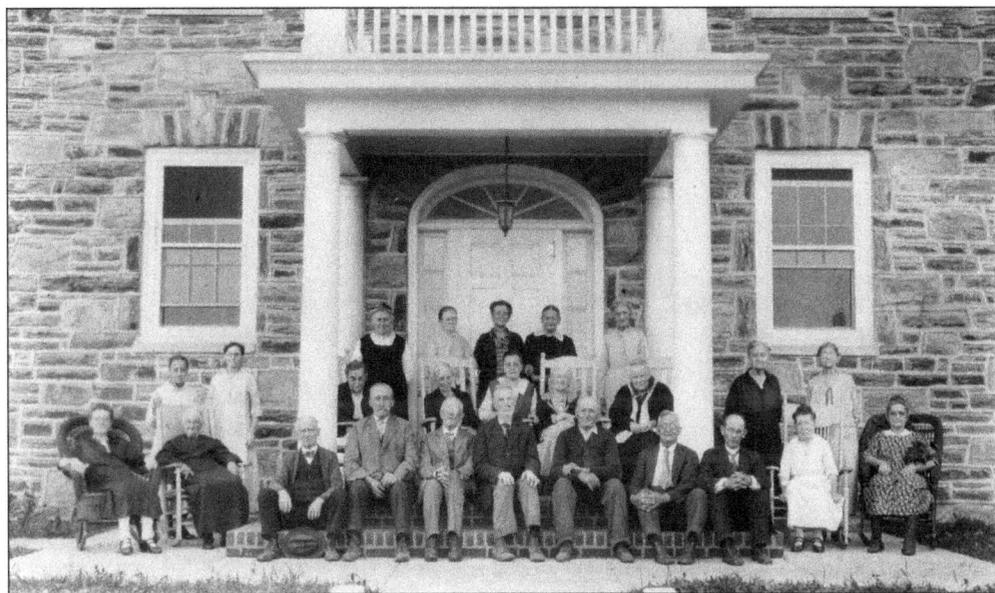

Christ's Home Retirement Community opened in 1923 and housed 28 residents. These c. 1930 photographs show residents in front of the original Street Road building (above) and picking apples in the orchard (below). The stick was used to shake apples loose from the trees, some of which are still standing. Every year at harvesttime, local residents would head to Christ's Home to participate in canning operations. Local church groups joined this massive undertaking as well. Today there are 220 senior residents in the continuing-care facilities that include independent living apartments, Shepherd's Crossing cottages, personal care, and skilled-nursing facilities. A replacement for the present healthcare facility is planned for the future. (Both, courtesy Christ's Home.)

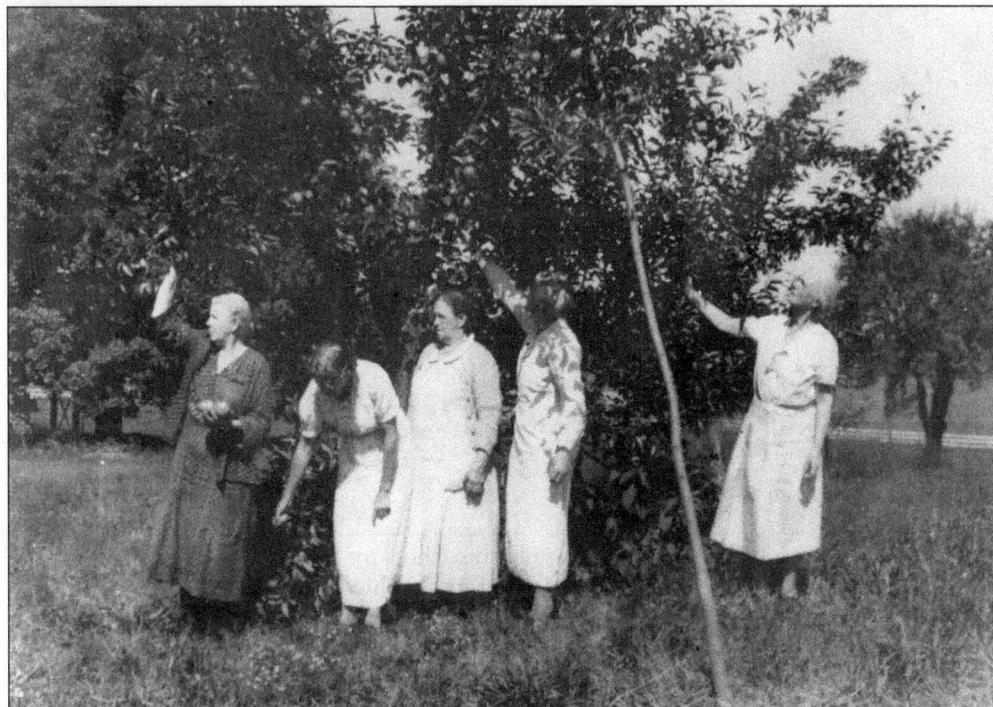

In historic Hartsville (Crossroads), located partially in Warwick, the Reverend William Tennent founded Log College and Gen. George Washington commissioned the Marquis de Lafayette. Legend says the first official American flag was unfurled here over Washington's troops. Postmaster general Benjamin Franklin likely visited the Hartsville Hotel while traveling the New York–Philadelphia mail stage. His friend Rev. Charles Beatty lived across the road and had been chaplain to Franklin's frontier militia in 1755–1756. (Courtesy Jack and Ann Regenhard.)

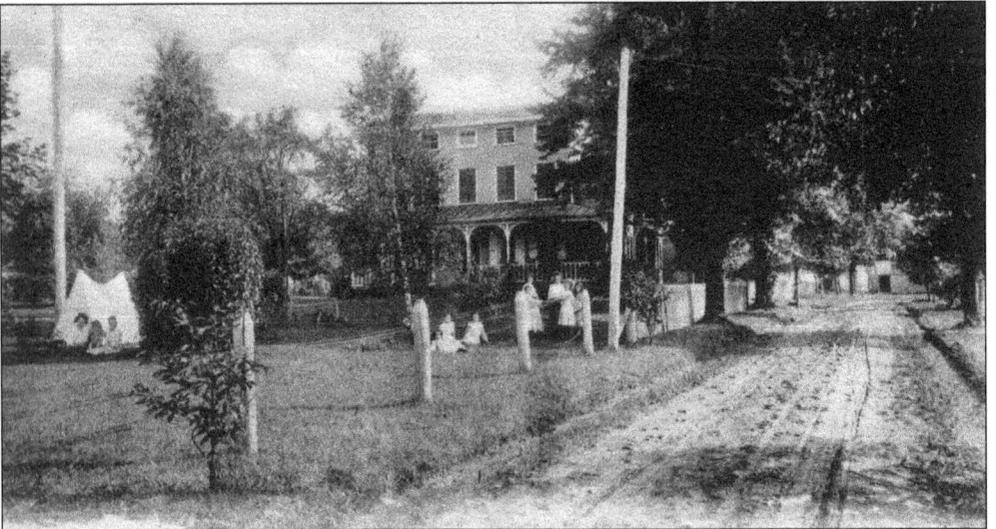

Samuel Emlem Jr. left $20,000 in 1837 to establish a school for free male orphaned children "of African or Indian descent." After initially operating in Ohio, the institute was relocated to a 55-acre Solebury farm in 1857, then to land with better soil in Warminster Township in 1873. It closed 19 years later. In 1897, Philadelphian Episcopalians acquired the property (now a shopping center) and opened St. Stephens' orphanage, seen here in the early 1900s. (Courtesy Jack and Ann Regenhard.)

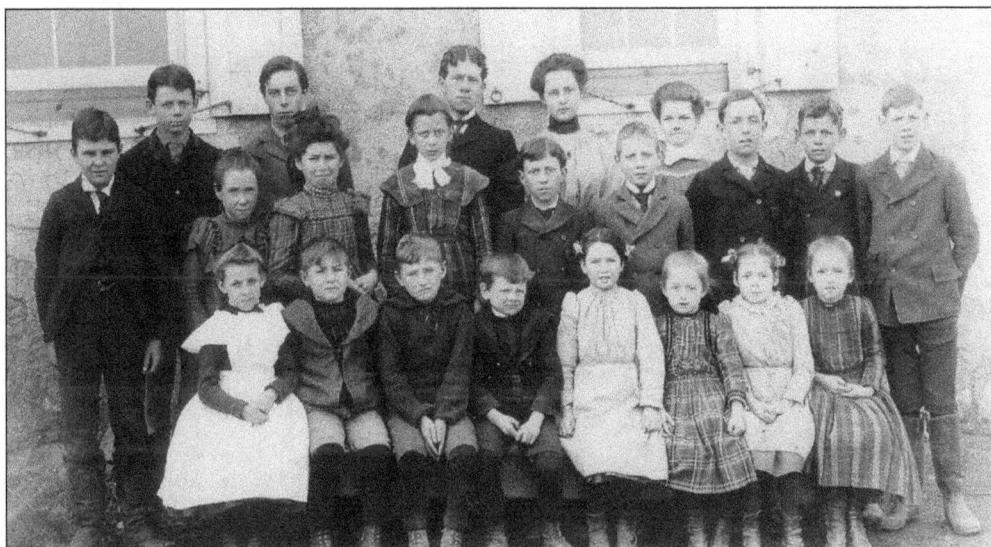

Student Mary Ritchie Locke, a future Warminster Elementary School teacher, was photographed with her classmates c. 1900. (Unfortunately, Mary cannot be identified). The school is believed to be Oak Grove, built 1840 on Street Road between Madison Avenue and York Road. It was Warminster's first free public school and located where a Friendly's Restaurant is today. Ivyland children attended school here from 1878 through 1895, waking quite a distance daily. (Courtesy of Paul Locke.)

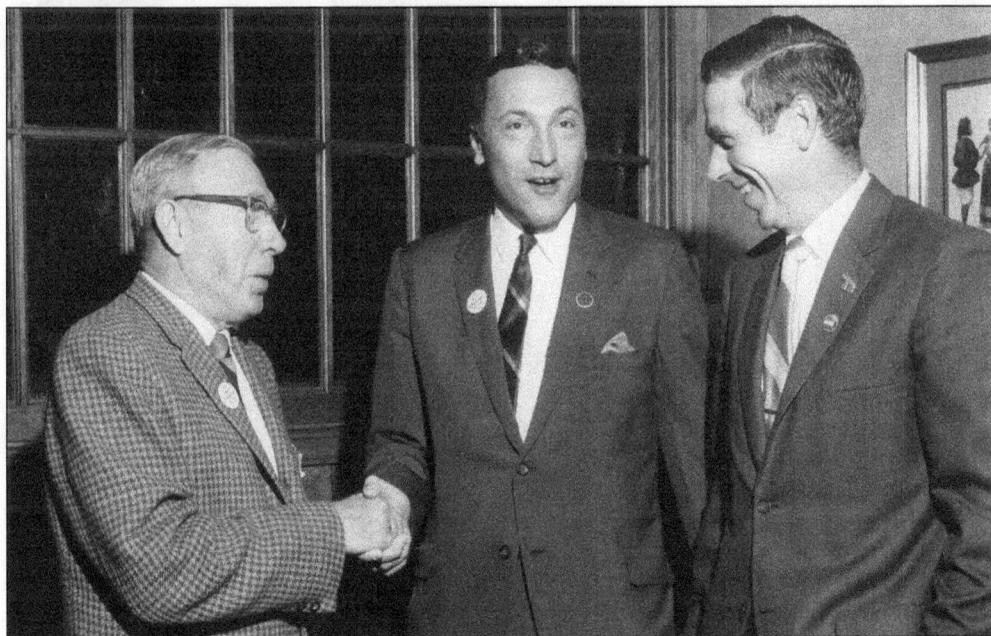

Joseph W. Hallowell Sr. (left) was a leader in agricultural organizations, a committeeman, township supervisor, commissioner, tax collector, and school director. Joseph's father, Morris, was York Road Turnpike commissioner c. 1900. His son Penrose (right) was Pennsylvania's Secretary of Agriculture, 1979–1985. Here future U.S. Secretary of Health and Human Services Richard S. Schweiker welcomes Joseph and Penrose to his Senate election committee in 1968. The Hallowell Pavilion in Warminster Community Park was named in his honor. (Courtesy of Penrose Hallowell.)

71

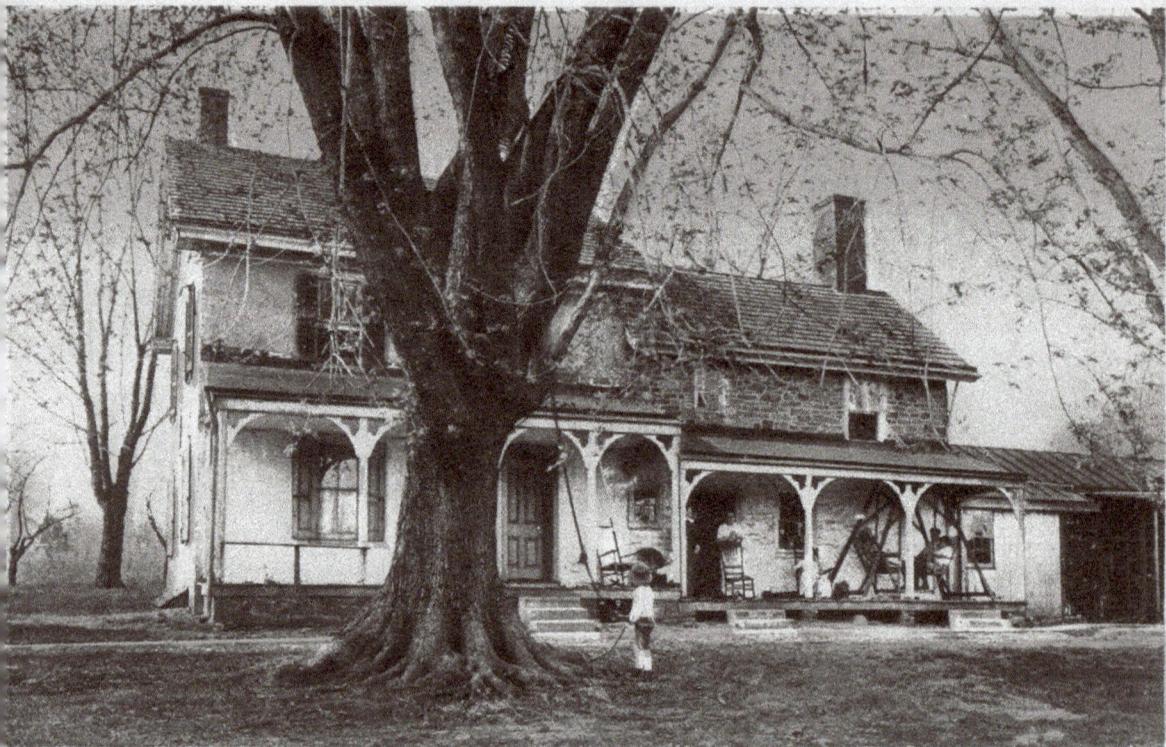

WASHINGTON NESHAMINY HEADQUARTERS, HARTSVILLE ABOVE HATBORO, PA.

The Moland house lies a half mile above Warminster's Bristol Road border on Old York Road in Hartsville (Crossroads) and was the headquarters for Gen. George Washington before the Battle of Brandywine. Around Hannah Moland's home on the "slopes of Carr's hill . . . Jamison and Ramsey farms" were 11,000 troops. Lafayette, who was commissioned here, described them as fine soldiers, yet "ill armed . . . still worse clothed" and many "almost naked." Several early writings claim the American flag adopted in the Flag Act by congress on June 14, 1777, was first flown here during the August 10–23, 1777, encampment. William "Lord Stirling" Alexander, Maj. Gen. Nathaniel Greene, Gen. Henry Knox, Gen. Anthony Wayne, and others were present, and Count Casimir Pulaski, a top European cavalry commander, first met Washington here, arriving with a letter of introduction from Benjamin Franklin. (Courtesy Jack and Ann Regenhard.)

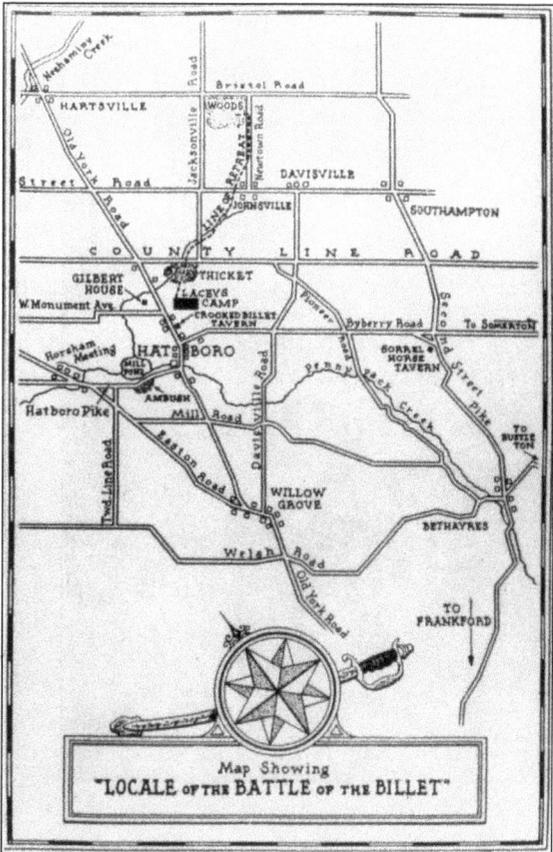

Map Showing
"LOCALE of the BATTLE of the BILLET"

During British control of Philadelphia in 1778, Gen. George Washington assigned 22-year-old Gen. John Lacey Jr. command of an independent campaign to block delivery of supplies from Bucks County and the surrounding region to the British. At dawn on May 1, Lacey's men were victims of a surprise attack when patrol officers failed in their duties. Most of Lacey's 300 troops were untrained and unarmed new draftees. Completely surrounded as they fled north (see Line of Retreat on map at right), they fought their way to Bristol Road and safety, thwarting Col. John Graves Simcoe's strategy to capture Lacey and his entire force. Locals drawn by gunfire and smoke witnessed numerous atrocities committed upon wounded and dying soldiers by the Queen's Rangers. Thirty-five of Lacey's men perished, and many were captured; Lacey and the rest escaped. Reenactors of the event are seen below. (Both, courtesy CHHS, Inc.)

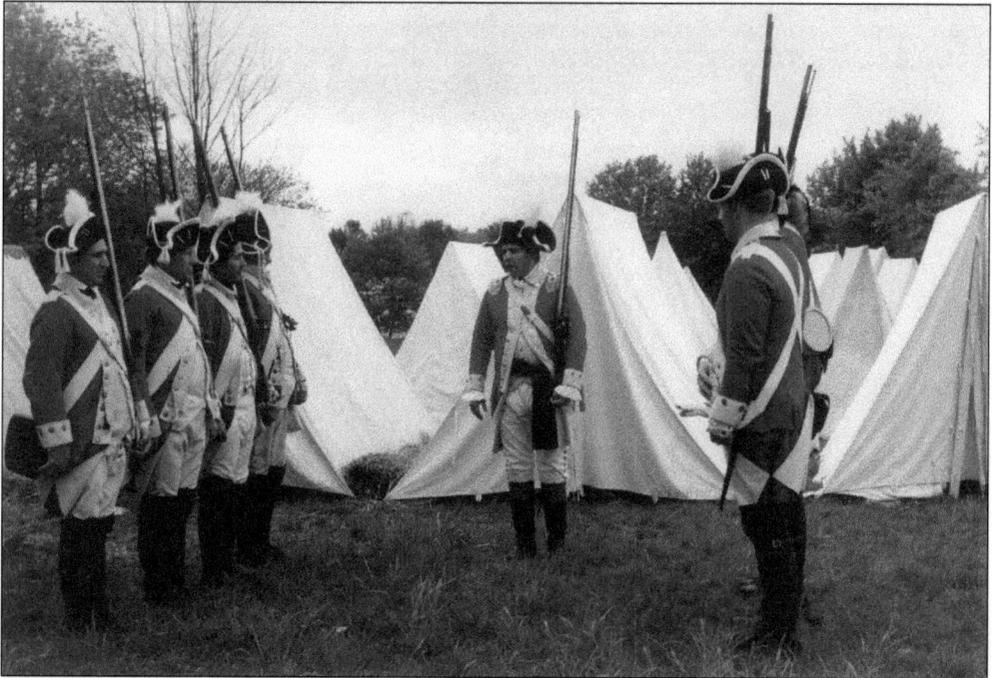

The historic district of Hartsville was notable for its 17th- and 18th-century educational institutions. Over time, this Old York Road home was owned by several teachers, including Rev. Douglas Turner, Eleanor Fisher, and now Pauline Bush (pictured). Fisher was fondly recalled for the ice cream Dixie cups she distributed to the neighborhood children on Halloween in the 1940s. The monstrous ash tree shown was removed in 2005. (Courtesy Pauline Bush.)

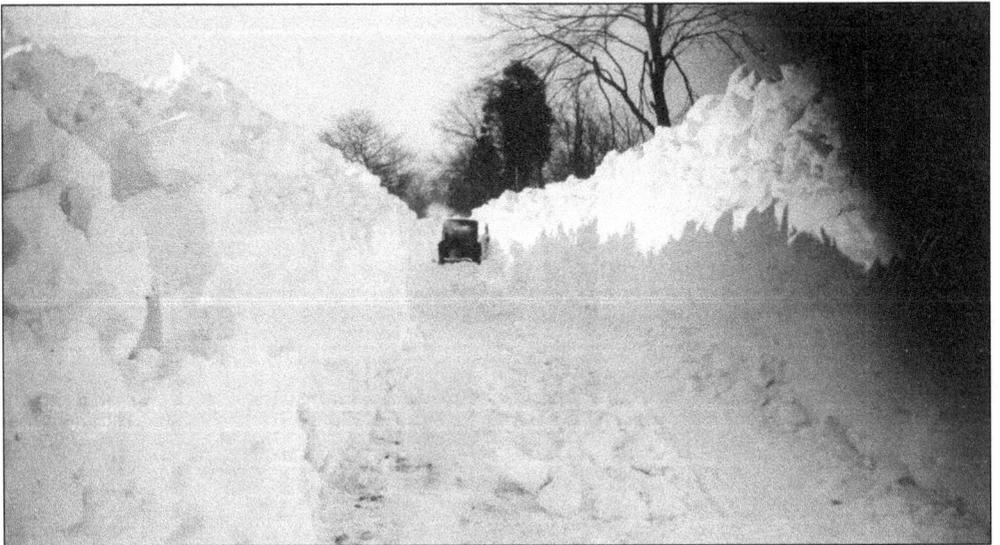

During the blizzard of 1935 (January 22–24), Warminster residents had to dig out from one of the worst snowstorms to ever hit the area. Roads were cleared by local farmers and boys, including Carl and George Fulmor, whose sister Phyllis Hurst recalled the event from her childhood. National Weather Service records indicate the area was buried under almost 17 inches of snow during the storm. This photograph was taken on Bennett's Lane. (Courtesy Phyllis Hurst.)

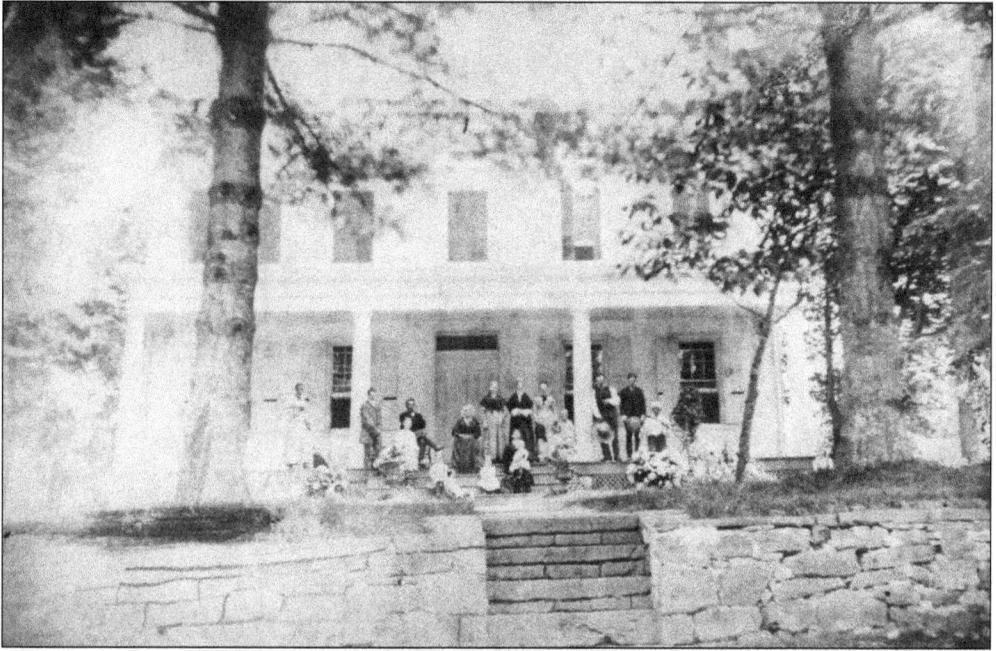

Successful farmer Robert Darrah, a former ensign in the War of 1812, purchased 125 acres from his father, James, in 1828. He and his wife, Catherine Galt, had nine children. To ensure their education, he added a schoolhouse to his property around 1835 and offered to pay a schoolmaster $240 annually plus " 'board 'round." Two daughters—first Rachel, then Rebecca—subsequently married Douglas Turner, who taught them both before becoming pastor of the Neshaminy Church in 1848. The manor house (both images) on Bristol Road west of Old York Road was not built until around 1850. During the Revolution, Darrah's grandfather, Capt. Henry Darrah, headed a militia of minutemen. He purportedly provided overnight accommodations in his Castle Valley home to General Washington several times but always sent his children to neighbors to minimize disturbances. Robert and Catherine's home remains in private hands. (Both, courtesy Bernice Graeter-Reardon.)

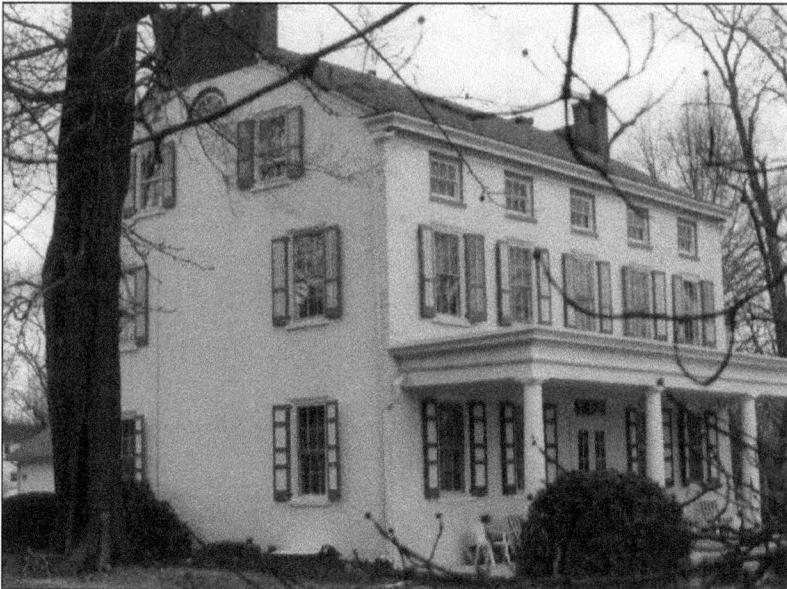

UNION CHAPEL, JOHNSVILLE

Johnsville's Union Chapel, at Newtown and Street Roads, was built in 1898 by the Davisville Baptist and North and Southampton Reformed Churches to accommodate a growing Union Sunday school that met at the Prospect Hill schoolhouse. It later served as a community center where Halloween events, Christmas parties, and covered-dish community suppers were held as late as the mid-20th century. It became Johnsville Reformed Church in 1955. In the early 1900s, Mr. Notshover produced hand-loomed rugs and carpets nearby. (Courtesy Jack and Ann Regenhard.)

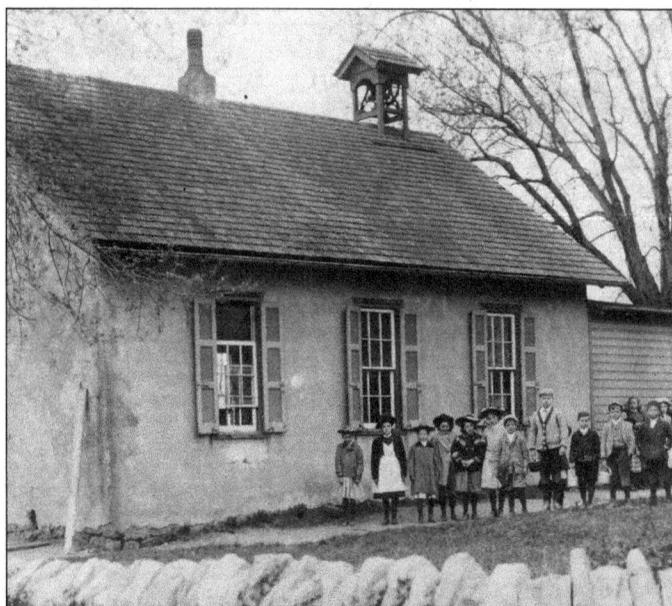

The 1871 *Bucks County Business Directory and Gazetteer* listed Prospect Hill as one of three schools in Warminster along with Willow "Vale" [sic] and Oak Grove. It was built atop Davisville Hill on Street Road in 1842 and demolished 100 years later in 1942. Although the schools closed for two months every summer, Prospect Hill, pictured around 1890, was forced to close at least one entire winter in 1882 due to cold and heating problems. (Courtesy Jack and Ann Regenhard.)

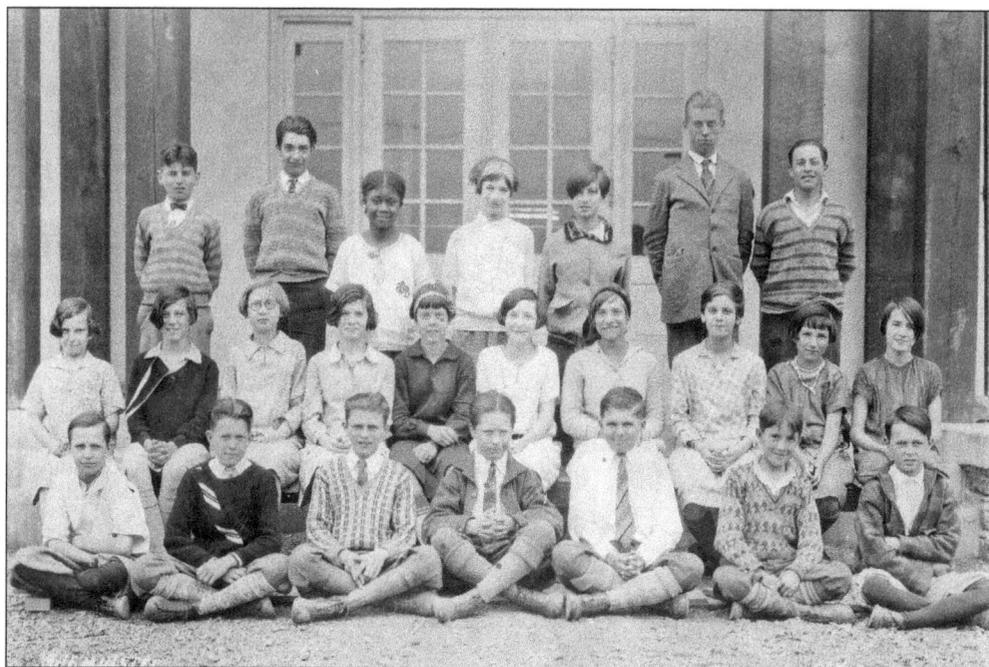

Warminster Elementary School was preceded by Oak Grove (1840), Willow Dale (1840), and Prospect Hill (1842). The 1871 *Bucks County Business Directory and Gazetteer* indicates the average monthly teacher salary was $35 and the school board president resided in "Horshamville." Students pose for a group photograph in 1928. By 1972, two rooms had been added and 198 students were enrolled. Today the building houses a daycare center. (Courtesy Centennial School District.)

Alvin Knight, a carpenter, bought this house in Johnsville on Newtown Road in March 1912. His new bride, Laura (née Conard), moved in upon their marriage on June 20, 1917, only four days before this photograph was taken. Laura is looking toward Street Road; the photograph perspective is looking north toward Bristol Road. (Courtesy Samuel Walker.)

Fourth-grade students in Elizabeth Duval's class at Centennial School around 1959 got hands-on experience feeding this baby goat. The animal was one of many pets raised by Elizabeth Duval's own children. Live lambs and silkworms, as well as dead horned toads and birds, all made it to the classroom for the children's inspection and enlightenment. (Courtesy Dr. Laure Duval.)

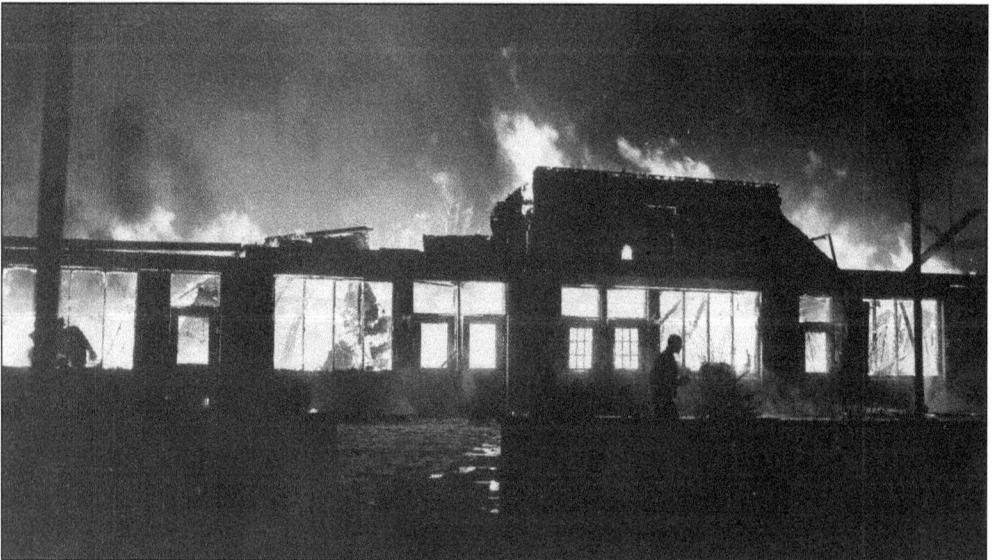

Life-threatening fires caused by arson, accidents, electrical malfunctions, and the like have always challenged Warminster's firefighters. Some of the most frustrating blazes are those that engulf wood-framed structures seemingly "built to burn," like the Old Country Village Shopping Center at Street Road and St. David's Avenue, seen here in August 1975. Rebuilt in a similar mode and renamed Tudor Square, it was later lost to yet another conflagration. (Courtesy Jim Krueger.)

# *Three*

# PROGRESS, GROWTH, AND CHANGE

A Federated Women's Club of Warminster committee chaired by present librarian Caroline Gallis opened Warminster's Free Library on Saturday, December 1, 1962, in a room of the first township building with 4,500 donated books and an equivalent amount in storage. Volunteer club members Kay Meissner (left) and Barbara Margraff (right), among others, catalogued books and were trained by librarian Alice Plotkin to maintain library services. The present facilities on Emma Road opened in 1977. (Courtesy Caroline Gallis.)

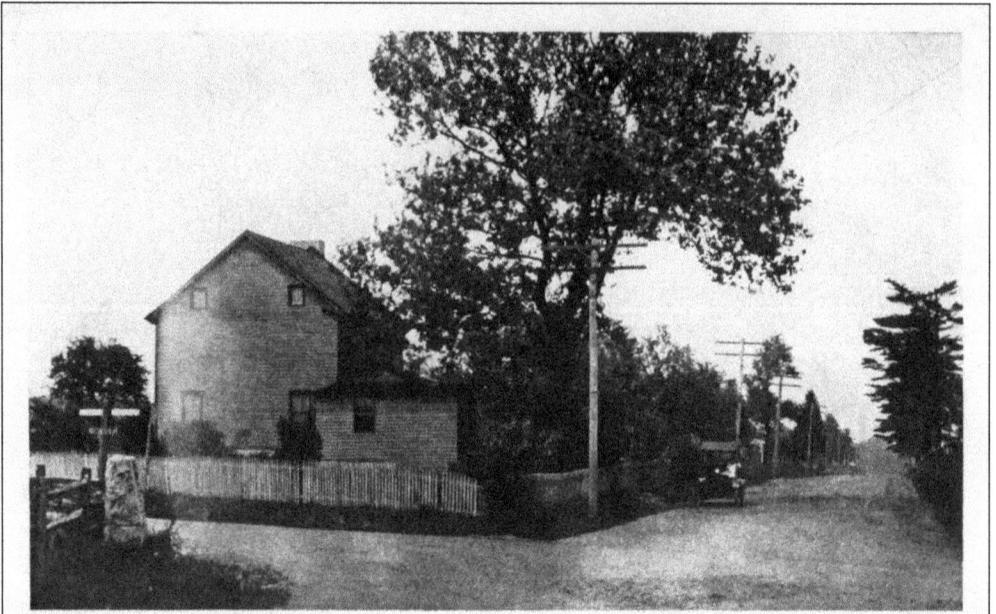

194. BUCKS COUNTY (P.A.) VIEWS
Chas. R. Arnold, Pub., Iuvland, Pa CORNER YORK AND STREET ROADS, WARMINSTER.
Memorial to John Fitch, inventor of the steamboat, at the left.

The early-20th century view above is looking north on York Road from below Street Road. The monument seen lower left (above) marks the general location where inventor John Fitch conceived his idea for steam-propelled transportation. Around this time (late 1700s), Thomas Beans owned the tavern (still operating) on the southwest corner of York. It was once the only public house in Warminster, and it was from here that he sponsored horse races on Street Road. The Fitch monument now stands on the northeast corner of the intersection at Hatboro Federal Savings building (below), located here since 1960. (Both, courtesy Jack and Ann Regenhard.)

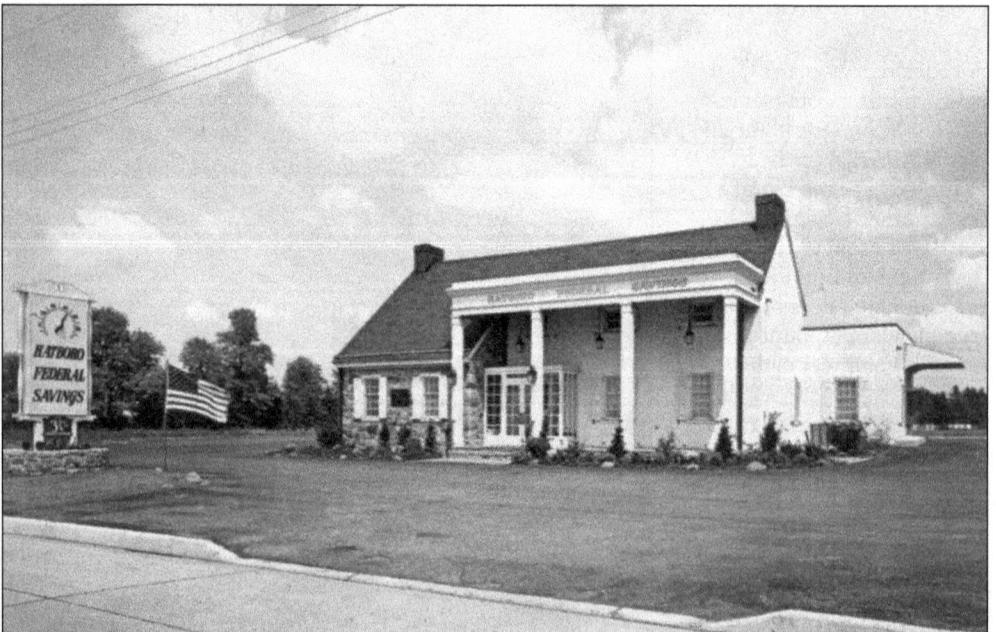

Before the days of moving to the city for work, family members traditionally stayed in the community. Here Alvin Knight and Laura Conard pose with a Model T Ford at the Conard farm in Johnsville during their courtship. One year later, following their marriage in June 1917, Laura moved into Alvin's home on Newtown Road directly across from that of her parents, Israel and Jennie. Her sister Sallie lived nearby after marrying another neighbor, Samuel C. Walker. (Courtesy Samuel Walker.)

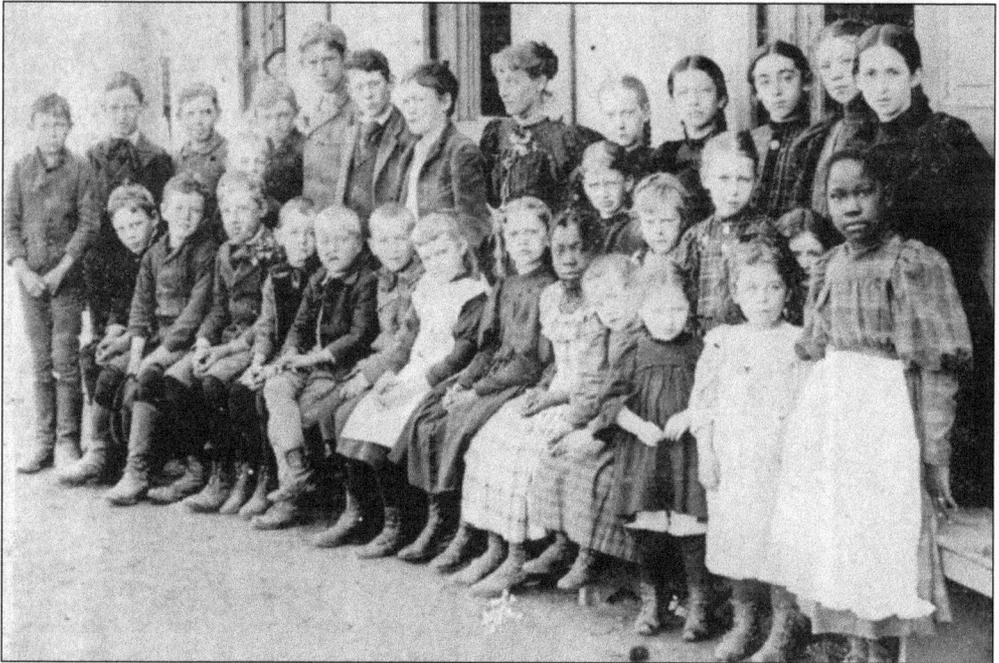

Legislation to ensure a free education for all Pennsylvania children was enacted in 1834. Six years later, Warminster Township opened two one-room schoolhouses, first Oak Grove, then Willow Dale. Above is the 1896 class of Willow Dale School located at Street and Norristown Roads. It was demolished in 1960 to widen Street Road. In 1970, Willow Dale Elementary was erected on Norristown Road. (Courtesy Beverly Blackway.)

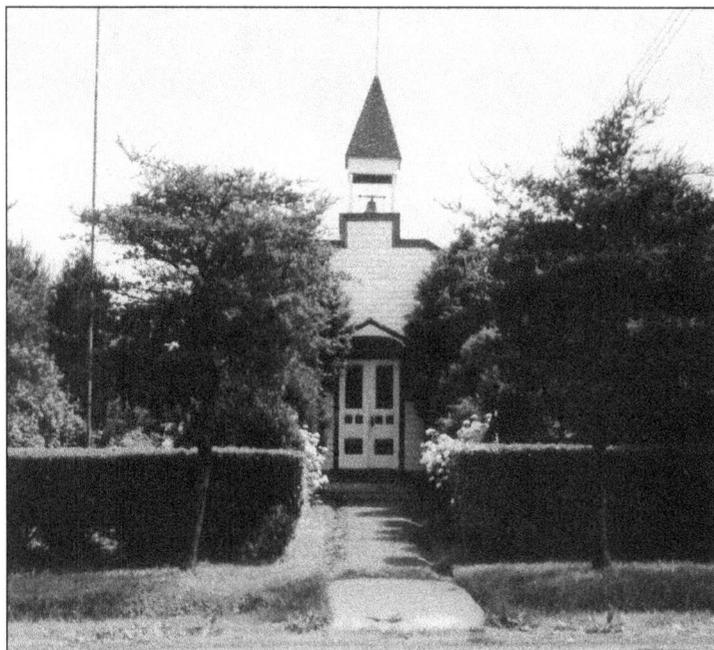

An influx of Catholics to Warminster after World War II increased demand for parishes. Volunteers built the Chapel of Our Lady of Perpetual Help (pictured), at Madison Avenue and Fir Street, in 1933 for approximately 32 families wishing to regularly attend Mass. In time, the Archdiocese opened St. John Bosco on County Line Road in 1953, followed by Nativity of Our Lord Church three years later. (Courtesy Nativity of Our Lord Church.)

After Nativity of Our Lord Church was established on new parish property at Street and York Roads in 1956, Mass was celebrated in the Carriage House Chapel Sanctuary (pictured). A new church-school building opened in 1958, when the area was still so rural some students were transported by horse-drawn carriages. On May 5, 1963, Mass was celebrated for the first time in the present church building, renovated in 2006 for the church's 50th anniversary. (Courtesy Nativity of Our Lord Church.)

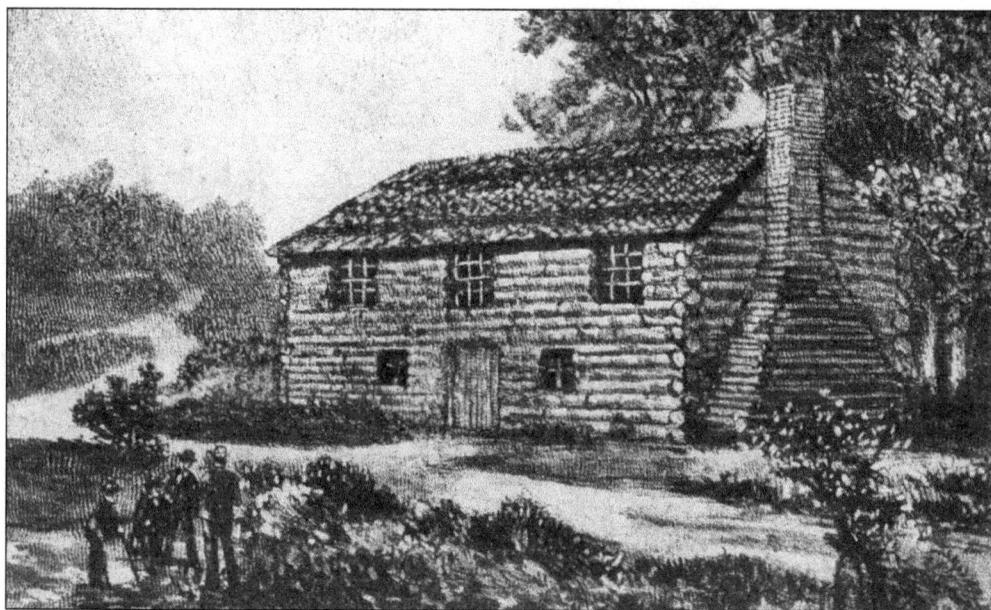

Following the building of Neshaminy-Warwick Church in 1727, Rev. William Tennent erected the renowned Log College on York Road, one of the first seminaries in America. Tennent, a fine classical scholar, taught theology, Hebrew, Latin, and Greek classics here until his death in 1746. The nation's earliest Presbyterian ministers, including Rev. Charles Beatty, a former peddler and longstanding preacher at Neshaminy-Warwick Church, were educated at the school before it closed 1746. A celebration including guest speaker Pres. Benjamin Harrison honored the school and its founder in 1889 to a crowd of 12,000–25,000 people. The 1889 drawing above was rendered from a description of an earlier image. The building's front-door key (below) was drawn by Millbrook Historical Society member Edward Price from a museum piece. A 1929 monument commemorates the site today and records 62 educational institutions tracing their origins to this humble academy, including Princeton University. (Above, courtesy Jack and Ann Regenhard; below, courtesy Edward Price.)

FRONT DOOR KEY TO THE LOG COLLEGE

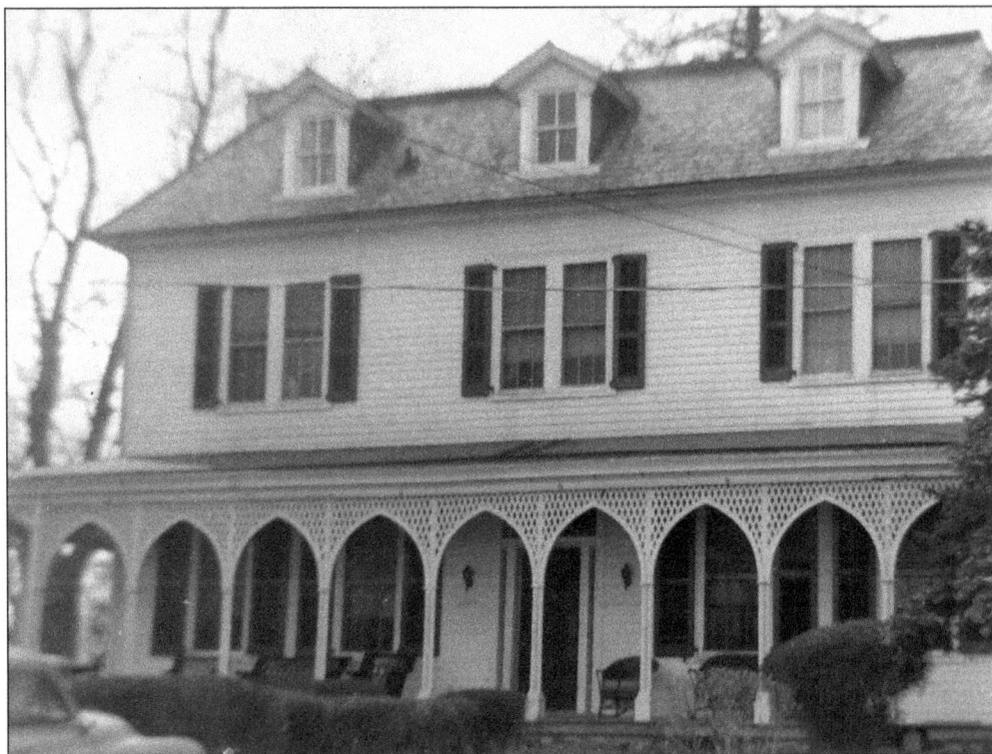

In the late 1820s, James Patriot Wilson (a minister and later Delaware's surveyor general) and son James renovated and erected buildings on their new Hartsville property. James Jr., future Delaware College president, opened a classical academy for boys around 1831 in the small building seen next to the family mansion below. From 1850 to 1863, the Roseland Female Seminary operated here before the property was purchased by prominent legislator Joseph Barnsley and his wife, Lydia, in 1870. It was mostly an inn during the 20th century. After the Roseland Inn (above), Duffy's Inn and Tavern (also known as Minnie Duffy's) operated here from 1950 to 1980. The Olivers purchased the York and Old York Roads landmark in 1982 and renamed it Hartsville Inn (below); it closed in 1997. Warminster native Keith Lock operated it as a haunted mansion for Halloween in 1999 before its demolition in 2004. A replica now stands in its place. (Above, courtesy Beverly Blackway; below, courtesy Diane Tangye.)

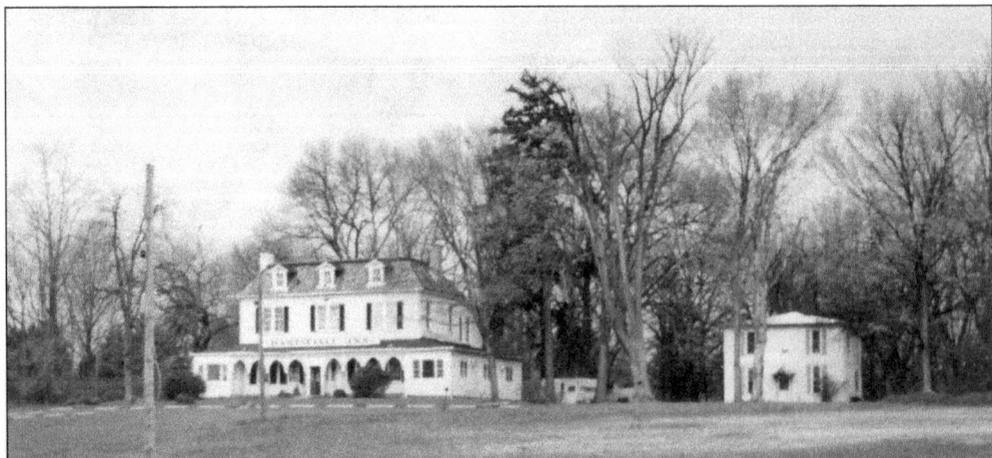

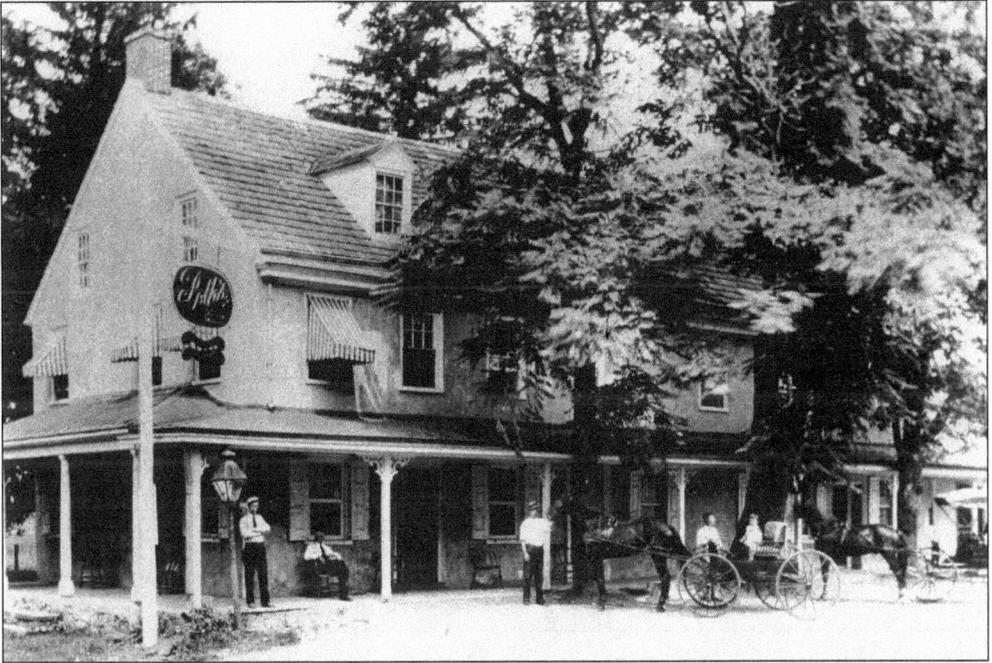

These two views show contrasting times for Hartsville Hotel, a tavern long popular with local residents lying on the Warwick side of Bristol Road at Old York Road. It began operating in 1744 under proprietor John Baldwin. As the main mail stage between Philadelphia and New York stopped and changed horses here, Benjamin Franklin may have visited several times when serving as postmaster general. Col. William Hart, Revolutionary War veteran, county commissioner, and nemesis of the Doan outlaws, was proprietor from 1780 to 1817. Just before Prohibition began in 1920, beer could be purchased here for 10¢ per glass and "fancy" drinks for 25–50¢. Before the building was demolished in 1965, local resident Elmer Rinck salvaged the well seen at right below, although its whereabouts are unknown. Rick Parker's station now sits on the site of this former community anchor. (Above, courtesy Rick Parker, Inc.; below, courtesy Beverly Blackway.)

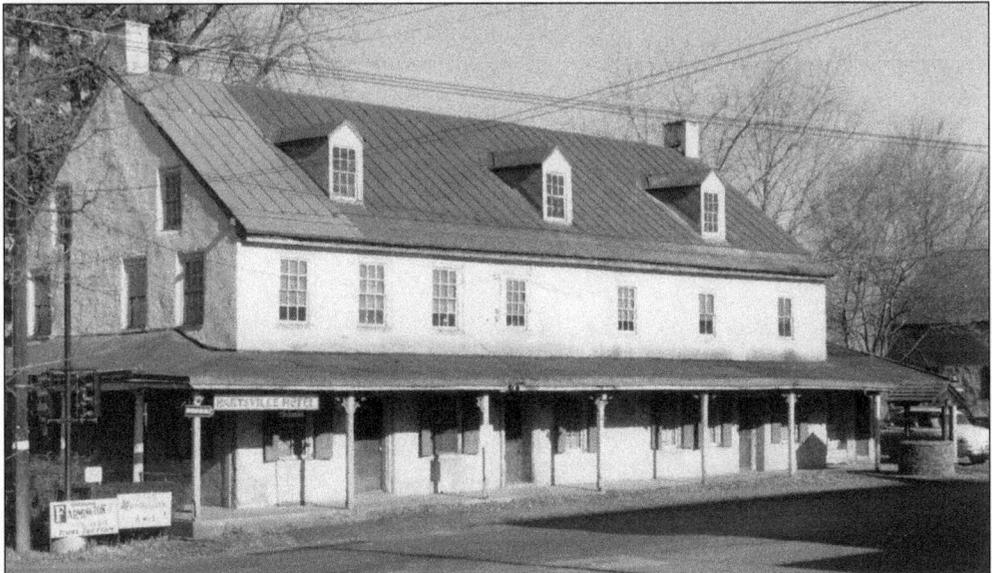

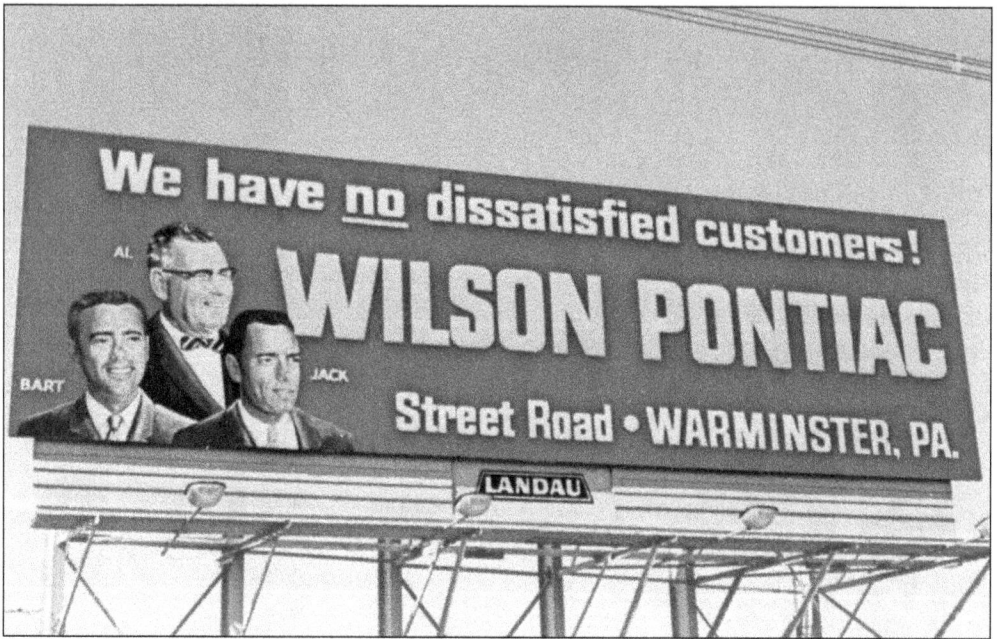

Lafferty Chevrolet had little competition in the used car trade until Al Wilson relocated his Pontiac dealership (billboard above) from Hatboro to Warminster in the mid-20th century. Wilson's 8 acres of automobiles (partial lot shown below) was located on Street Road next to Nativity of Our Lord Elementary School. Nativity of Our Lord Church is seen behind the school building. The home seen in the rear on the right is the rectory, located on what was once the Todd property. Here local recruits during World War I trained in the fields under army officer George Ross. Archbishop Wood High School was built on the other side of the trees seen at left. Al's sons, Bart and Jack, eventually sold the business to the Brandow Agency. (Both, courtesy Jack and Ann Regenhard.)

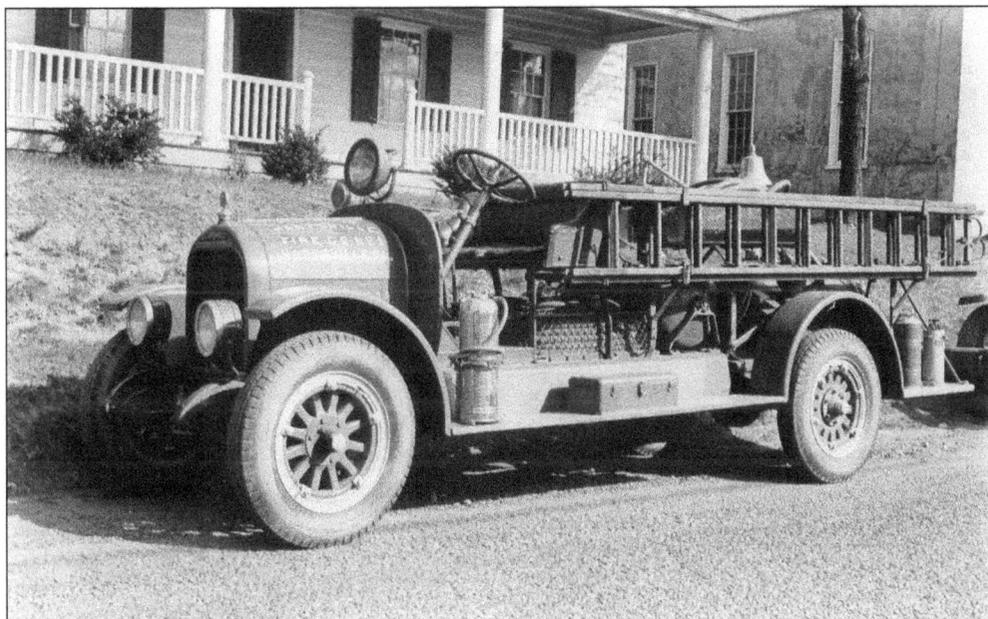

The Hartsville Fire Company began in 1924 with a Model T Ford chemical truck donated by the Jamison Fire Company (stored for years in the stable adjacent to the Hartsville Hotel after retirement). The department soon purchased the 1924 Brockway LaFrance fire truck (above) for $3,600 with the help of their Ladies Auxiliary, fund-raising suppers, and memberships at $2 per household. Unfortunately this truck had limited capabilities, as its two tanks of soda acid had to be hand-cranked to build pressure and were quickly emptied. A used 1925 White Hahn pumper (below) offered improved features over the Brockway and was acquired in 1939. It pumped a continuous supply of water from its source, usually a pond or stream, carried more life-saving equipment, and had better lighting. The old lyceum in the rear served as the company's firehouse from 1927 to 1971. (Both, courtesy Hartsville Fire Company.)

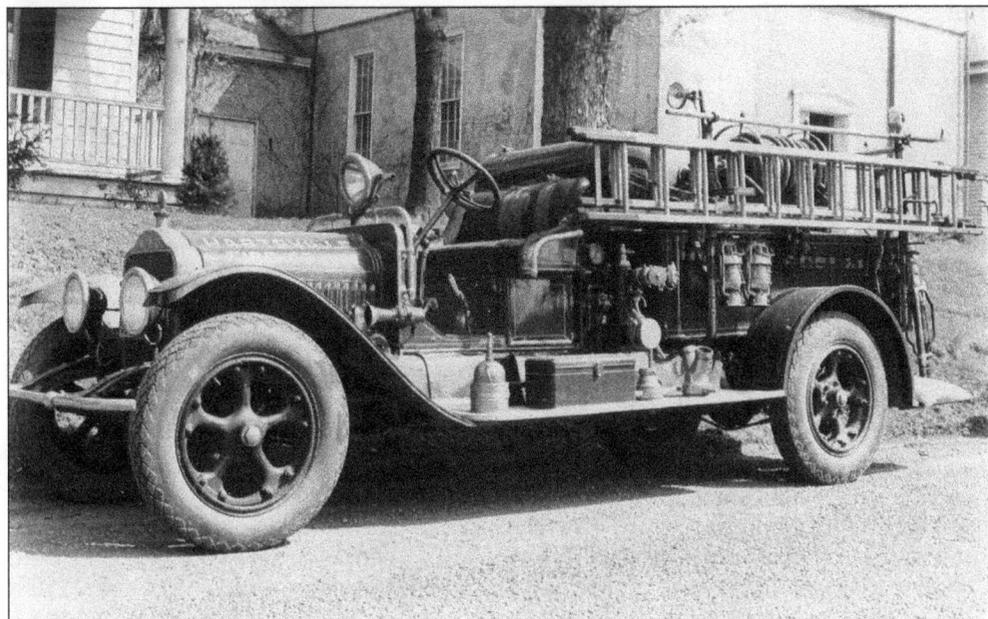

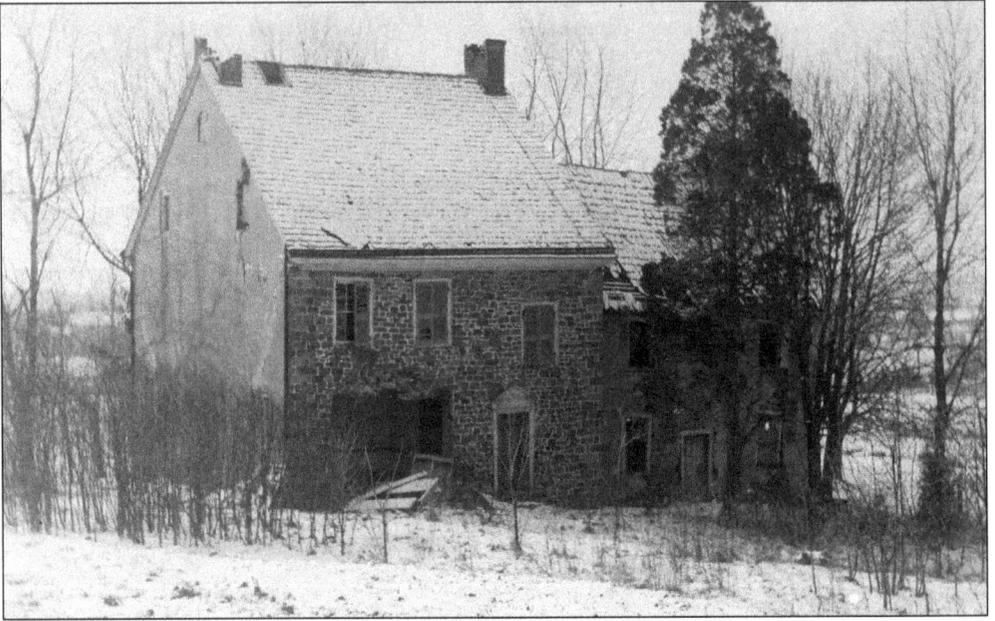

This house stood on the Comly Bennett property just off Centennial Road in Johnsville not far from where the Abington Health Center's Warminster campus is located today. The farmhouse had incredible views of what had once been gorgeous countryside. According to Sam Walker's recollection, it had been abandoned since at least the early 1930s. (Courtesy Samuel Walker.)

This helipad was one of many advanced services provided by Warminster General Hospital (WGH), the first hospital in Pennsylvania to acquire a full-body CAT scanner. It was also the first hospital in Bucks County to establish a Medical Detoxification Unit and a Mental Health Unit. Service to the community has been a hallmark of this facility, now the Abington Health Center's Warminster campus, for 35 years. (Courtesy Abington Memorial Hospital.)

Warminster General Hospital (above) opened on May 8, 1974, with 140 beds, 125 medical doctors, and advanced equipment, such as intercoms and closed-circuit television systems linked to nurses' stations. Progressive from the beginning, the institution quickly became accredited by the Joint Commission on Accreditation of Hospitals in recognition of its advanced standards of care. Today, as the Abington Health Center–Warminster Campus, it provides extensive outpatient services as well as an inpatient hospice unit. The farmland pictured in the photograph below is the site of Warminster Hospital before construction of the facility. (Above, courtesy Abington Memorial Hospital; below, courtesy Beverly Blackway.)

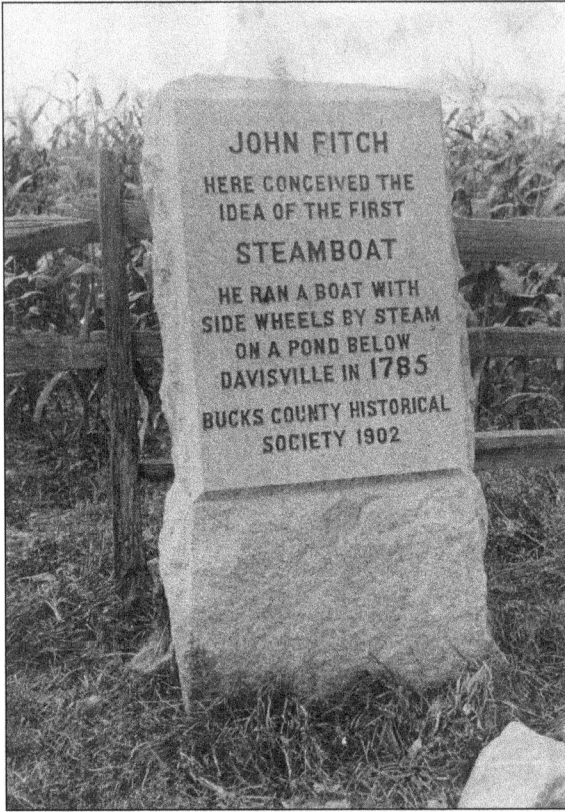

Mason John Fitch—whose background includes having been a clock and watchmaker, silversmith, peddler, army lieutenant, gun maker, surveyor, mapmaker, engraver, and 18th-century adventurer (during his travels he was held prisoner by both Native Americans and the British)—invented the world's first commercial passenger steamboat. His idea for a steam-driven conveyance came to him when a couple in a horse-drawn "riding chair" quickly passed him on Street Road as he was "limping along," hobbled by rheumatism. (Courtesy Jack and Ann Regenhard.)

The original William Tennent High School (pictured here under construction) at Newtown and Street Roads welcomed 900 juniors and seniors upon opening in 1955. Besides a general education curriculum, boys took graphic arts, metal, or woodworking classes, while girls took typing, shorthand, and homemaking. Population increases led to an additional senior high school opening in 1973 next to Johnsville Elementary. It included a large gymnasium, fine arts center, and driver education range. The school pictured was demolished in 1989. (Courtesy Beverly Blackway.)

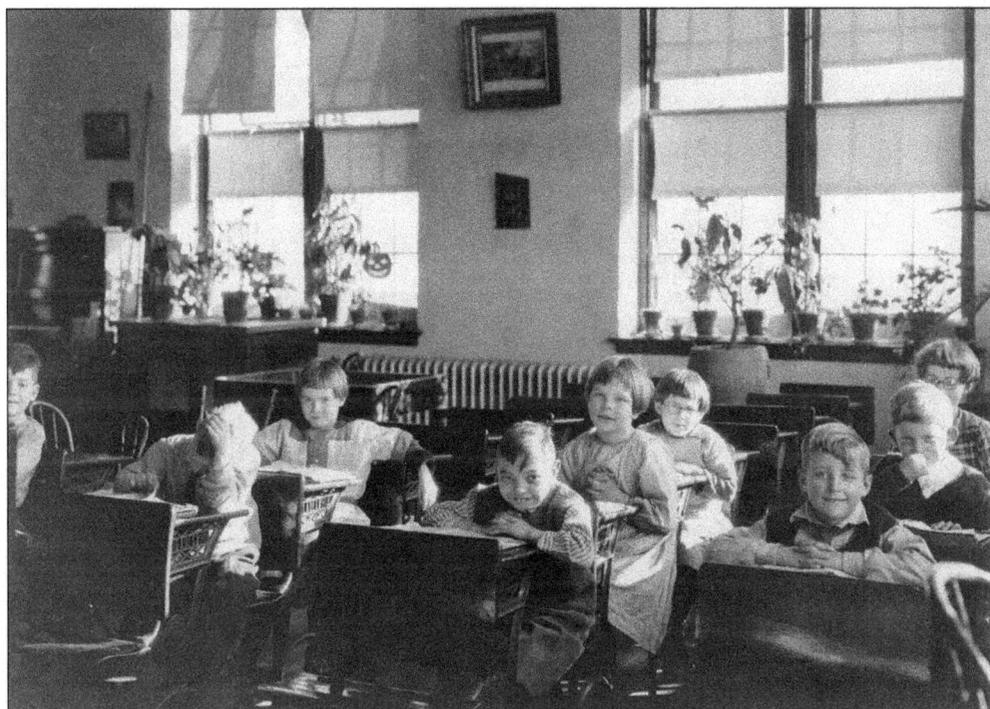

These children enjoyed attending their new school, a two-story building erected on Christ's Home for Children property in 1923. An elementary curriculum was taught for grades one through eight. In addition, girls learned cooking, sewing, and clerical skills, while the boys learned a trade such as shoemaking, carpentry, and printing. Today the building is under renovation for future program use. (Courtesy of Christ's Home.)

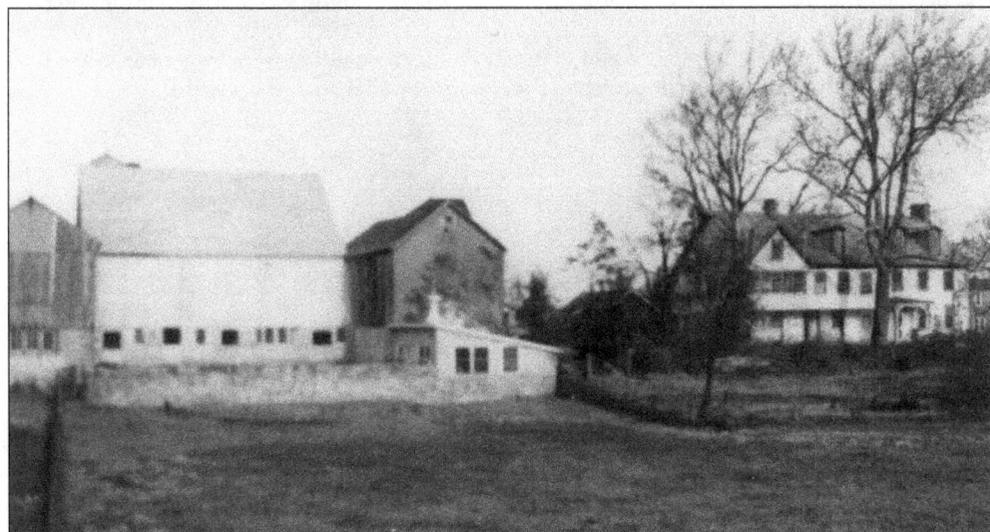

Charles and Elizabeth Kirk, unhappy their young son's friends assembled at their Abington home whenever they went out, subsequently purchased this 119-acre Hart farm in 1840. Charles described it as "desirable . . . with good buildings, a fair proportion of timber, and in a good neighborhood." The navy acquired the property in 1944, creating "Quarters A," home to a succession of commanders. It now serves Gilda's Club, a cancer support community. (Courtesy Douglas Crompton.)

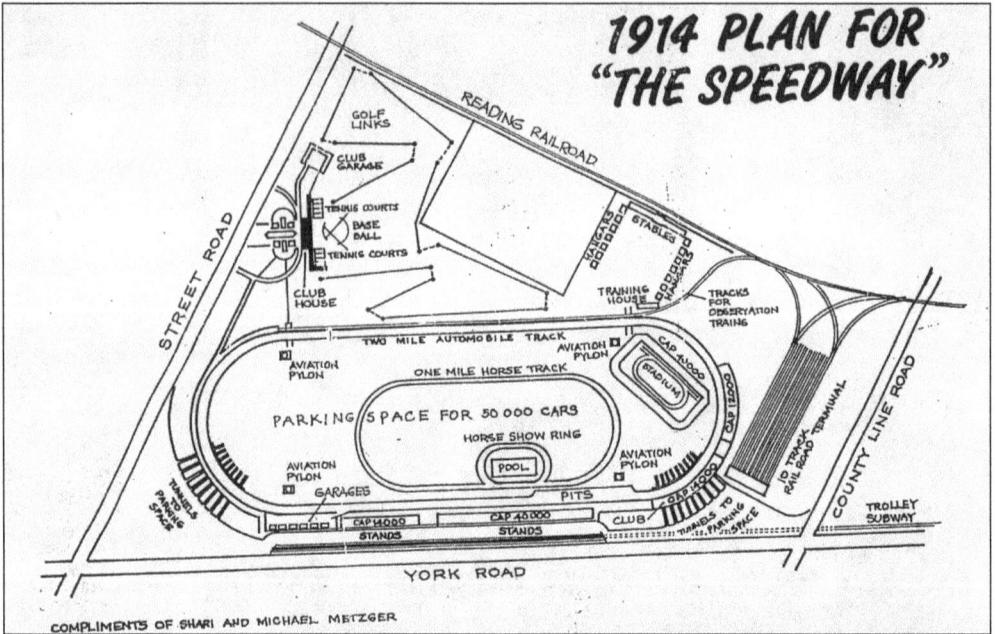

1914 PLAN FOR "THE SPEEDWAY"

COMPLIMENTS OF SHARI AND MICHAEL METZGER

Capitalizing on its ease of access, beauty of surroundings, and proximity to popular Willow Grove Amusement Park, Warminster was selected by prominent investors for America's second motor speedway. For $250 each, 4,000 life members were given grandstand seats and parking rights, plus athletic and social club access. In 1915, ground was broken for a massive complex (above) featuring a wooden two-mile automobile racecourse with highly banked ends (below) and 60,000 viewing seats. The Speedway enterprise would potentially include a horseracing track and show ring, tennis court, golf course, gun club, swimming pool, aviation field for air shows and training, and deemed the "most attractive" feature by a newspaper, a country club within 40 minutes of Philadelphia's city hall. Despite a "whirlwind campaign for members," an opening date of October 7, 1916, failed to materialize. Labor and material problems resulting from America's entry into World War I ultimately killed the project. (Both, courtesy Charles L. Hower II.)

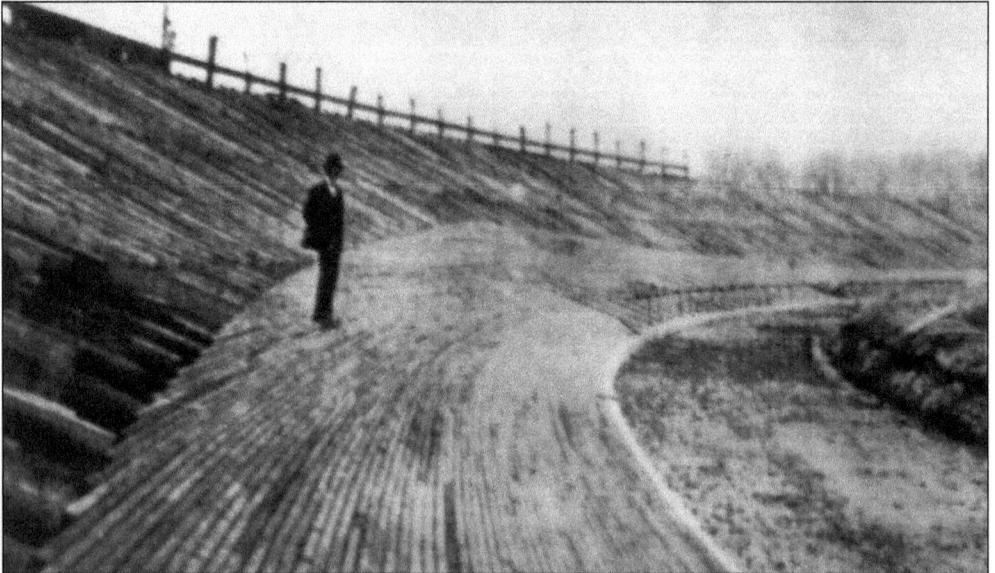

Charles Leonard Hower Sr. (foreground) was treasurer and secretary for the Philadelphia Motor Speedway Association, developers of a massive project thwarted by World War I when labor costs skyrocketed and materials were limited. After the Speedway failed to materialize, Hower purchased the entire tract to build the Speedway housing development. He and his son Robert (pictured above) sold 25-feet-by-140-feet Speedway lots for $18 and up directly to the public under their Club Plan—one dollar down and another dollar per week. The Speedway development included 4,000 homes bordered by County Line Road, Street Road, York Road, and the Reading Railroad. The 1925 lot plan below shows unsold lots (unshaded); note the racecourse outline. Smaller Greenbrier lots, west of York Road, offered water and electricity. Both developments provided "hard roads," and between them 3,000 lots were sold by 1925. (Both, courtesy Charles L. Hower II.)

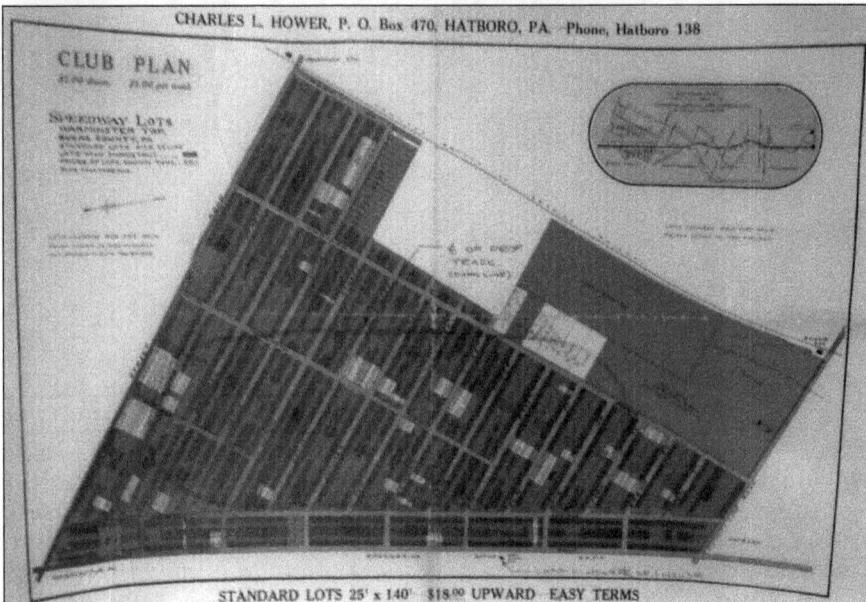

Five years after a new $17,000 Oldsmobile ambulance was purchased in 1968, Warminster's Central Engine House celebrated acquisition of two new Imperial Pumpers, including the one shown here, with a parade and dedication event. Today the engines at Warminster's three firehouses (East, West, and Central) are supplemented by advanced equipment, including hydraulic rescue tools, thermal imaging cameras, automated external defibrillators, self-contained breathing apparatuses, and water/ice rescue equipment. (Courtesy Jack and Ann Regenhard.)

Ice hockey fever shook the region following the Philadelphia Flyers' reign as Stanley Cup champions from 1973 to 1975. Locals were understandably excited when team member Bill Flett (left) and renowned goaltender Bernie Parent (second from left) participated in the ground breaking of Face-Off Circle, a new ice-skating rink on York Road. They are seen here at the construction site around 1975. Public skating, ice-skating lessons, ice hockey, and celebratory events continue here today. (Courtesy Diane Tangye.)

Lydia Klimek, the first female firefighter with the Hartsville Fire Company, was one of perhaps only 300 women nationwide in the profession when this photograph was taken in 1979. Female firefighters were such a new phenomenon that the U.S. Fire Administration convened a seminar on the subject in Maryland that same year. Klimek was photographed at a December 21 event with Russ Klieman, fire chief from 1944 to 1954. (Courtesy Hartsville Fire Company.)

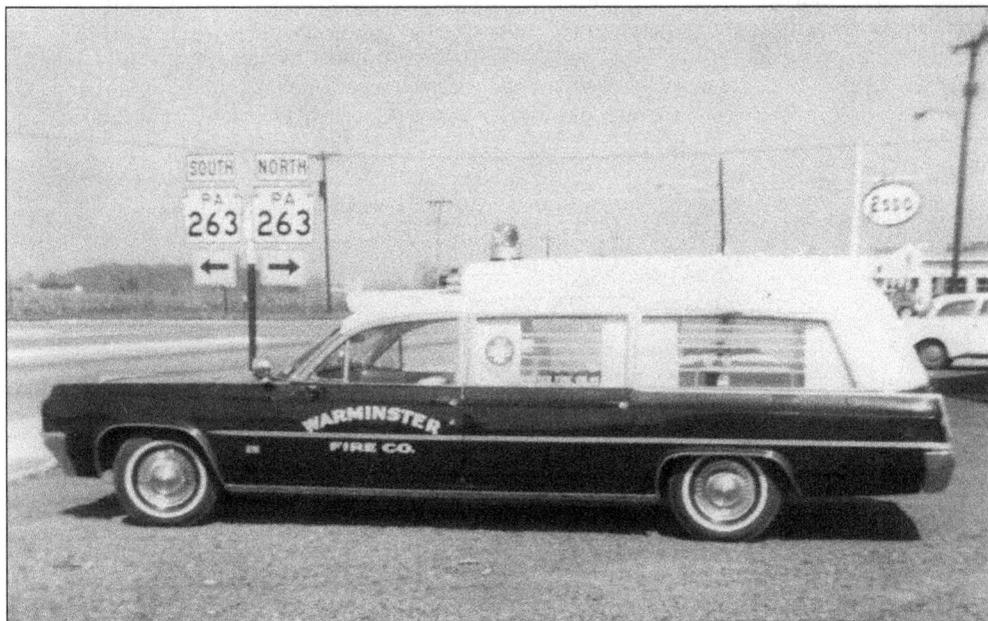

After much debate within Warminster's Fire Company, $500 was finally appropriated to purchase this secondhand ambulance. Capt. Albert Beyer managed the first ambulance crew and took emergency calls in his home, as did then township manager and funeral home owner Burton Decker. Around 5:00 a.m. the morning after the ambulance's first official appearance (at the 1961 Memorial Day Parade) it picked up its first customer—a pregnant woman in the throes of labor. (Courtesy Jim Krueger.)

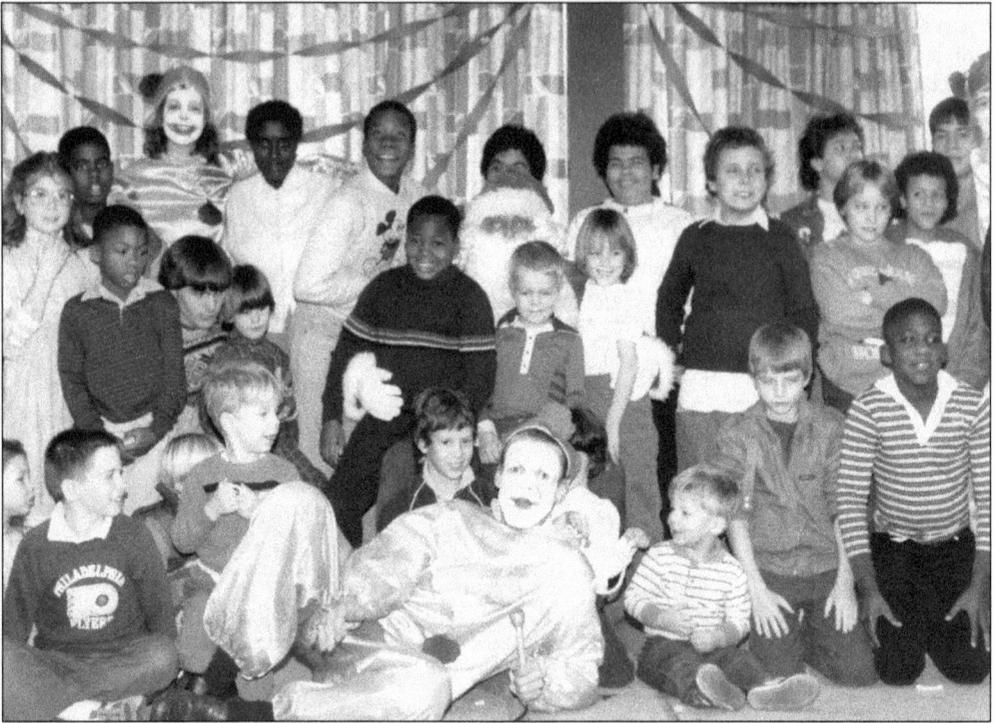

Children from Christ's Home of Warminster and Bethanna Home of Southampton excitedly attended the annual Christmas party given for them by the NADC personnel. The event began in the 1950s and was funded by employee contributions. Entertainment included animal acts, jugglers, clowns, puppet shows, and music, and each child received a personal gift from Santa. Employee Mike Cannon (front) donned a clown suit for this party. (Courtesy Douglas Crompton.)

This brick house (with basement and two-car garage) was one of several erected around 1941 along Street Road by family and friends who operated the Davisville Hosiery Mill. Freimut Viehweger, who became a planning commission member and developer of the Davisville Shopping Center in the 1950s, lived in this home with his family. Neighbors were relatives, friends, and their families, who comprised the entire block. (Courtesy Jean Rice.)

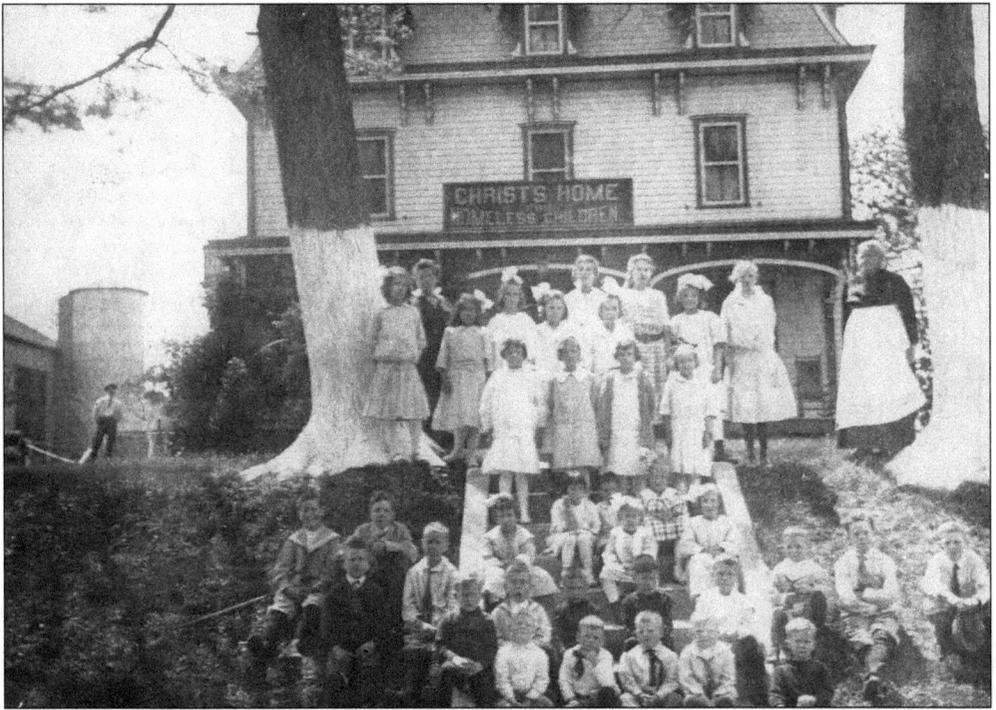

In 1907, Christ's Home began relocating children from their Philadelphia facility to the recently purchased Carrell farm in Warminster. Although the building pictured housed only boys, a girls' dorm was opened the following year. A complex of cottages and apartments for children ranging from newborns to 18 years of age has since replaced both buildings. Dedicated house parents using the Teaching Family Model provide all the care. (Courtesy Christ's Home.)

It is hard to believe this sleepy dirt road with roaming chickens is the same congested Street Road residents know today. The view looking west shows Craven Hall on the left and Walton's general store, which also housed the post office, across the street behind the hitching post. Today this intersection encompasses a five-lane highway and a traffic light. (Courtesy Samuel Walker.)

# The Steam-Boat

IS now ready to take Paffengers, and is intended to
   fet off from Arch ftreet Ferry in Philadelphia eve-
ry *Monday, Wednefday* and *Friday,* for *Burlington,
Briftol. Bordentown* and *Trenton,* to return on *Tuefdays,
Thurfdays* and *Saturdays*—Price for Paffengers, 2/6 to
Burlington and Briftol, 3/9 to Bordentown, 5f. to
Trenton.                                    June 14.   tu.th ftf

After testing his idea on a Davisville pond, John Fitch launched the world's first successful steam-propelled freight and passenger vessel. During the summer of 1790, his steamboat business (advertisement above) conducted at least 30 trips between Philadelphia, Trenton, and other riverside towns within 30 miles, accumulating an estimated 2,000–3,000 miles. A patent drawing of his successful steamboat is below. To compete with stagecoaches, Fitch charged less and offered free beer, sausages, and rum. Despite a party-like atmosphere, he lost money on each trip and, consequently, his investors. Lack of financing ended his endeavor at the end of the season. Seemingly beset by troubles throughout his life, Fitch ultimately died a bitter, broken man in 1798 at age 55. (Both, courtesy John Fitch Museum.)

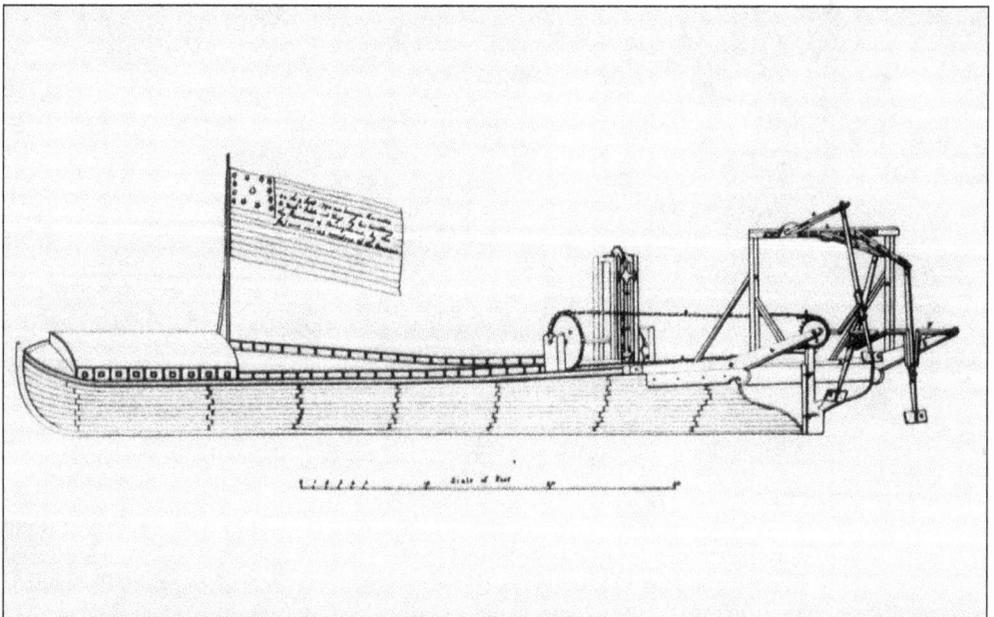

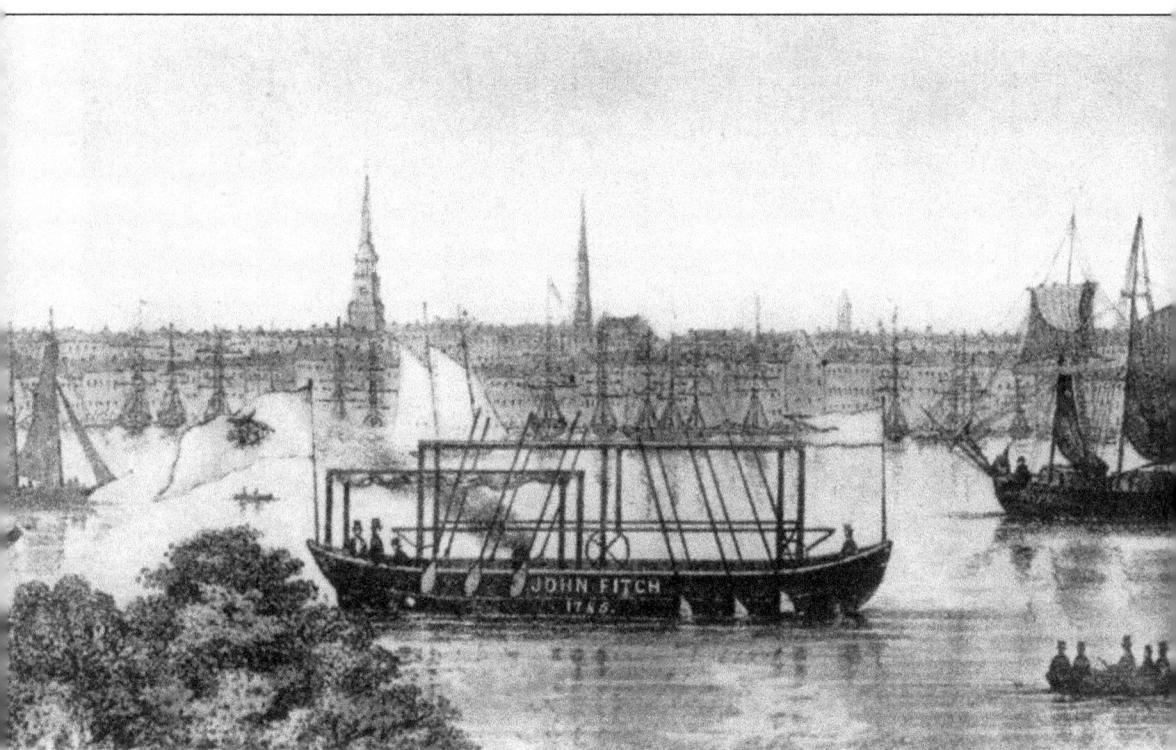

JOHN FITCH'S STEAMBOAT AT PHILADELPHIA

After building his model at Cobe Scout's "log shop" in Warminster, John Fitch demonstrated the world's first successful passenger steamboat by taking some Constitutional Convention delegates on a Delaware River cruise on August 22, 1787. His steamboat traveled up to 8 miles per hour against the current, twice the speed Robert Fulton's boat achieved 16 years later. This image is an early artist's conception of the boat Fitch used in his demonstration. (Courtesy of the John Fitch Museum.)

Otto Viehweger Sr. arrived from Germany in 1920. In time, he began the Davisville Hosiery Mill, Inc. and employed family members and friends in the manufacture of DaVille nylons. The building (which now houses CW Industries) was located on Davisville Road. In the mid-1950s, when seamless stockings became unfashionable, brand sales declined. Otto Jr.'s sons Freimut and Gerhard, his brother Herbert, and assorted friends then formed a new corporation, Davisville Center, Inc. They built the Davisville Shopping Center and were significant contributors to Warminster's growth and development. Pictured from left to right are Otto Jr.'s brother Rudolf, wife Lina, mother Lina, father Otto Sr., and brother-in-law Rudolf Bach. (Both, courtesy Jean Rice.)

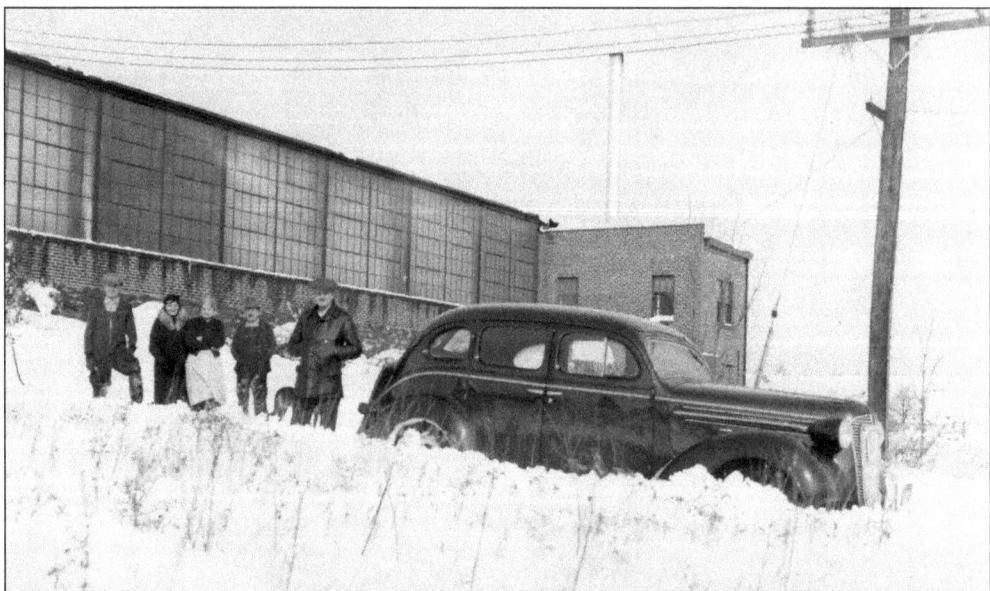

Warminster police officers (1966–1967) formally pose in uniforms undergoing radical change. Knee-high boots had just been eliminated. Soon the uncomfortable Stetson hats—a real challenge to an arresting officer on a windy day—would go as well. Chief Paul Brennan sits at the center of the first row, while future detective and highway safety officer Clarke Tangye stands in the third row, fourth from left. (Courtesy Diane Tangye.)

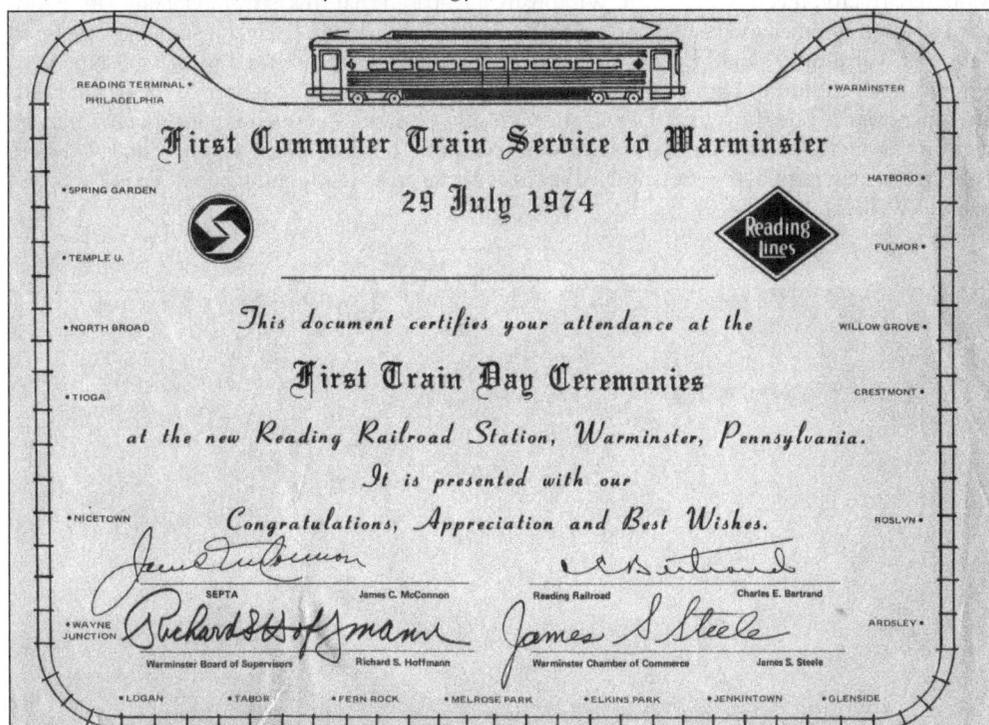

First Commuter Train Service to Warminster

29 July 1974

This document certifies your attendance at the

First Train Day Ceremonies

at the new Reading Railroad Station, Warminster, Pennsylvania.

It is presented with our

Congratulations, Appreciation and Best Wishes.

A public official ceremoniously drove one golden spike into a newly laid train track in the spring of 1972 to launch construction of the first U.S. rail extension in 40 years. Warminster's train station and 1.8 miles of electric track subsequently opened from Hatboro to Warminster in July 1974. Commuters were especially delighted with the 310-car lot, a luxury missing at the Hatboro station. Participants at opening-day ceremonies received this commemorative certificate. (Courtesy Diane Tangye.)

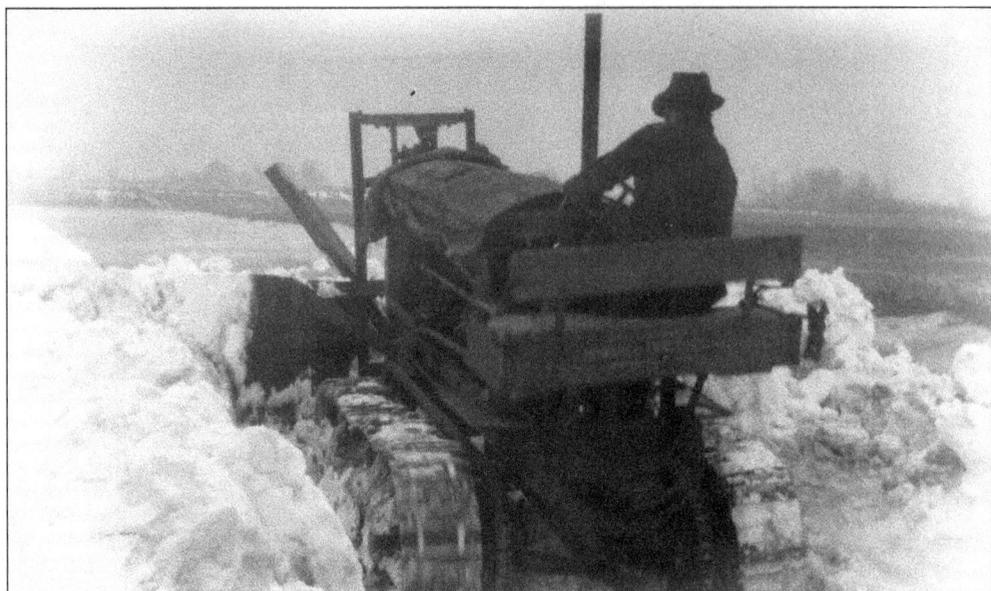

Monarch Tractor, Inc. of Watertown, Wisconsin, advertised that this early model (above) "builds good roads in summer and keeps them open in winter." The Monarch Tractor snowplow pictured here was Warminster's first. Previously, farmers, local citizenry, and hired workers—some with legs wrapped in burlap bags tied with twine for warmth—came together to clear the roads after a snowfall. The shovel marks and snow chunks deposited by such laboring crews may be seen in the image below taken on Newtown Road. The horses pulling a wood-filled sled were photographed in front of the present-day Blackway home, in a view looking north. (Both, courtesy Samuel Walker.)

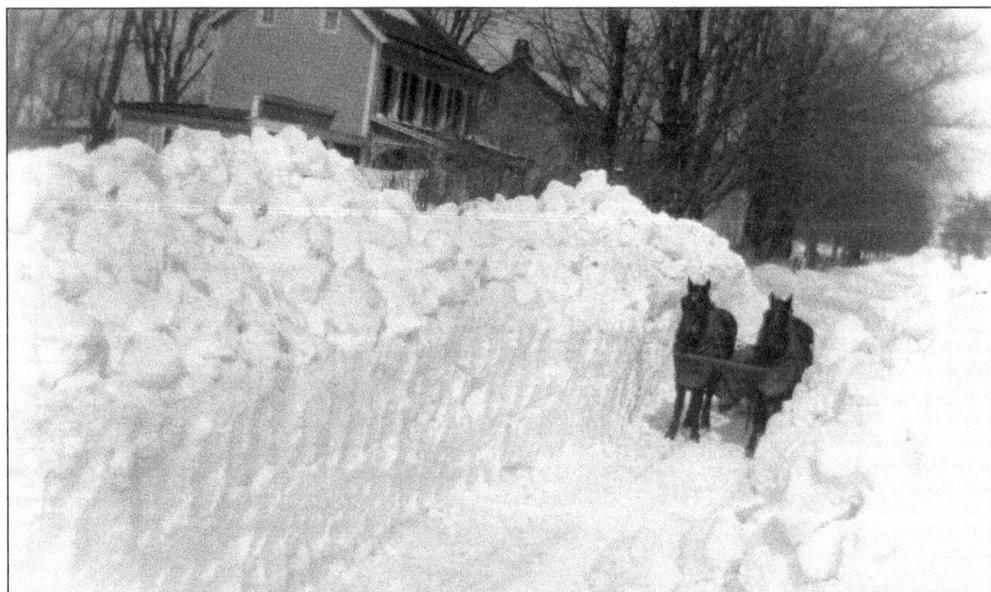

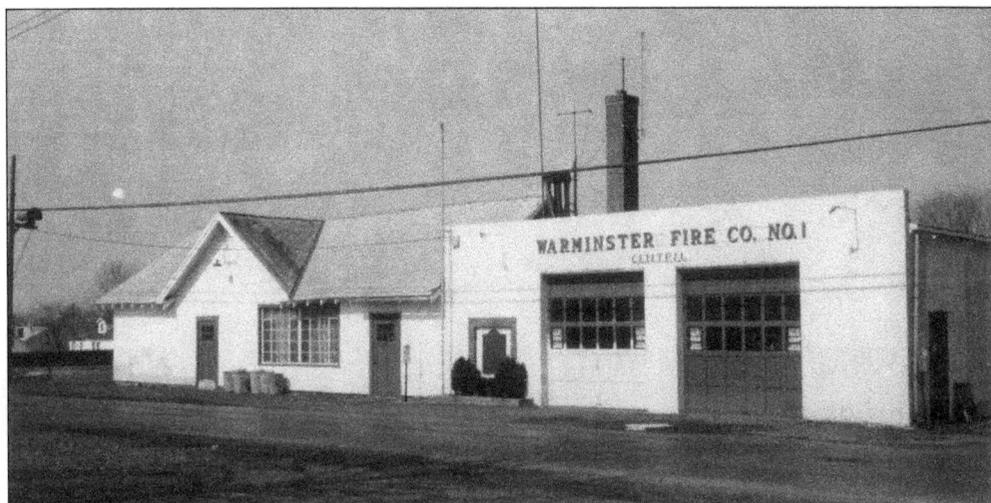

After residents tried to bring a disastrous fire under control in 1927 with buckets and garden hoses at the Tressider home, which burnt to the ground, the first Warminster Fire Company was formed. The Central firehouse at Madison Avenue is seen above around 1948 before the wood section (left) was razed for a new fire station and catering hall. Later, Hartsville, Lacey Park, and West End fire units were created to serve the expanding community. In 1973, the Madison Avenue firehouse was replaced by a five-bay station on the same site. Below is a 1959 photograph of Central Warminster Fire Company members: (from left to right) firefighters Joe Knox and Ralph Kirk, officer John Fallenstein, outgoing chief Fred Kreuzberg, John Pilawski, and fire policemen Capt. Ben Winans and John Lindenmuth. Seen at right is a World War II bronze memorial plaque now located in Warminster's township building. (Both, courtesy Jim Krueger.)

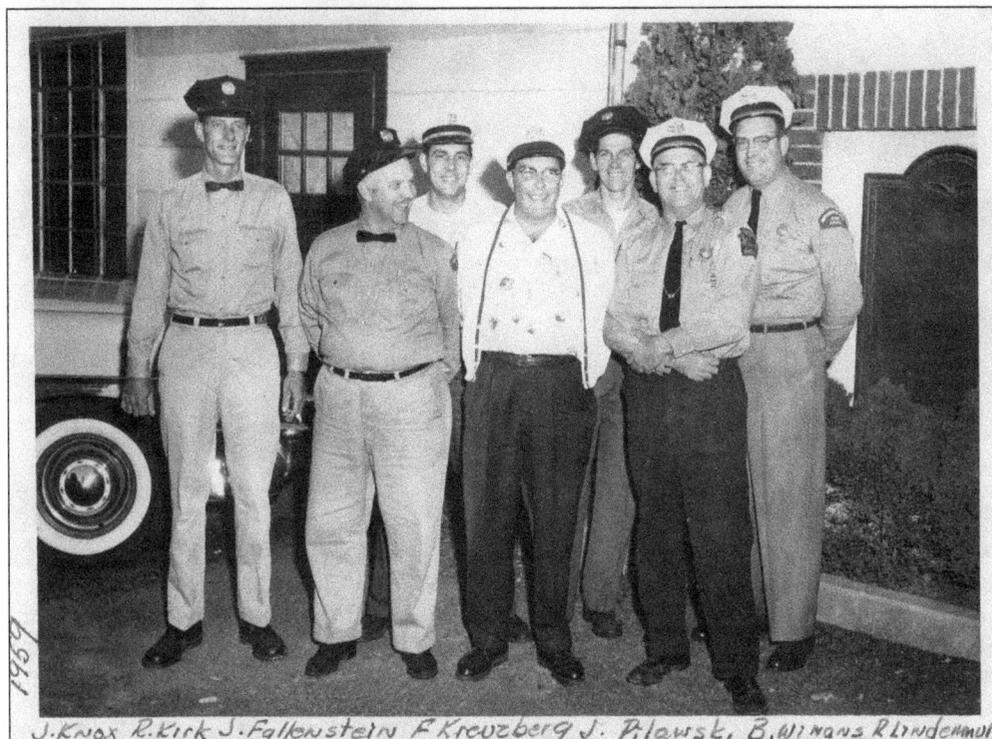

J.Knox  R.Kirk  J.Fallenstein  F.Kreuzberg  J. Pilawski  B.Winans  R.Lindenmuth

The Rorers, previous store owners, built this small general store on Street Road in Johnsville in 1944. Many residents appreciated being able to shop locally rather than having to travel to Hatboro for groceries. Anna Rorer was postmistress here until August 31, 1959, when the postal branch was discontinued and optional door-to-door delivery began. Mailboxes were relocated to the Clock Tire Mart until February 27, 1965, when this contract branch and the last 15 boxes were closed. (Courtesy Beverly Blackway.)

Erik Fleischer, original member and current president of Craven Hall Historical Society, Inc. (established in 1977), estimates 15,000–20,000 hours of volunteer sweat equity has gone into saving Craven Hall. Over 90 percent of all funding to support restoration of this historic home at Street and Newtown Roads has come from small donations and individual contributions. Colonial cooking demonstrations are now conducted using the centuries-old fireplace seen here undergoing restoration. (Courtesy CHHS, Inc.)

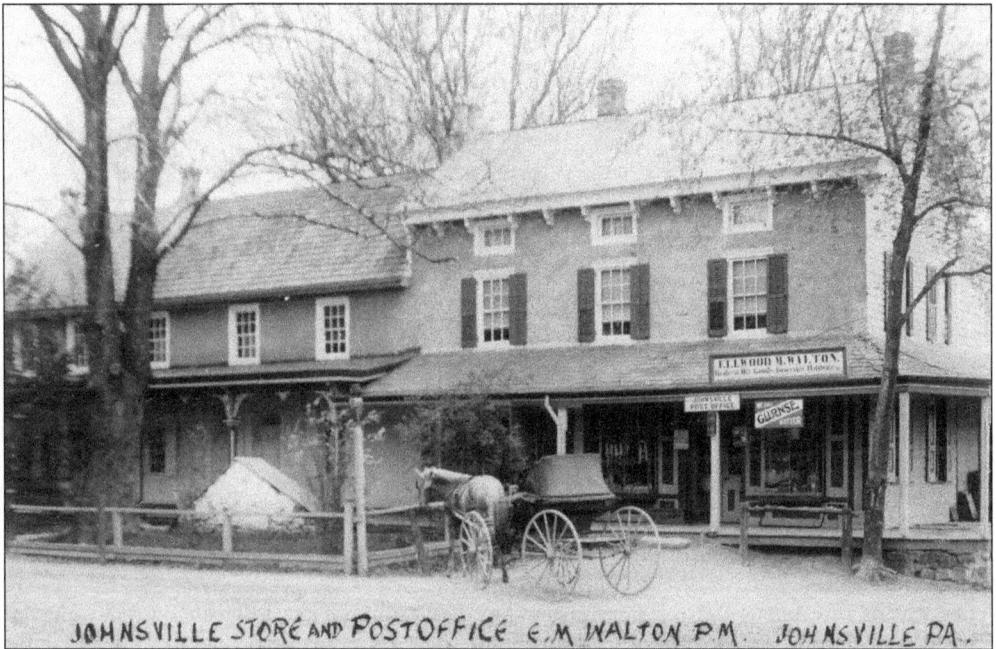

JOHNSVILLE STORE AND POSTOFFICE E.M WALTON P.M. JOHNSVILLE PA.

James Craven built a "store-house" for son John in 1814 on the southwest corner of Street and Newtown Roads "on the only corner not covered with native forest trees." The vicinity quickly became known as Johnsville. Mr. and Mrs. Lewis Walton and, later, son Elwood, operated the dry goods, grocery, and hardware store and post office seen above in the late 1800s. When the 12-room building was demolished for road improvement in 1944, then owners Harold and Elizabeth Rorer built a smaller facility behind it facing Street Road. After their deaths, Harold's sister Anna operated the business until 1959, completing 30 years of family management. The Rorer's home, seen at left in the image below around 1942, later housed apartments and several businesses. The last owner, an Oldsmobile dealer, had the historic landmark bulldozed in 1978 to improve the visibility of his adjacent car lot. (Above, courtesy Jack and Ann Regenhard; below, courtesy CHHS, Inc.)

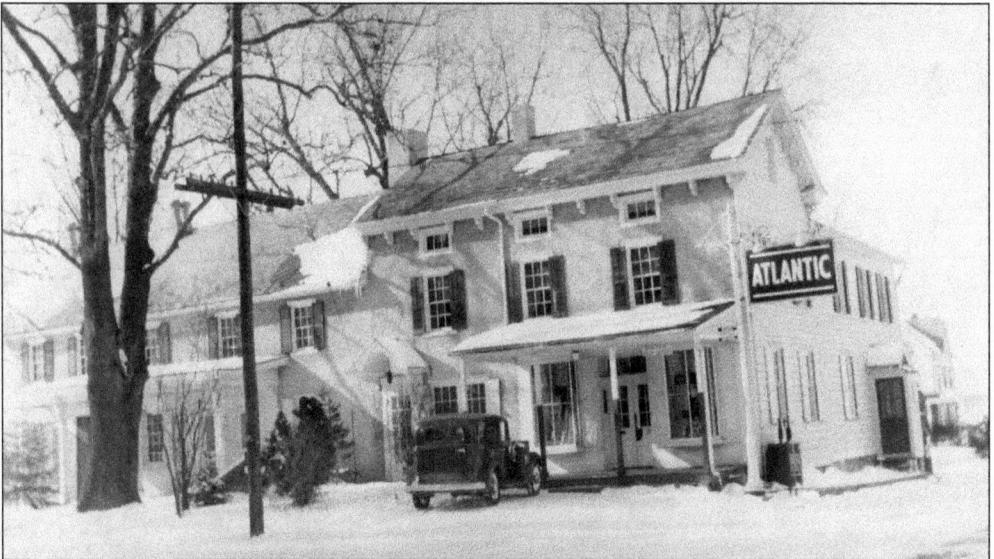

The Cravens were among Warminster's earliest landowners. In the late 18th century, Giles Craven set aside a small graveyard (see Arnold postcard above when known as Vansant graveyard) for family, friends, and neighbors. In the 1960s (below), it began deteriorating from neglect and vandalism. A 1971 *Today's Spirit* article by Beverly Blackway about two concerned 10-year-old boys prompted community action. Elementary and high school students, under school administration leadership, led various cleanup and restoration efforts over the next decade. Andrew Zellers-Frederick facilitated placement by the Veterans Administration of 12 headstones for Revolutionary and Civil War veteran graves. Craven Hall Historical Society, Inc. now owns and maintains the graveyard and preserves remnants of markers destroyed in the 1960s for future restoration. Today a trace of the old wagon path from Newtown (formerly Johnsville) Road is still visible. (Both, courtesy CHHS, Inc.)

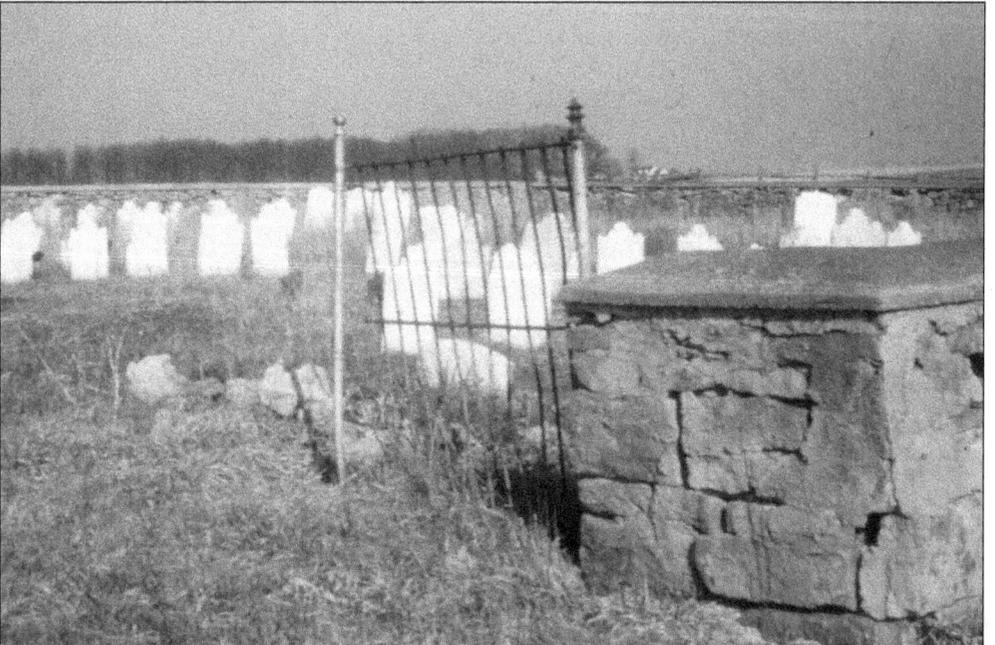

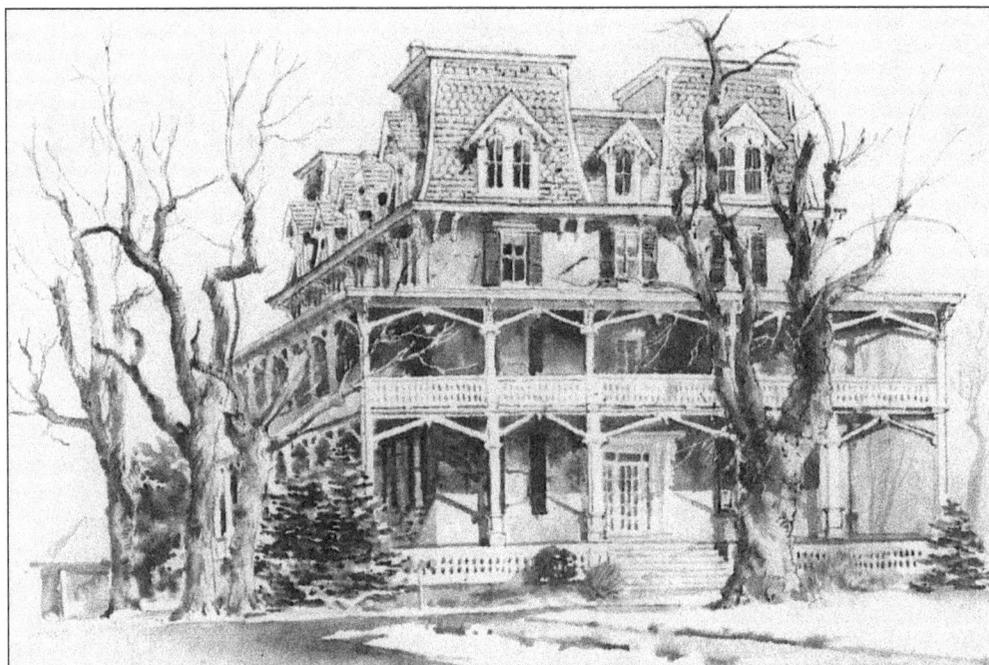

Edwin Lacey envisioned a beautiful hotel and country village destination for visitors to Philadelphia's 1876 Centennial Exposition. Unfortunately, a financial depression halted his development activities, and his hotel (rendering by Ranulf Bye) was not to be. The railroad Lacey anticipated, however, ultimately brought growth and prosperity. The charming community of Ivyland exists today thanks to Lacey's entrepreneurial endeavor. In 1903, Ivyland was granted borough status, incorporated Breadyville, and separated from Warminster Township. (Courtesy Bensalem Historical Society.)

The earliest conception of Warminster was that of a township of properties with a main street cutting through its middle. Indeed, a 1734 map shows the perfectly straight Street Road bordered on either side by the land holdings of Noble, Cadwallader, Longstreth, Gilbert, Bean, Craven, Scout, Tennent, and other families. Although lined with commercial enterprises today, it was still a sleepy dirt road in the early 1900s, as seen here. (Courtesy Jack and Ann Regenhard.)

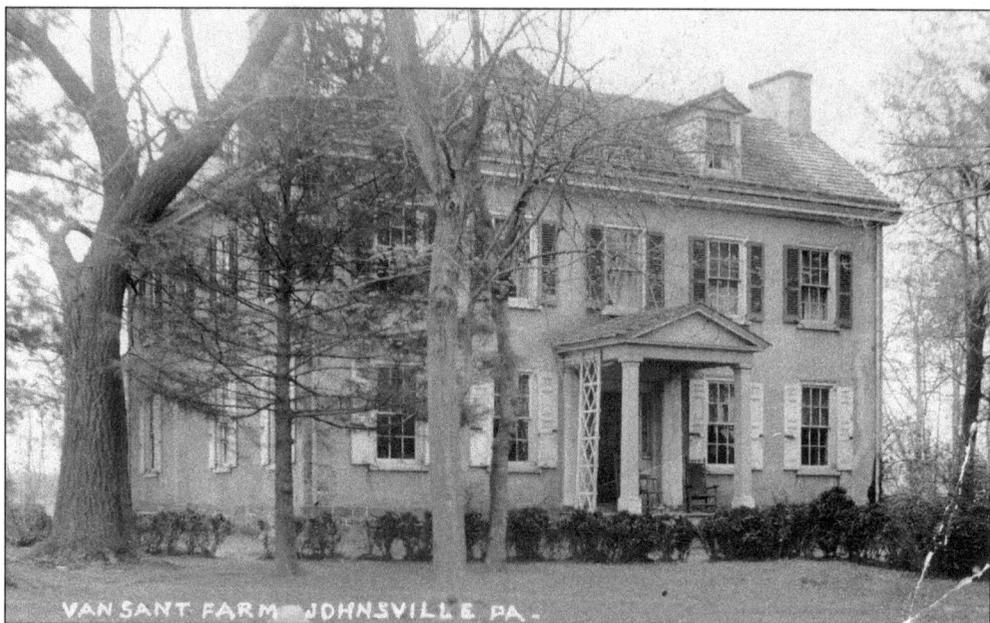

VAN SANT FARM JOHNSVILLE PA.

Rev. William Tennent preached in the 1720s where Craven Hall stands today. Decades later, family members treated injured soldiers here following a nearby Revolutionary War skirmish. The mansion (above around 1900, below 1970s) became school district property and was used for seventh and eighth graders and administrative offices of McDonald School in the 1950s. In 1977, this late-18th-century landmark was nearly sold to a nearby Oldsmobile dealer who intended to raze it to give Street Road motorists a better view of his new showroom. Outraged, retired social studies teacher Ella Rhoads rallied the community toward historic preservation. In 1980, she received the U.S. Department of Interior's highest honor for her successful efforts in preserving the nation's historic heritage. Today Craven Hall, listed on the National Register of Historic Places, hosts multiple community groups, such as the Craven Hall Historical Society, Inc. (Both, courtesy CHHS, Inc.)

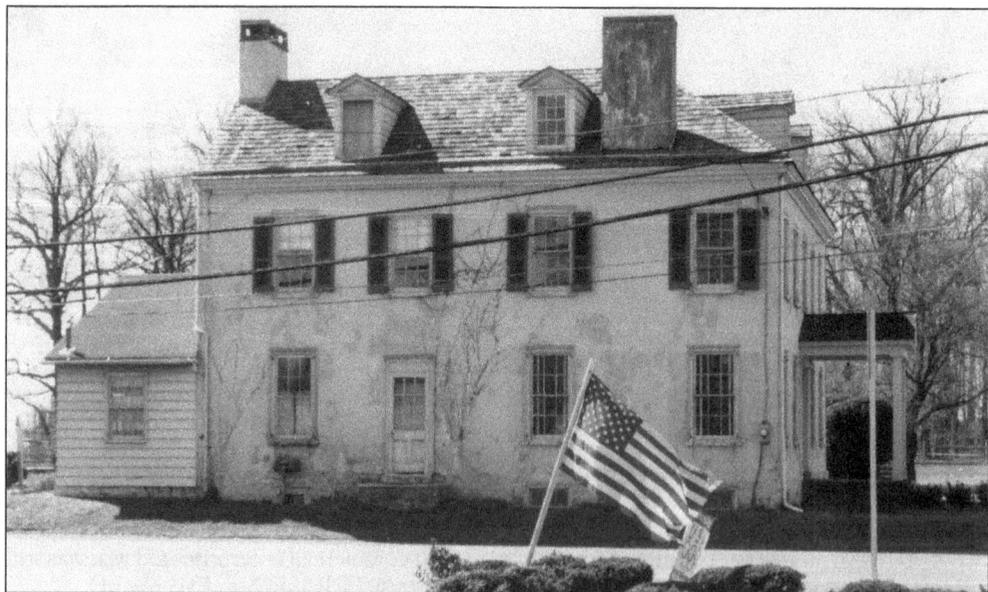

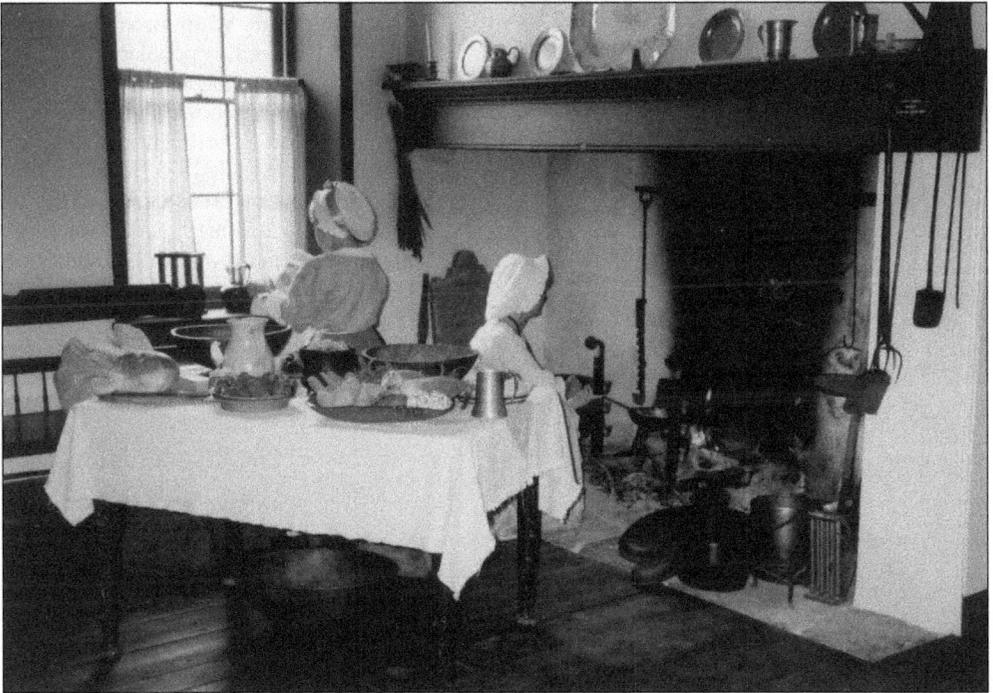

When Ella Rhoads and other locals formed Citizens for the Preservation of Craven Hall, Inc. in late 1977, they were joined in their efforts by community and civic groups, corporations, students, and even letter-writing Brownie troops. In 1978, a historical architectural structure review highlighting the building's distinctive characteristics recommended preservation. Bristol's Grundy Foundation provided $10,000 for a much-needed roof while Jaycees, Kiwanis, and Key Club members scoured it top to bottom. The Citizens for the Preservation of Craven Hall, Inc. has since presided over restoration, managing fund-raising, grants, volunteers, and events to keep this historic Warminster treasure viable. The volunteers in period attire demonstrating colonial cooking (above) are among many volunteers who have participated in Craven Hall reenactment events. The image on the cake (below) was used in the first fund-raising effort—the sale of pen-and-ink drawings. (Both, courtesy CHHS, Inc.)

To accommodate Warminster's growing needs and expanding population, Street Road was widened several times. This image shows a telephone pole, later moved, jutting from a new section added in July 1975. To the right is a plane built by Brewster Aircraft. Behind it is the former Quaker Meeting House where many of the community's citizens worshipped and married until 1962. (Courtesy Beverly Blackway.)

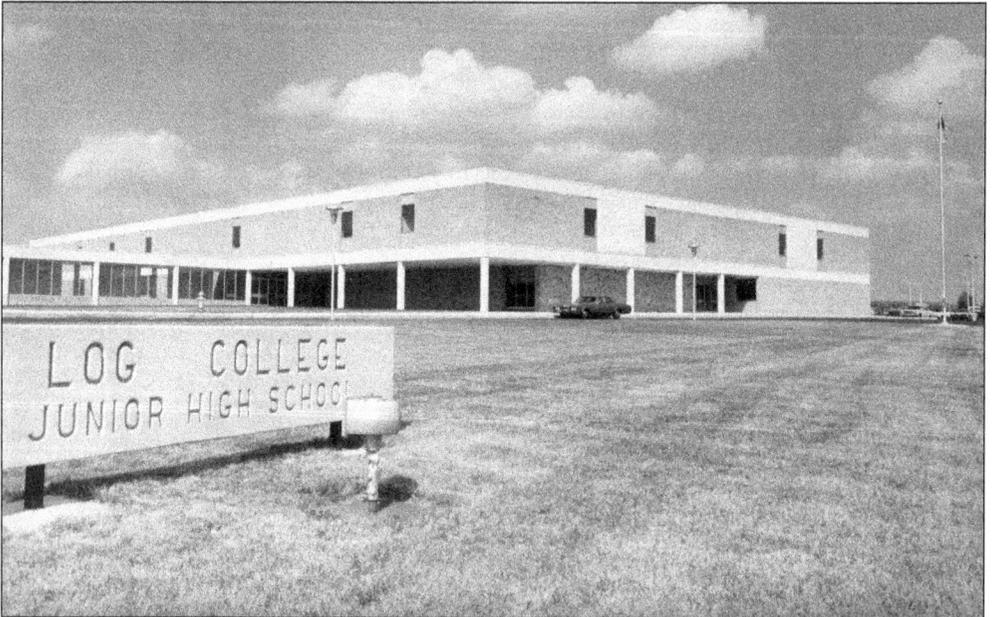

It cost almost $4 million to construct Log College Junior High on Norristown Road in 1968. Vincent Dovico, building and grounds superintendent, supervised construction, making this his seventh district school in 14 years. The school boasted a library for 15,000 books and a swimming pool. Extracurricular programs included band and orchestra, wrestling, hockey, basketball, soccer, and both varsity and weight football. Today the Log College Middle School has approximately 750 students enrolled. (Courtesy Centennial School District.)

Hartsville Fire Company has battled countless fires since beginning in 1924. It formed after neighbors, using garden hoses and buckets, failed to stop the destruction of Archie Darrah's barn. An annual membership fee of $2 was established and payable in installments. The lyceum on Old York Road, formerly a church annex, library, and social hall used by the Literary Society and Women's Club, was purchased for the firehouse in 1927 and used until 1971. In 1973, to celebrate its 50th anniversary, the company organized a firefighters "Olympics," holding "hot-rod" fire truck races on a NADC runway. Hartsville was among the first companies recognized by the state fire commissioner for having at least three-quarters of its members obtain Voluntary Fire Service Certification. Firefighters are shown in the mid-20th century in service at Amsco Toy Company (right) and relaxing after battling a blaze (below). (Both, courtesy of Hartsville Fire Company.)

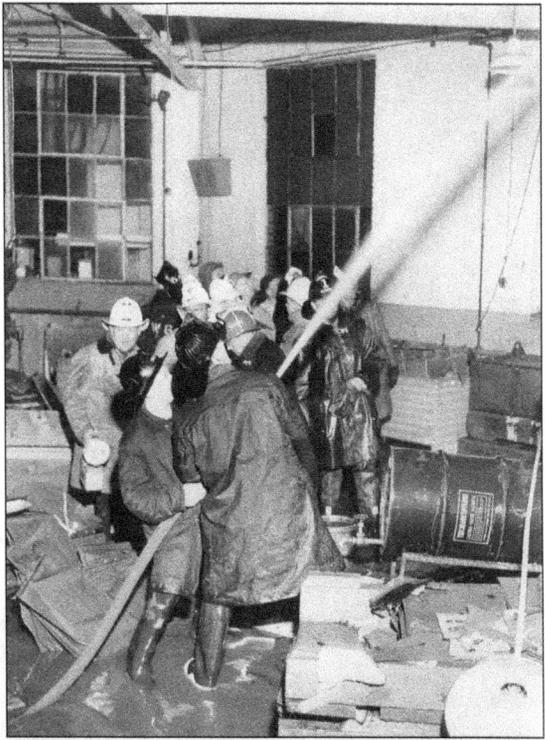

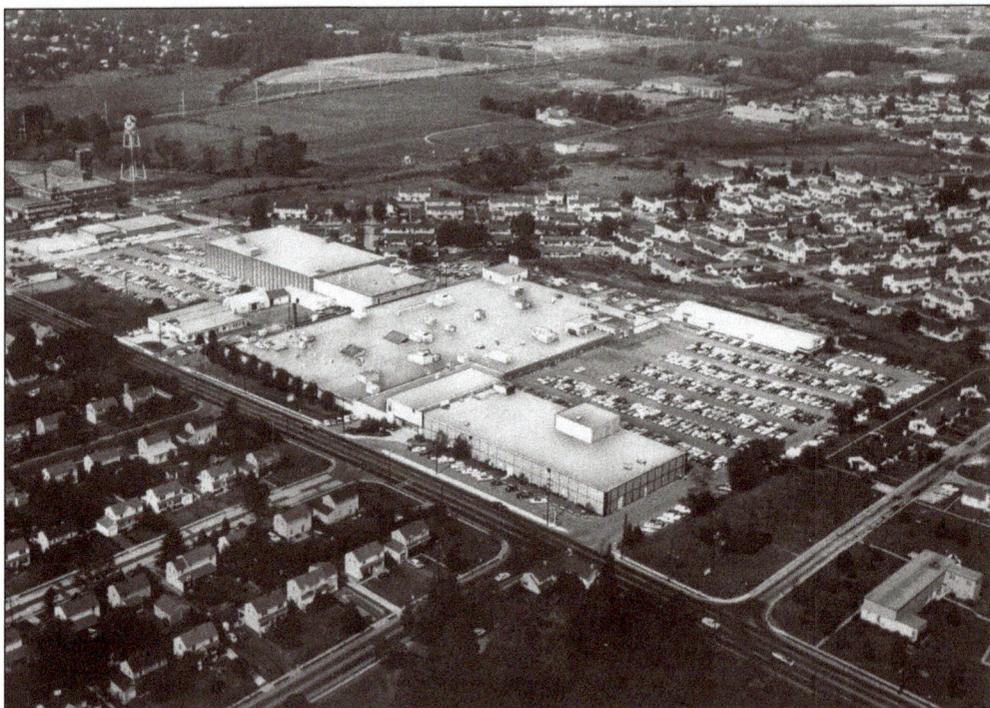

Fischer and Porter, manufacturer of measurement and control instruments, relocated to Warminster around 1941 and employed up to 2,000 people at its peak. Cofounder, owner, and Drexel's prestigious Science and Technology Award winner Kermit Fischer was both a maverick and benevolent employer. After a tragic 1971 accident in Belgium, his ashes were interred in the building's front wall. They were returned to his family in 1999 following acquisition by process control instrumentation maker ABB. (Courtesy Beverly Blackway.)

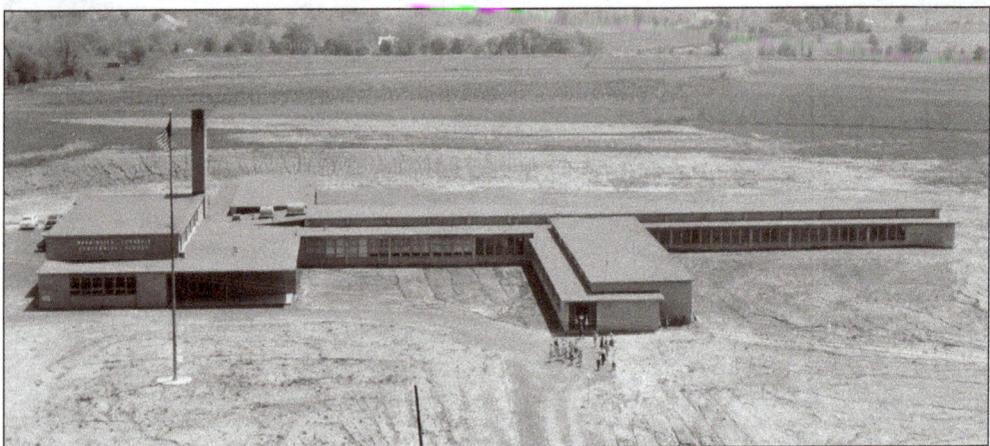

Centennial School (later Johnsville Elementary), dedicated in May 1953 and overseen by Alta Leary, brought modern educational facilities to Warminster's burgeoning student population. Classrooms sported movable furniture and an all-purpose room for gatherings, gymnastics, lunch tables (folded down from the walls), and theatrical performances. A state-of-the-art sound system with AM-FM radio and "phonograph attachment for record playing" for classroom broadcasts were also provided. The building now houses the Centennial School District Administration offices. (Courtesy Centennial School District.)

Georges Duval, head of the Weapons Division at NADC, and his wife, Elizabeth Duval, a Centennial schoolteacher, were members of a flying club at NADC. As a member of the Ninety-Nines, an international organization for female pilots, Elizabeth flew in the Powder Puff Derby and other transcontinental air races, one of which was from Saskatchewan, Canada, to Nicaragua. She also flew across the Atlantic Ocean to Barcelona, Spain, in a twin-engine plane. (Courtesy Dr. Laure Duval.)

In 1931–1932 Amelia Earhart spent considerable time at Pitcairn Field (now Willow Grove Naval Air Station), one of the busiest Northeastern U.S. airports at the time. Here she trained with Skip Lukens on the autogiro, predecessor to the helicopter. After crash-landing her first autogiro in Abilene, Texas, Amelia was sent a new one, which she flew to California. Clarence Morris photographed Amelia and her husband, George Palmer Putnam (far right), at Pitcairn Field in 1931. (Courtesy Beverly Blackway.)

The Berlin Wall separated loved ones for 28 years (1961–1989). One year after it finally fell, reuniting East and West Germany, the first slab to be sent outside the country for display arrived in Philadelphia. Over 20 years later, this five-ton behemoth stands in the lovely garden of the Vereinigung Erzgebirge German Club on Davisville Road, a symbol of the Iron Curtain and fortitude of the German people. (Courtesy Jack and Ann Regenhard.)

The Davisville Hardware store had previously been a variety store and retailer of children's clothing. This mid-1950s photograph was taken at its grand opening. Ron Rice and Harry Bach, both employed by Davisville Center, Inc., managed the store from the mid-1970s to the early 1990s. Today the building has been repurposed yet again as a dollar store. (Courtesy Jean Rice.)

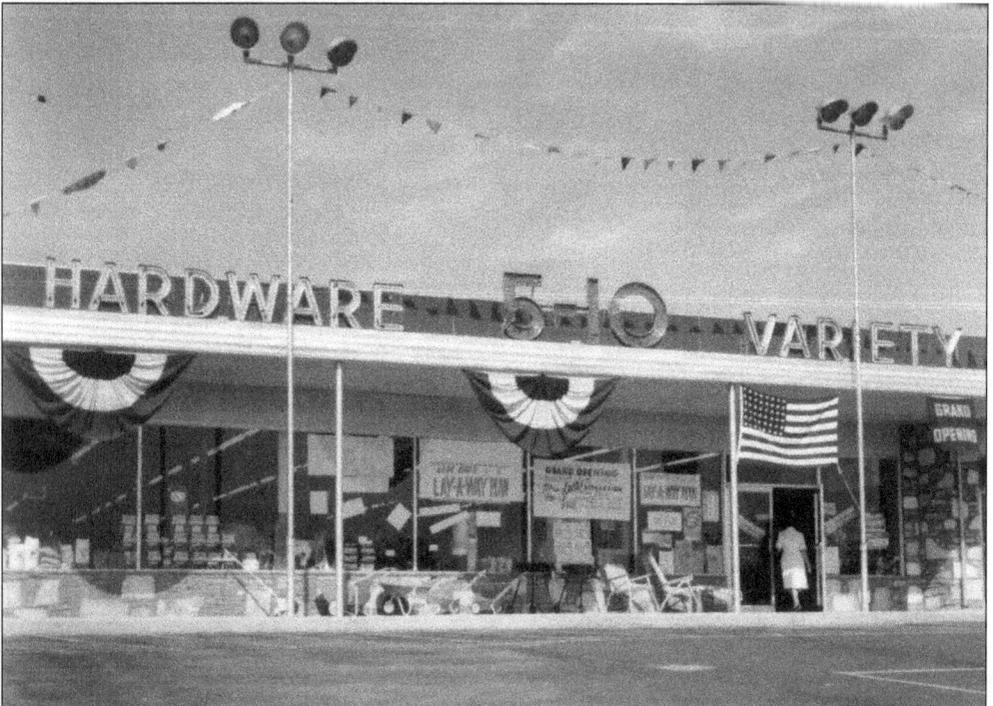

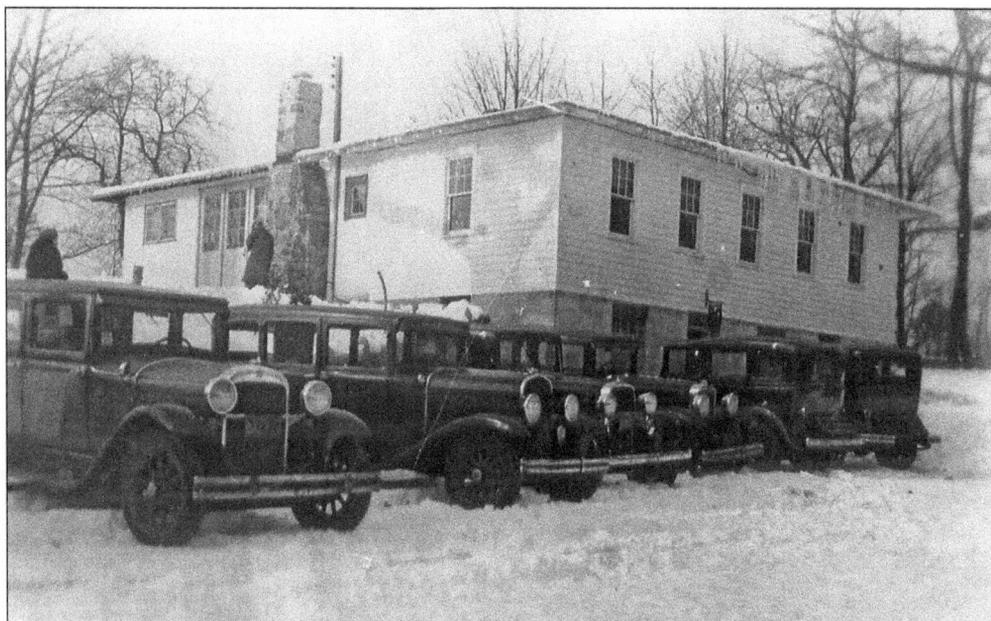

Experienced knitters from Germany's Erzgebirge region immigrated to America in the early 1900s to work in newly established hosiery mills. Eight men subsequently formed the Vereinigung Erzgebirge German Club. In 1932, they purchased 32 acres along County Line Road and converted the home there into a clubhouse (above). By the 1950s, they boasted a beautiful new clubhouse (below), a pool, and almost 70 recreational acres. Today a piece of the Berlin wall is displayed in its garden, a sober reminder of the former Iron Curtain. (Both, courtesy Vereinigung Erzgebirge German Club.)

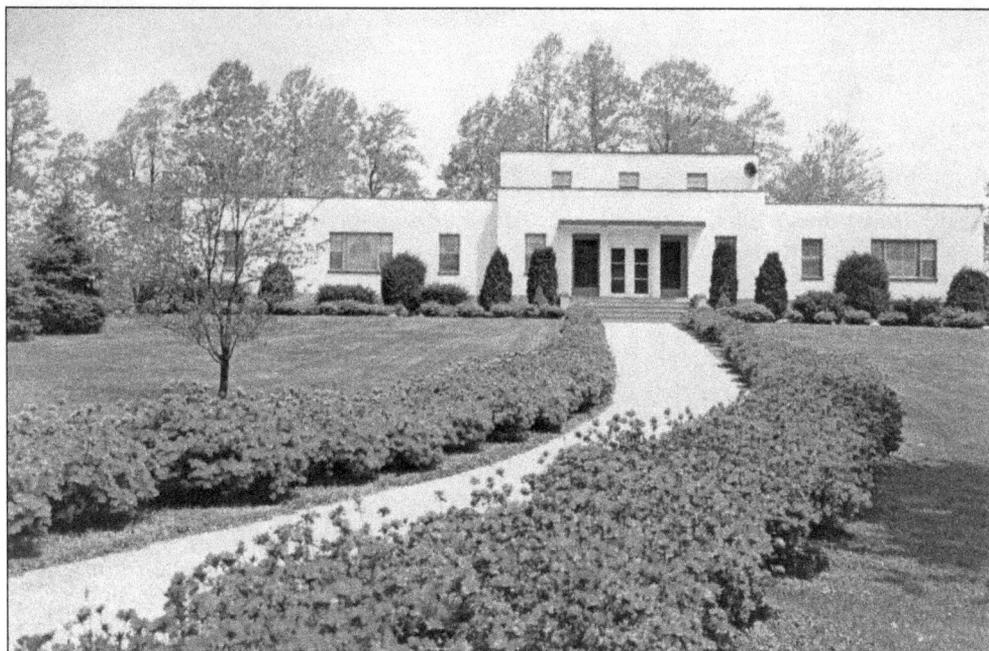

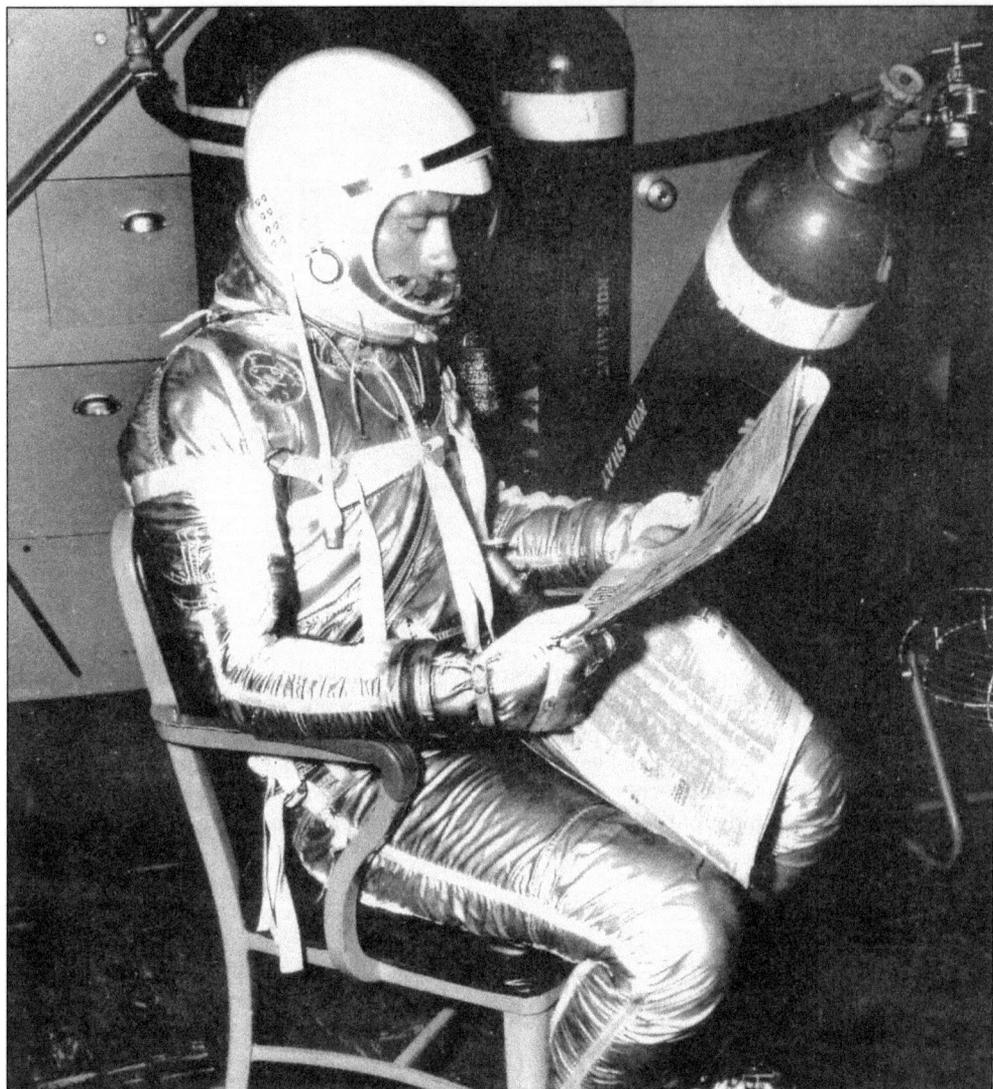

From July 31 through September 1961, U.S. Air Force captain Donald "Deke" Slayton was one of seven future astronauts from NASA to participate in the Astronaut Acceleration Training Program conducted at the human centrifuge in Johnsville. Slayton was preparing for the Mercury Atlas mission and joined by John Glenn, Scott Carpenter, Gordon Cooper Jr., Virgil Grissom, Alan Shepard, and Walter Schirra Jr. Here he patiently awaits his "gondola" ride with a newspaper. (Courtesy Douglas Crompton.)

# *Four*

# NAVAL AIR DEVELOPMENT CENTER

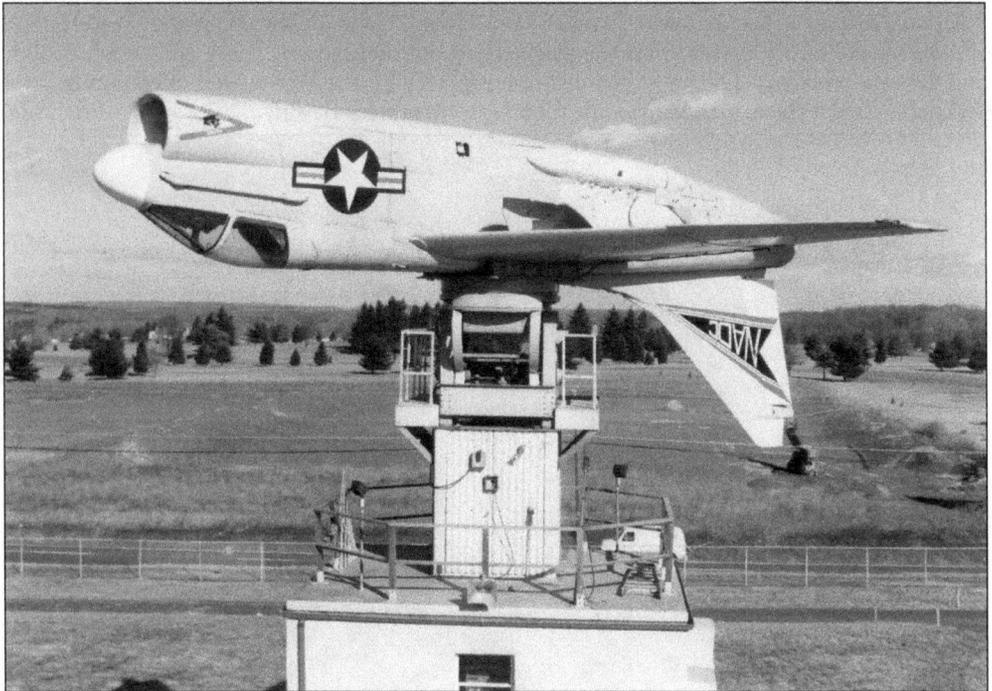

This upside down plane, a landmark on Bristol Road near Newtown Road, was part of the Navy's newly created full-scale aircraft test facility in August 1991. This A-7 (and other models) provided a ground-based facility for antenna testing that was more economical than in-air testing. The objective was to design, test, and evaluate state-of-the-art aircraft communication technology and emerging electronic warfare technology. Today, on Ann's Choice property, only the support structure remains. (Courtesy Douglas Crompton.)

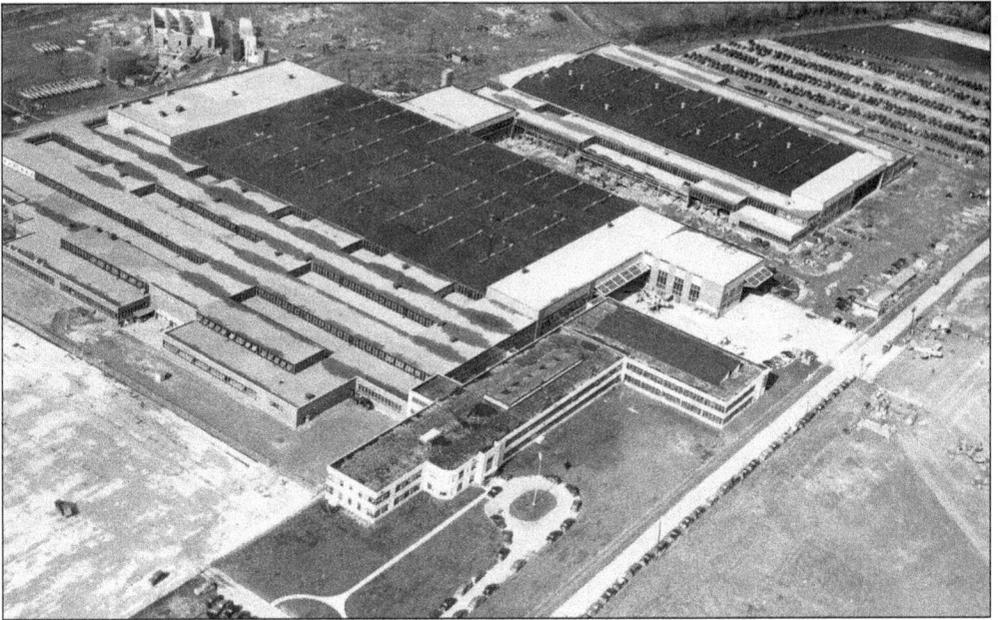

Leading aircraft supplier Brewster Aeronautical Corporation expanded beyond its New York and New Jersey operations in 1939 following Hitler's European invasion. They purchased 730 acres in Johnsville and constructed runways, hangars, and a $5 million plant. Two years after Pearl Harbor, Brewster employed 6,800 workers but was plagued by severe management, labor, production, quality, and delivery problems. The navy assumed responsibility for the Warminster operation in 1944 and designated it the Naval Air Modification Unit. (Courtesy Beverly Blackway.)

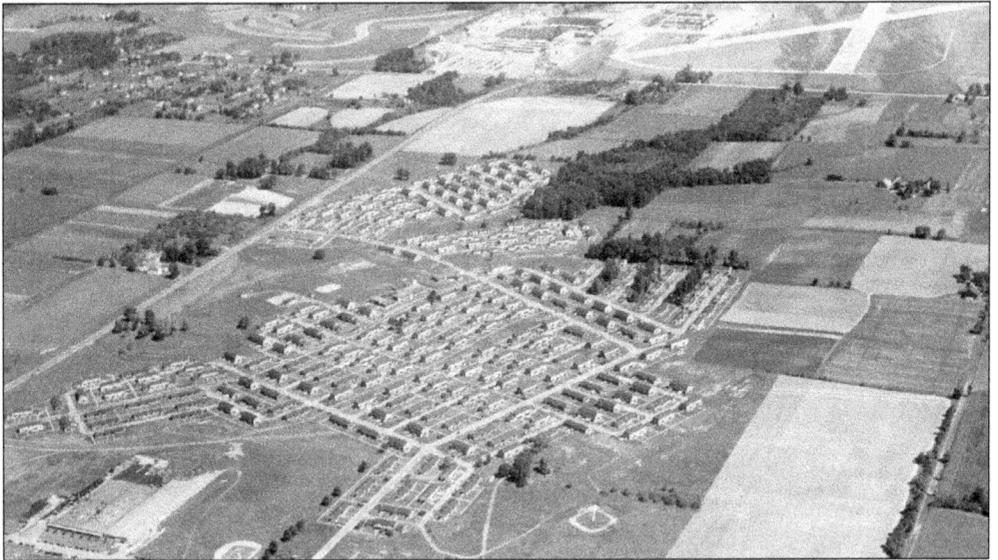

Twelve hundred brick and masonry homes, designed in two- to six-family buildings, sprouted in Johnsville in 1943 to house workers for military supplier Brewster Aeronautical Corporation. Lacey Park (seen in the foreground in 1948) was conceived and completed in a project considered "the speediest ever . . . engineered by government." The development deteriorated under private ownership in the 1960s to early 1970s; it was revitalized in 1975 under the Warminster Heights Development Corporation and Home Owners Association. (Courtesy Beverly Blackway.)

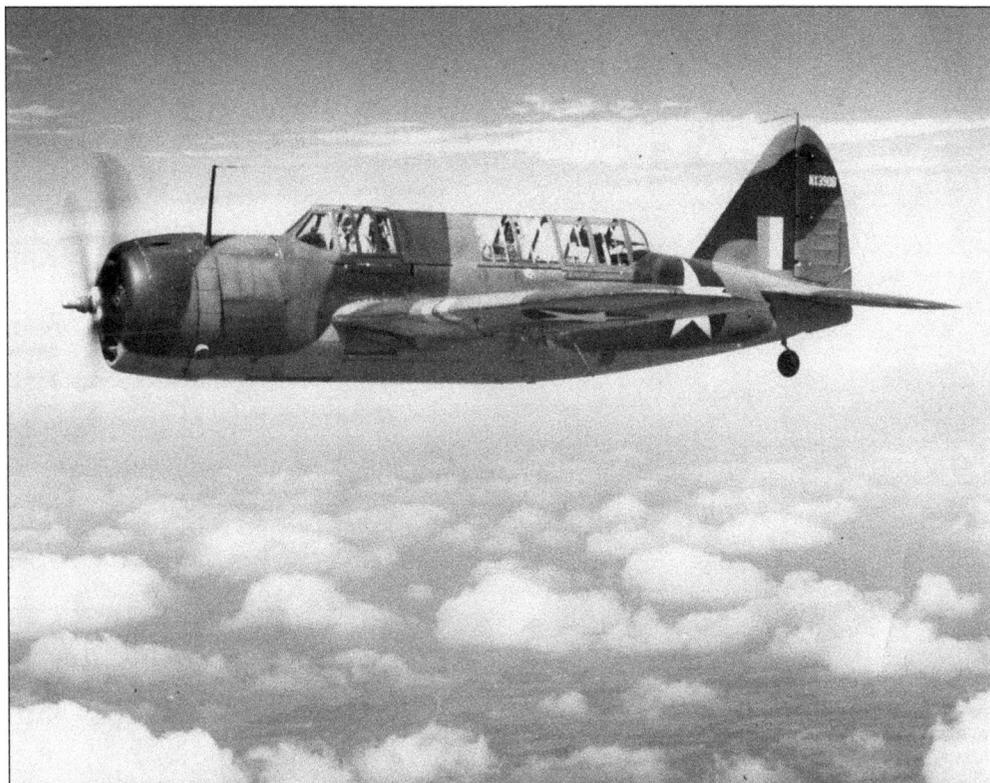

During World War II, Brewster Aeronautical Corporation of Johnsville built Corsair fighter planes, Buccaneer dive-bombers, and a dive-bomber called the *Bermuda* (above) for the British. Pictured at right are two young unidentified test pilots who were required to evaluate new planes under varying and often dangerous conditions. From 1976 to 1994, a group called the Brewster Restoration Team dedicated 16,000 hours to rebuilding a hybrid of the Bermuda-Buccaneer bombers in hopes it would become part of a proposed Johnsville Armed Services Museum. The aircraft was instead shipped to the National Museum of Naval Aviation in Pensacola, Florida, in anticipation of the closing of the Johnsville Naval Air Warfare Center. (Above, courtesy Beverly Blackway; right, courtesy Doug Crompton.)

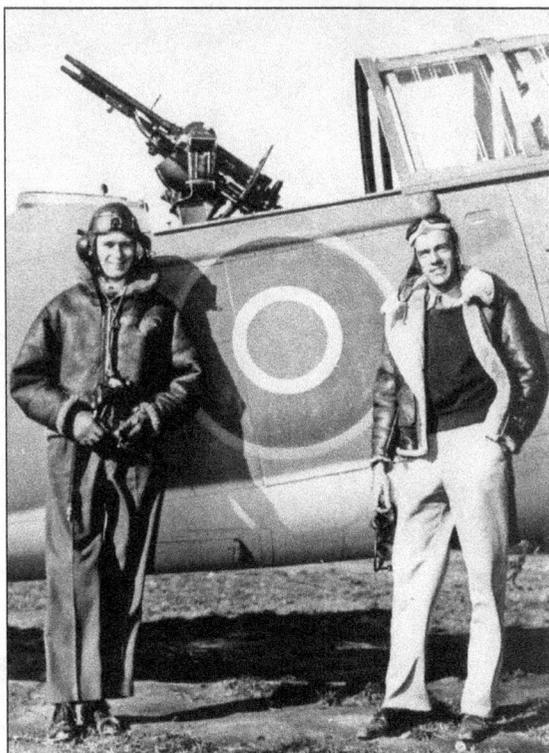

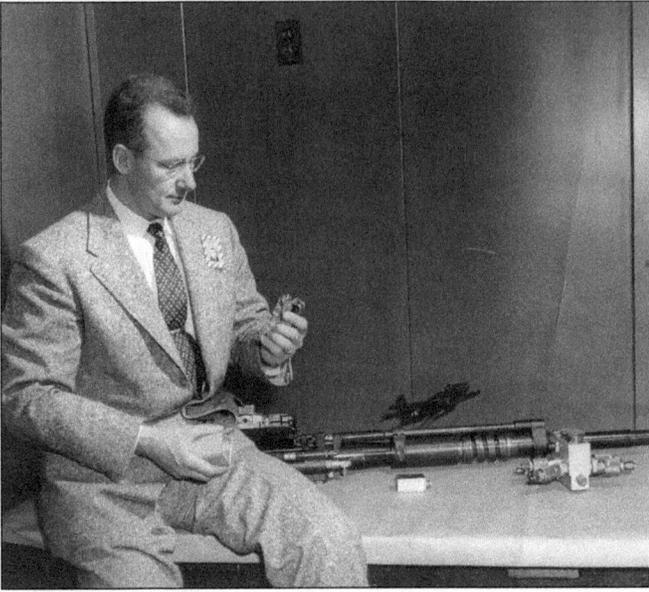

Georges S. Duval, assigned top-secret clearance, directed the development of advanced weapons systems at the NADC's Weapons Division from 1948 to the mid-1970s. Prior to becoming a Warminster resident, he helped establish the Buckingham Zoning Commission and the Bucks County Conservancy (now the Heritage Conservancy). Remaining civic-minded, he subsequently served many years as a member of Warminster's School Authority. (Courtesy Dr. Laure Duval.)

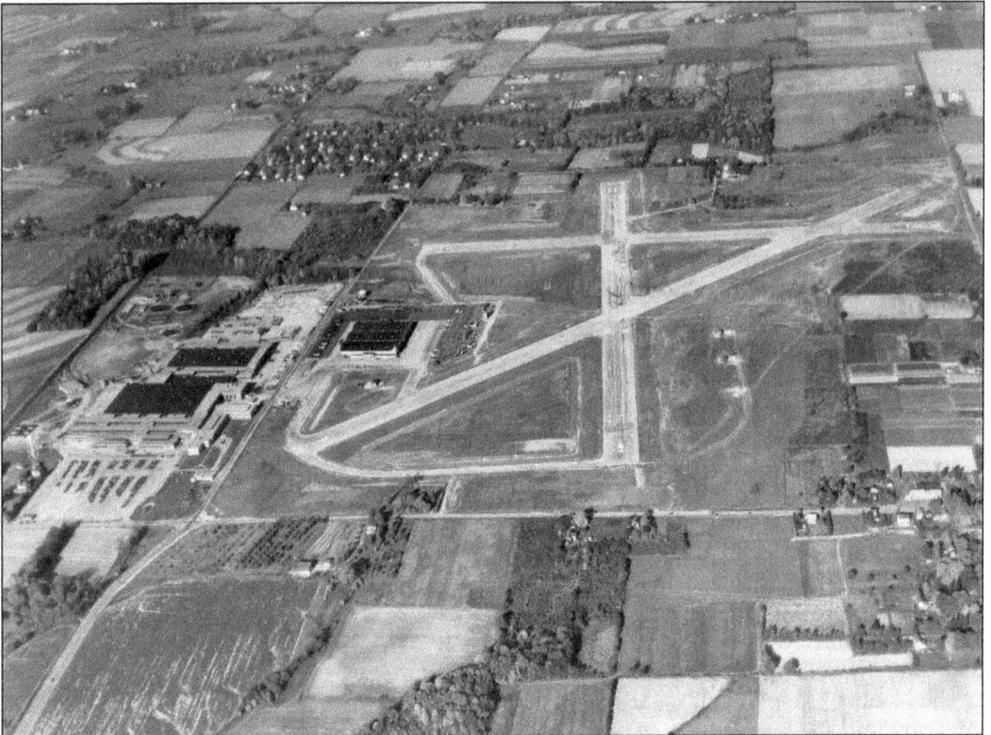

*Intelligencer* article "From World War II to Space Age" described the NADC's half century in Johnsville. In 1944, Brewster Aircraft facilities became the Naval Air Modification Unit (seen in 1946), then NADC in August 1949. Soon multiple research labs were humming, and the world's largest centrifuge was installed. NADC's technological breakthroughs and dedicated workforce (approximately 3,500 by the mid-1980s) unquestionably contributed to America's might before services transferred to the Naval Air Warfare Center in Patuxent River, Maryland, in 1996. (Courtesy Beverly Blackway.)

120

In the late 1960s, Marvin Foral of the NADC Radar Division in Johnsville developed a high-frequency millimeter radar. Here he is seen conducting weather-impact studies on the water. According to USN Commander C. M. Rigsbee, Foral's millimeter radar design was the first in the world at its particular frequency to operate successfully and reliably. Potential applications included security, search and rescue, and other critical detection operations requiring precise target identification. (Courtesy Nancy Andal.)

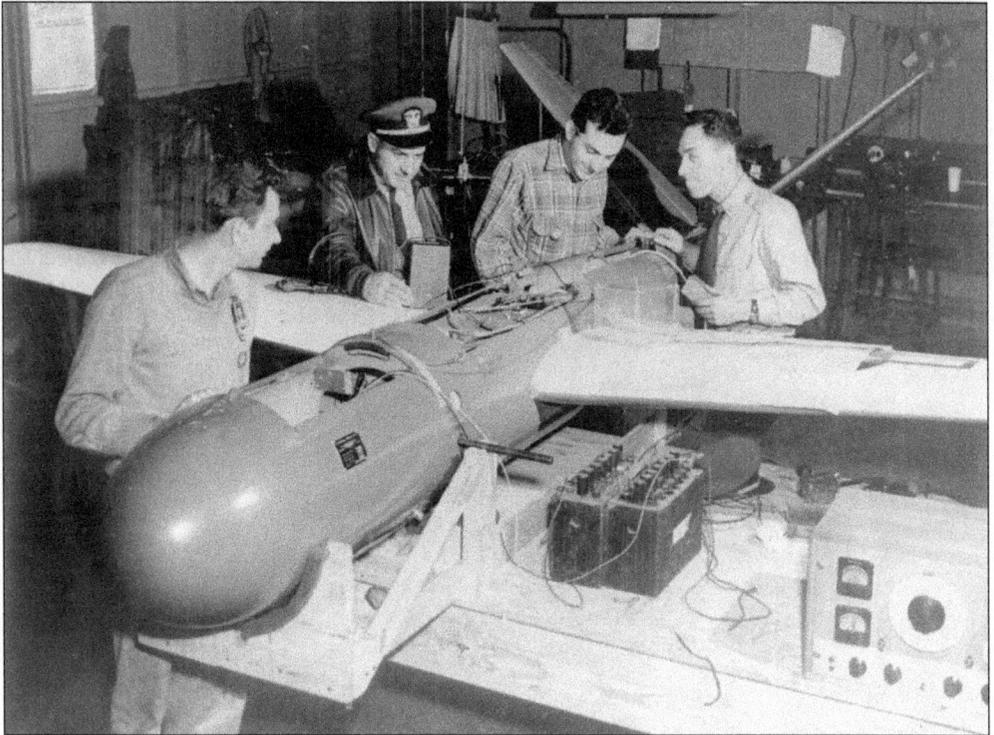

To evaluate new weapons performance, the NADC initiated development programs to design and electronically outfit drones (unmanned aircraft) and conducted test firings at ranges throughout the country. Obsolete aircraft were converted into multiple-mission targets and equipped with automatic pilots, remote controls, and performance auxiliary measuring systems. Personnel seen at work creating a drone are part of the Aeronautical Engineering Division, the group responsible for target systems, including aircraft conversion and target launchers. (Courtesy Douglas Crompton.)

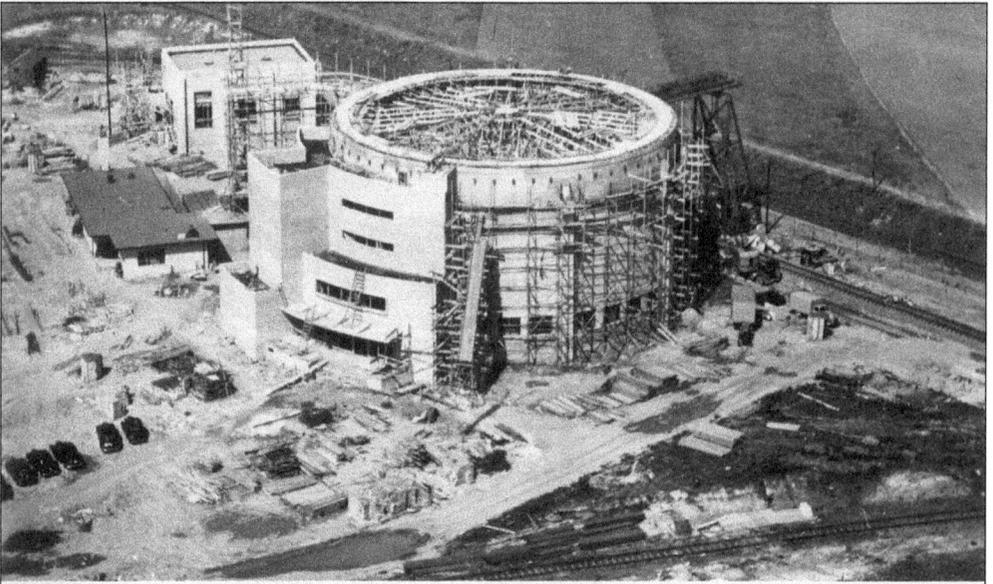

U.S.N.A.D.S., Johnsville, Pa.
(Human Centrifuge Project)
Human Centrifuge Building - Aerial of.
15835    Contr. NOy-13841    Restricted    Spec. 17955    5/31/49

To study effects of high-performance aircraft on humans, the NADC built the Aviation Medical Acceleration Laboratory. The experimental lab's cylindrical building of reinforced steel and concrete (above under construction in 1949) contained the world's largest centrifuge (below). In the early days of America's space program, monkeys were the initial test subjects. Human flight simulation experiments determined endurance limits, movement and position techniques, and flight uniform requirements. *Mercury*, *Gemini*, and *Apollo* astronauts, including Alan Shepard, Gus Grissom, John Glenn, Scott Carpenter, Neil Armstrong, Buzz Aldrin, and 25 other NASA astronauts, received training here. Later in the mid-1960s, jet-transport pilots from all major commercial airlines trained in turbulence simulation tests here. (Both, courtesy Douglas Crompton.)

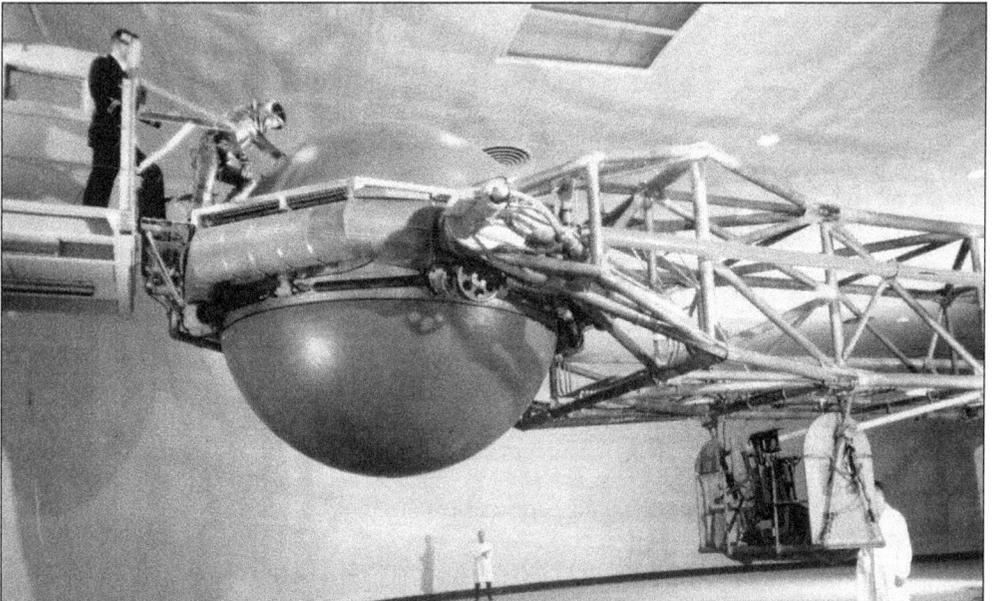

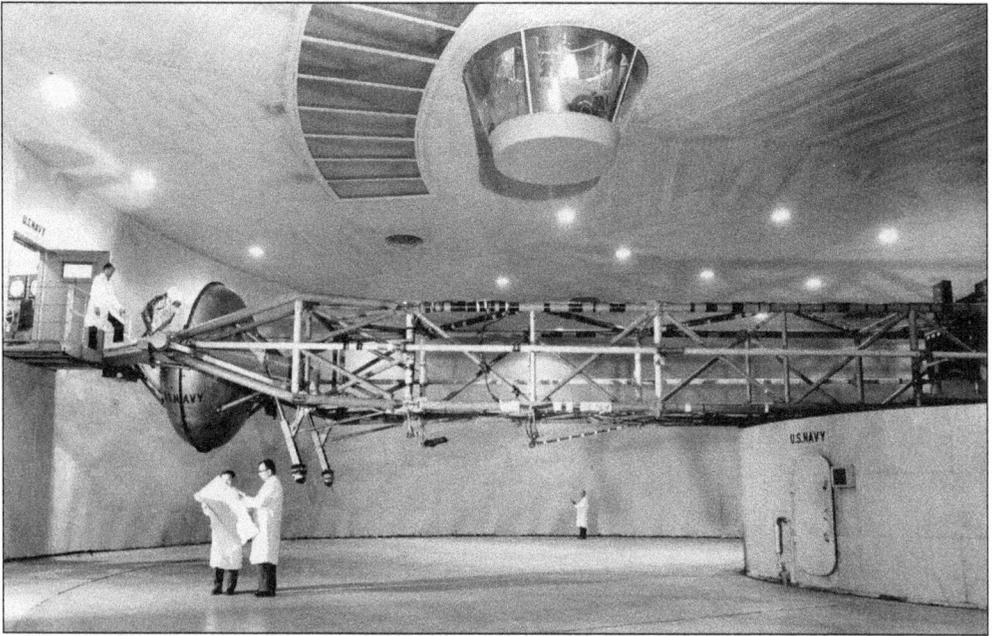

The Centrifuge at the NADC Aviation Medical Acceleration Laboratory was designed to test tolerance of gravity forces on the body (animal and human). Flight simulation took place in the gondola (above), which was mounted and spun on a 50-foot tubular steel arm. Powered by a 4,000-horsepower motor, it could reach 180 miles per hour in less than seven seconds and achieve acceleration forces up to 40 times the force of gravity. Interior centrifuge walls, floor, and ceiling were covered with 1/16-inch copper to protect instruments from magnetic and electrical interference. Observation equipment and monitors recorded vital signs during flight simulation and were controlled for many years by Lou Passavanti (below) from a small room called the "blister." In 1964, the gondola and arm were replaced and all other aspects of the centrifuge modernized for new flight simulation projects. (Both, courtesy Douglas Crompton.)

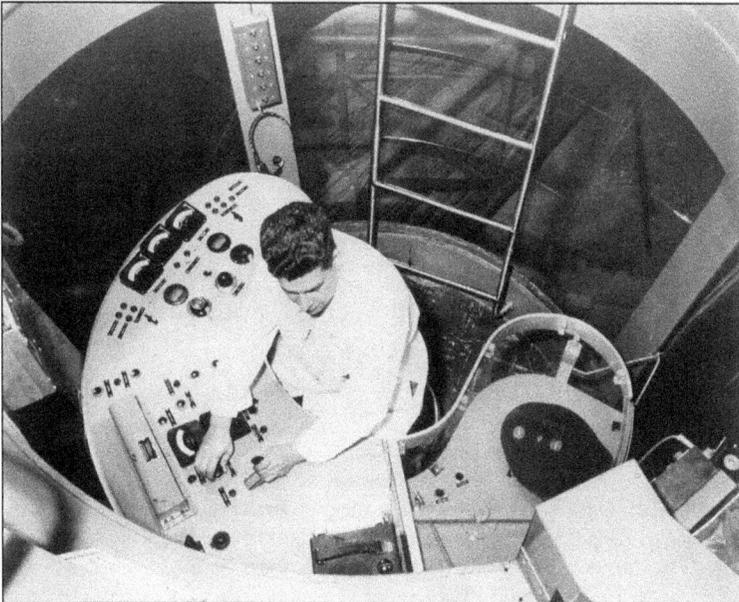

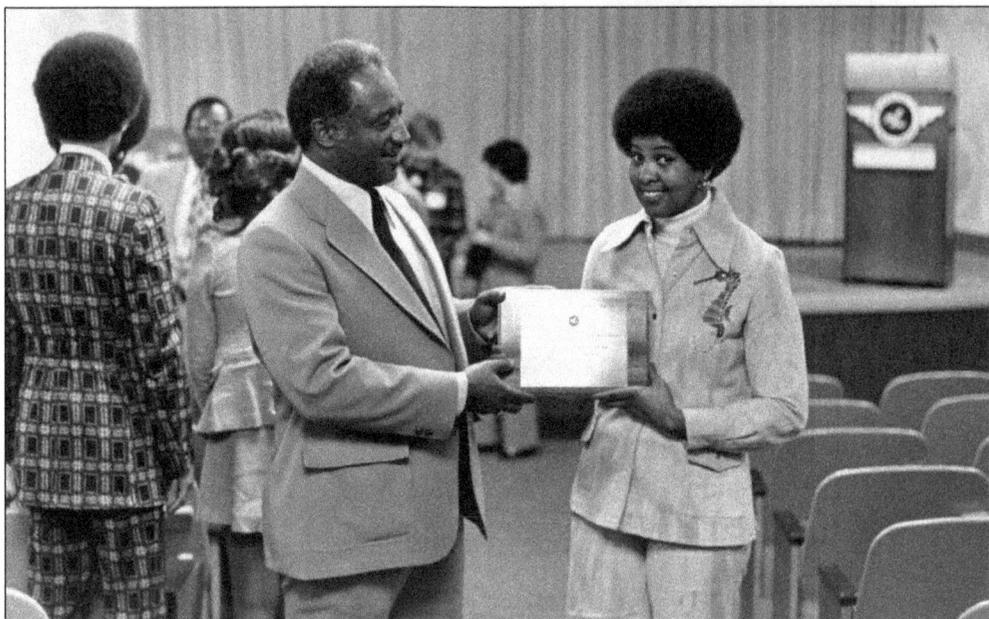

Pantsuit-clad Rebecca Gray, receiving award from EEO director Gilbert Ridley, was one of 13 women (still called "girls") in 1971 vying for the Navy Relief Queen title. The honor was bestowed on the contestant who collected the most fund-drive contributions. At the time, controversy surrounded women wearing pants to the office. An opinion survey on the subject was published in the NADC newsletter, the *Reflector*, only months before. (Courtesy Douglas Crompton.)

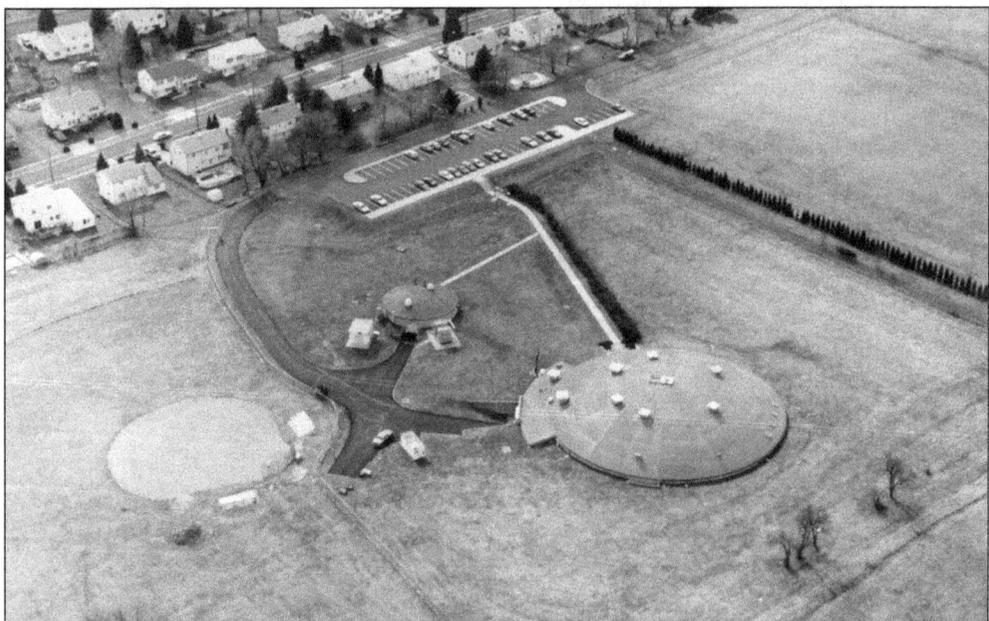

After the navy moved its navigation center from Brooklyn to Johnsville, this large dome-shaped facility, partially underground and atop solid bedrock, became an inertial navigation development laboratory. Equipment such as gyroscopes for inertial navigation systems on aircraft, submarines, and ships were engineered here. The lab now functions under Pennsylvania State University's Applied Research Laboratory's Navigation Research and Development Center. (Courtesy Douglas Crompton.)

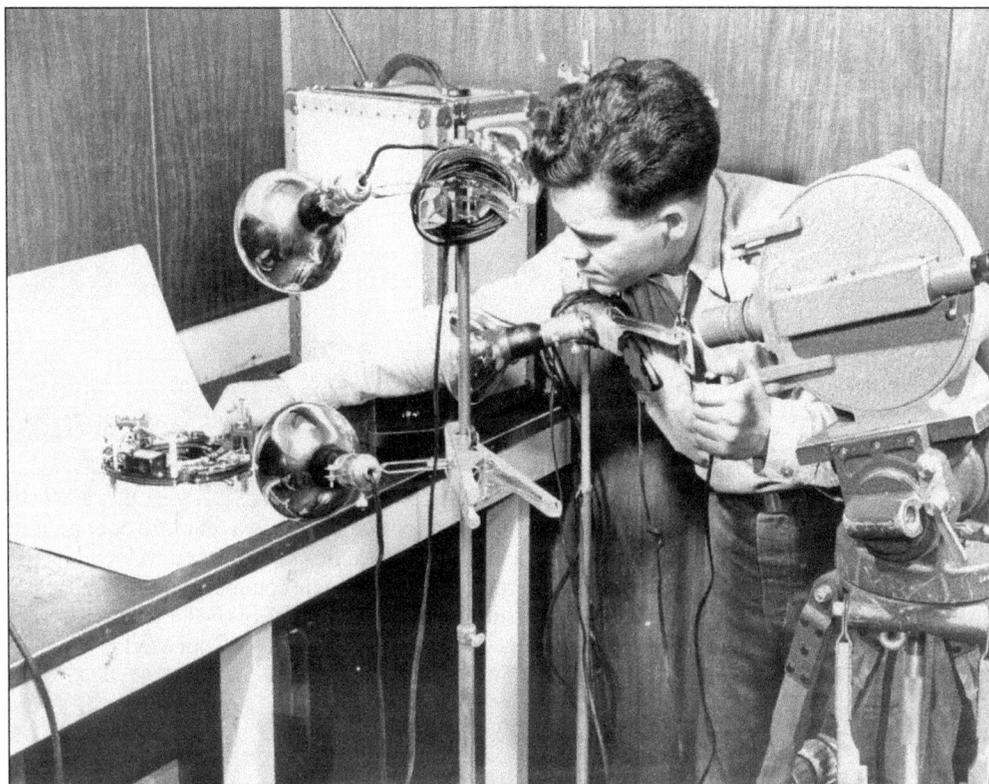

Airborne photographic equipment and systems were developed and evaluated at the Aeronautical Photographic Experimental Laboratory (APEL) that moved from Philadelphia to Johnsville in 1953. Early research in airborne photography led to the prototyping of cameras, control systems, and aerial motion picture devices. Still-photography services for various departments at the base were also provided. Here a photographer prepares to film and document a project's prototype design. (Courtesy Douglas Crompton.)

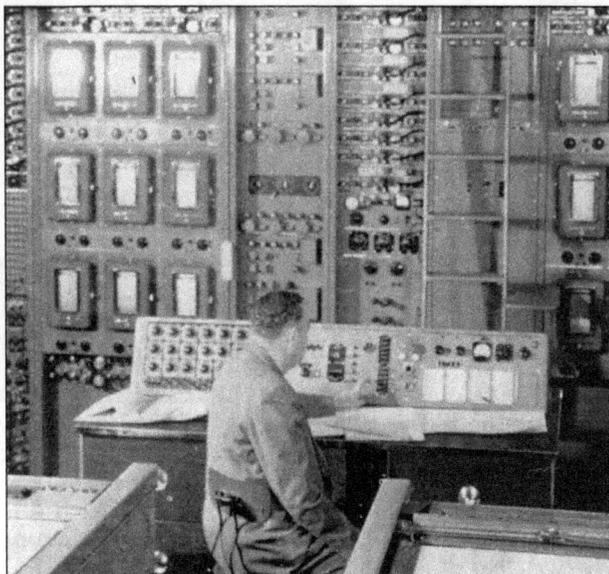

Johnsville's Analytical and Computer Equipment Laboratory opened in 1950. The Typhoon, a then state-of-the-art RCA analog-digital hybrid computer consisting of 50,000 vacuum tubes, was installed in 1952, enabling systems and operations research studies. Linked to the human centrifuge, it thrust the NADC "into the heart of America's manned space effort" and was used to train astronauts in spaceflight simulations. Five analog computers providing twice the capacity replaced it after its 1968 dismantlement. (Courtesy Douglas Crompton.)

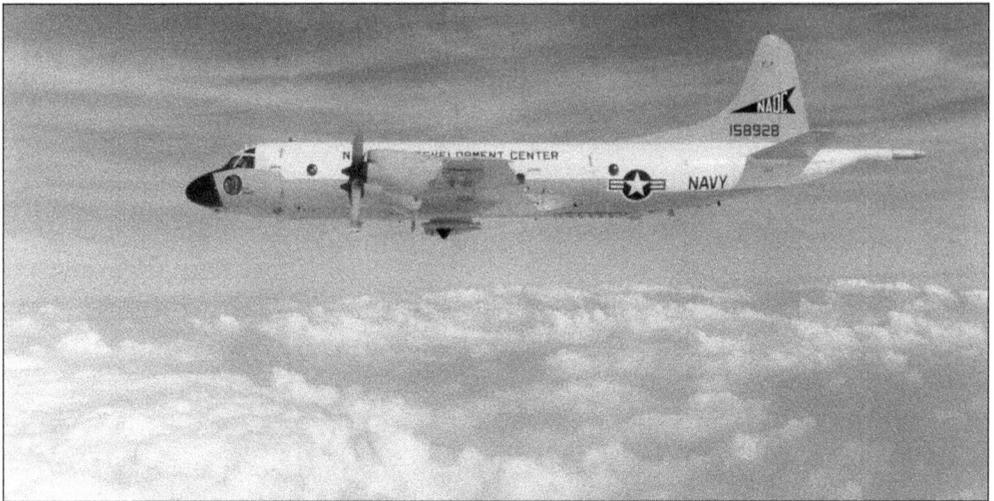

The P-3 *Orion*, the navy's frontline, land-based maritime patrol aircraft, was put into operation in the 1960s to counter growing Soviet submarine threat. Its weapons system was developed by the NADC and used one of the first airborne digital computers to integrate communication, navigation, acoustic, non-acoustic, and ordnance weapons subsystems. The P-3, one of the larger engineering projects at the NADC, continues in service for the navy today. (Courtesy Tom Merkel.)

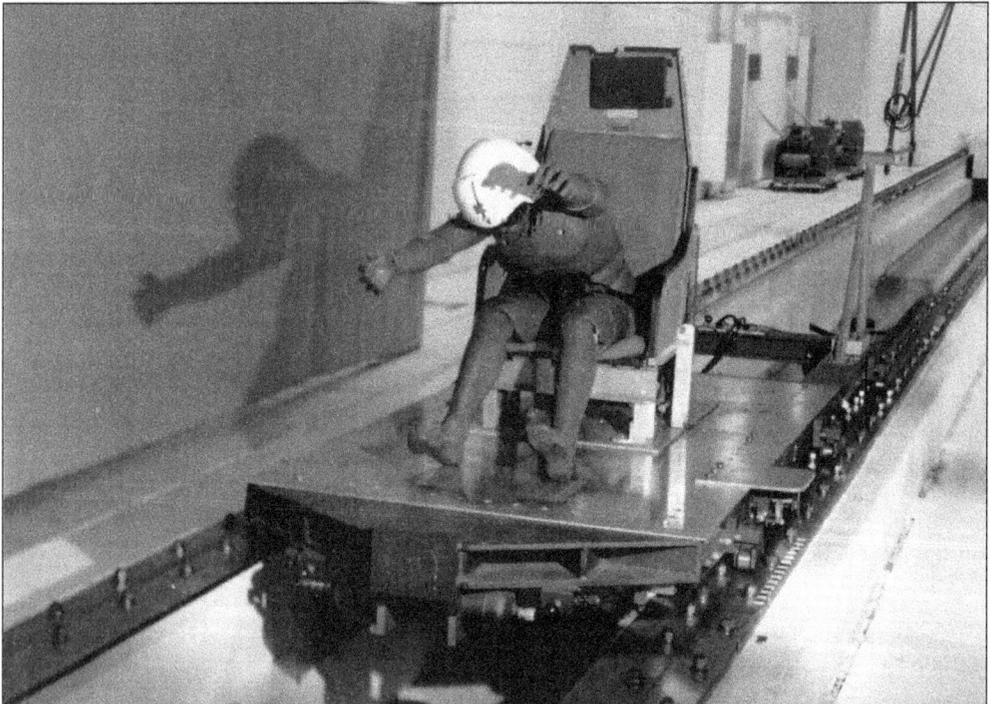

The Aviation Medical Acceleration Laboratory came into existence to support the world's largest centrifuge, dedicated at Johnsville in June 1952. Eventually this included the horizontal accelerator shown and other facilities. Data collected from testing greatly aided in the development of ejection seats, crashworthy seating systems, pilot and astronaut suits, and other related aviation safety equipment, as well as helping to refine the anthropomorphic mannequin shown, a human surrogate that allowed safe equipment evaluation. (Courtesy Douglas Crompton.)

After two years of preparation, Alan Shepard Jr. became the first American in space, piloting the *Freedom 7* mission on a suborbital flight on May 5, 1961. Afterward he praised the NADC centrifuge's computerized instrument displays for providing training simulation "very close" to his actual space experience. When later asked about his thoughts while waiting for the Redstone rocket launch, he replied "that every part of this ship was built by the low bidder." (Courtesy Beverly Blackway.)

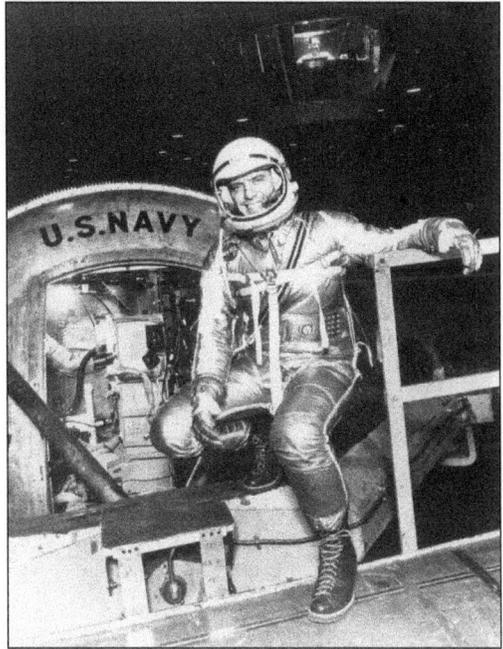

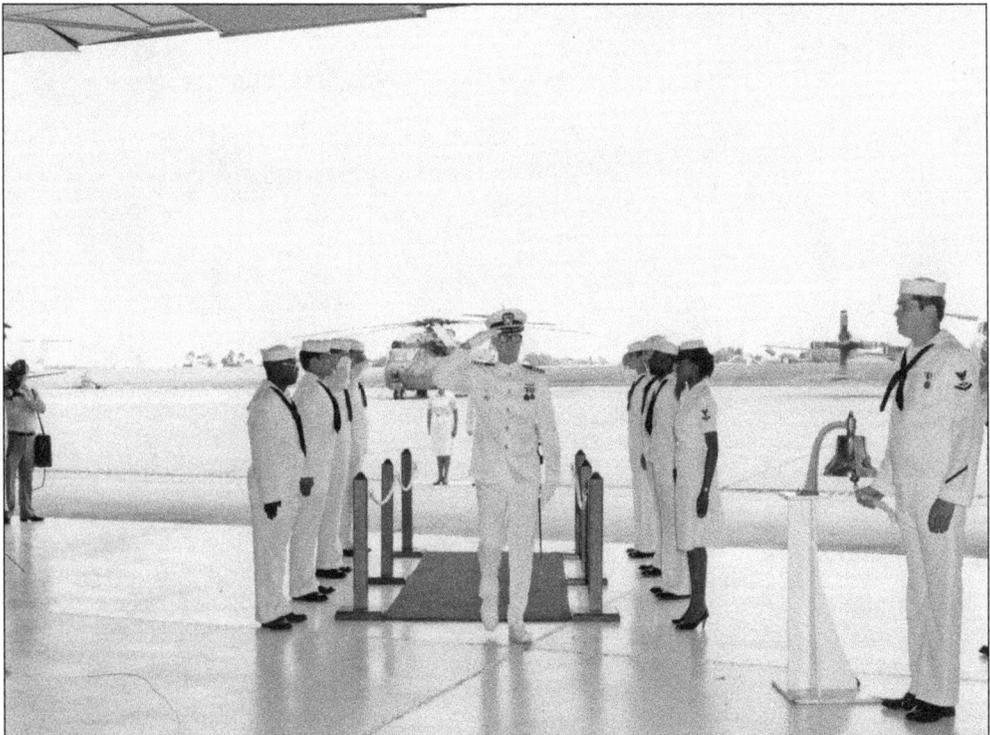

Pomp and circumstance attended every change of command ceremony at the NADC (redesignated Naval Air Warfare Center in 1992). Bands played, speeches were given, and guests watched as a formal change of base command unfolded. Capt. James B. Anderson, incoming commanding officer in 1981, was the 16th captain to take the helm at the NADC and one of 22 commanding officers to head-up Johnsville before base closure in 1996. (Courtesy Douglas Crompton.)

Visit us at
arcadiapublishing.com

www.ingramcontent.com/pod-product-compliance
Lightning Source LLC
Chambersburg PA
CBHW050607110426
42813CB00008B/2486